# MAKING MEDIA STUDIES

Steve Jones
*General Editor*

Vol. 93

The Digital Formations series is part of the Peter Lang Media and Communication list.
Every volume is peer reviewed and meets
the highest quality standards for content and production.

PETER LANG
New York • Bern • Frankfurt • Berlin
Brussels • Vienna • Oxford • Warsaw

DAVID GAUNTLETT

# MAKING MEDIA STUDIES

## The Creativity Turn in Media and Communications Studies

PETER LANG
New York • Bern • Frankfurt • Berlin
Brussels • Vienna • Oxford • Warsaw

Library of Congress Cataloging-in-Publication Data

Gauntlett, David.
Making media studies: the creativity turn in media
and communications studies / David Gauntlett.
pages cm. — (Digital formations; 93)
Includes bibliographical references and index.
1. Mass media. 2. Communication. 3. Digital media. I. Title.
P91.25.G38    302.23—dc23    2014040323
ISBN 978-1-4331-2335-1 (hardcover)
ISBN 978-1-4331-2334-4 (paperback)
ISBN 978-1-4539-1471-7 (e-book)
ISSN 1526-3169

Bibliographic information published by **Die Deutsche Nationalbibliothek**.
**Die Deutsche Nationalbibliothek** lists this publication in the "Deutsche
Nationalbibliografie"; detailed bibliographic data are available
on the Internet at http://dnb.d-nb.de/.

The paper in this book meets the guidelines for permanence and durability
of the Committee on Production Guidelines for Book Longevity
of the Council of Library Resources.

© 2015 David Gauntlett
Peter Lang Publishing, Inc., New York
29 Broadway, 18th floor, New York, NY 10006
www.peterlang.com

Printed in the United States of America

For Edie

# CONTENTS

## Part 4: More Thinking about Making

# ACKNOWLEDGMENTS

I'm hopefully getting better at collaborations—the secret, it turns out, is just to pick your collaborators really, really carefully—and this book has been helped, more than my previous ones, by things I've done with other people. And to come at it from the other angle, book-writing remains a solitary occupation, so the support of others is much needed. Therefore: acknowledgments.

Authors typically thank partners and children last, but that doesn't seem quite right, or certainly not in this case, as they deserve much the biggest slice of the acknowledgments pie-chart. So first of all, I offer my love and unwavering gratitude to Jenny, Finn, and Edie, without whose inspiration and support none of this would be possible.

For prompting me to write some of these things in the first place, I thank Henry Jenkins, Gillian Youngs, Mark Wolf, and Nelson Zagalo. And for encouraging me to turn it all into a book, and their fantastic support in the publishing process, thank you to Mary Savigar, Steve Jones, and Sophie Appel.

I am really grateful to Amy Twigger Holroyd, who generously pointed to ideas worth looking at and made many insightful comments. Thank you also to Clare Twomey, Shaun Moores, Jan Løhmann Stephensen, and Andrew Clay, who have given me further things to think about. And I thank my many

supportive colleagues, most notably Jeanette Steemers, Kerstin Mey, Silke Lange, Graham Meikle, Christian Fuchs, Heidi Herzogenrath-Amelung, Anastasia Kavada, Winston Mano, and Pete Goodwin.

Many thanks to Bo Stjerne Thomsen, Tina Holm Sorensen, and Andrew Bollington, and their colleagues at the LEGO Foundation, for some very inspiring conversations and collaborations. I am also grateful to Stella Wisdom and Nora McGregor at the British Library, and Rachel Bardill at the BBC, for their continued support.

I have also benefited from interesting conversations with many other people, including Mike Press, Simon Lindgren, Jen Ballie, Jamie Brassett, Anthony Quinn, Katie Smith, Kevin Walker, Julia Keyte, Sunil Manghani, Tiziano Bonini, Simon Keegan-Phipps, Roland Harwood, William Merrin, and Andrea Drugan.

Finally, thank you to lots of other humans on Twitter, which I do, personally, find to be a consistently supportive, useful and stimulating network.

All of these people have helped, but as ever, none of this is anyone's fault but my own.

---

Four chapters were originally published elsewhere, and have been a little revised and updated for this book:

Chapter 4, 'Creativity and participatory culture: A conversation with Henry Jenkins', was originally published on Henry Jenkins's blog (http:// henryjenkins.org) as 'Studying Creativity in the Age of Web 2.0: An Interview with David Gauntlett', on 3–7 August 2011. Reproduced under a Creative Commons Attribution 4.0 International licence, and by kind permission of Henry Jenkins.

Chapter 7, 'The LEGO System as a tool for thinking, creativity, and changing the world', was originally published with the same title in Mark J.P. Wolf, editor (2015), LEGO Studies: Examining the Building Blocks of a Transmedial Phenomenon, New York: Routledge. Reproduced by kind permission of the publisher.

Chapter 8, 'Creativity and digital innovation', was originally published with the same title in Gillian Youngs, editor (2013), Digital World: Connectivity, Creativity and Rights, Abingdon: Routledge. Reproduced by kind permission of the publisher.

Chapter 9, 'The Internet is Ancient, Small Steps are Important, and Four Other Theses about Making Things in a Digital World', was originally published with the same title in Nelson Zagalo and Pedro Branco, editors (2015), *Creativity in the Digital Age*, London: Springer-Verlag. Reproduced by kind permission of the publisher.

# · 1 ·

# INTRODUCTION

Media studies used to be more straightforward.

But not as interesting.

For a couple of decades, from the 1980s, media studies had settled into a reasonably stable cluster of subject areas, such as 'institutions', 'production', 'audiences' and 'texts'. 'Institutions' looked at the broadcasting and publishing industries as businesses and organisations with political and economic concerns; 'production' was about how the professionals working for those companies made the stuff; 'audiences' was about what people did with the stuff; and 'texts' was just about the stuff itself.

'Institutions' is still an incredibly relevant area of study, but the companies are all different. Many of them didn't exist 20 years ago, and in traditional terms aren't even 'media' companies at all, but are 'technology' developers, which means that they primarily engineer software platforms to gather data about people and show adverts to them, whilst acting like they are primarily about something else. Then there are the historically well-established institutions too, such as the BBC and Disney, but they are having to do lots of different things now—typically with everybody doing some of everything and trying to unify it somehow.

'Production', 'audiences' and 'texts', meanwhile, have all fallen apart. For some kinds of media—cinema, television, online broadcasting or narrow-casting, publications—these are still reasonably adequate terms, but there's not much very new or interesting to be said—or, to put it another way, the interesting things can be said by scholars of economics, business or sociology, leaving media studies somewhat adrift.

Thankfully there are lots of new things happening, but you wouldn't look at them in that way anymore. People still make stuff, and people still look at stuff, but often they are the same people doing both. (You will note that I've skipped over the study of individual 'texts' altogether, because—as I will explain briefly in chapter 3—I don't think you get to understand the role of millions of things in society merely by analysing one or two of the things).

For me, media studies today consists of a diminished blob of the old themes, but with two new peaks of exciting and vital activity on either side. One is basically inspiring and optimistic, and is about people being empow-ered through everyday making and creativity. The other is basically troubling and pessimistic, and is about data exploitation, surveillance and extreme new forms of computerised capitalism.

This book is almost all about the first one and not really about the second one. But both are important. The second one tends to get more attention, and some people argue as though the two peaks are in competition with each other—as if highlighting the importance of one set of negative concerns would show that an interest in the other set of positive possibilities was mistaken. But they are just separate points, operating on different levels. To try an analogy—with the necessary skills, you can make some effective weapons out of wood, and maybe you even live in a society where the use of wooden weapons is enjoying a resurgence, and some people have been seriously injured; but these observations could not be used to prove that trees are a bad thing.

## Unpacking 'Making Media Studies'

This book is called 'Making Media Studies: The creativity turn in media and communications studies'. The first bit, 'Making Media Studies', obviously points to the *making* dimension of media studies—by which I don't really mean the old focus on traditional media production techniques—how news-rooms or television studios are organised, or whatever—but on the more DIY, handcrafted meaning that we associate with makers and maker culture today. And we are interested in the relationship of those making processes with the

kind of online digital media that enables everyday people to create and share material, and to be inspired by that made by others.

It's a kind of media studies which has *making* at its front and centre. It's about being able to *do* things with media—not just talk about what other people do with them, or what they do to us. It's about being hands-on, which means it's still about ideas and critical engagement, but expressed through making things rather than just writing arguments. (We can still write too, of course, but the writing might be more powerful when informed by the experiences of making and exchanging). To borrow three key distinctions from the anthropologist Tim Ingold (2013: 3):

- it's about learning *with* media, rather than learning *about* media;
- this is because we intend to move *forward* through building meanings and understandings, rather than looking *back* over accounts of how things are;
- and this is because our aims are primarily *transformational,* rather than being essentially *documentary.*[1]

Here, the shift proposed for media studies mirrors the development of research in the field of design, where a practice known as 'research through design' has emerged. As suggested originally by Frayling (1993), this is distinct from 'research *for* design'—the kind of research that is done to *inform* design activities—and 'research *into* design', which is what Ingold would call 'documentary' work, being *about* design and designers. 'Research *through* design' is the more interesting one, being a process of exploring ideas through design practices—rethinking design by turning the innovative and reflective aspects of design back upon the practice itself, and creating new knowledge (Frankel & Racine, 2010; Sevaldson, 2010). More simply, it's a matter of *doing* design in order to generate new ideas and to examine what design means. Similarly, we need to *make* things with media in order to *think* more thoroughly about the opportunities and risks associated with different materials, tools and services, both within themselves, and when out in the world.

---

1    What I have borrowed from Ingold are the distinctions between learning 'with' or 'from' versus learning 'about'; moving forward versus looking back; and a 'transformational' versus 'documentary' mode of exploration. Perhaps, to be clear, I should note that Ingold is writing generally, about learning from making and doing—his comments are not directly, or only, about media, and are certainly not a commentary on, or prescription for, media studies in particular.

Then our subtitle, 'The creativity turn in media and communications studies', refers to the same kinds of things, highlighting in particular the act of *creating* media and communications, rather than, say, *receiving* news, information, or entertainment. It does engage with political, economic, technological and business systems, in terms of how they support or suppress everyday creativity, which means it has a relationship with the other 'peak' described above—the serious concerns about surveillance and exploitation.

As creativity fundamentally signals a positive intent, to make a difference in the world—even if we disagree with what others are trying to achieve with their creative efforts, they are still creative efforts—the creativity turn in media and communications studies is also about trying to find a useful role, and valuable applications, for media and communications studies *itself*. This includes, among other things, thinking about how today's technologies can be used to support and exchange creative practices without negative consequences—in other words, thinking more positively about solutions to the kinds of problems which obsess those scholars on the *other* peak mentioned above. We prefer *making* to *describing*—so this approach involves not just describing problems, but making solutions; or, for things that are not easily changed, at least making creative and provocative interventions which have an impact on people and foster the necessary motivation for change.

The creativity turn in media and communications studies involves thinking about creativity, and creative uses of media and communications, but also thinking creatively about the subject. What are the new ways of doing media and communications studies? How has the subject changed so it is not always going over the same old issues? What approaches and methods can help media and communications studies to be innovative and useful in spheres beyond itself?

These are absolutely crucial questions, not least of all because media and communications studies has done sufficiently well within universities that discussion of its more concrete concerns has been adopted by departments of sociology, politics, psychology, business, economics, even geography. Media and communications studies needs to keep ahead to avoid becoming redundant. So questions of innovation and value are important, exciting—and unavoidable.

'Making media studies' is therefore about making media as both a subject, and a method; and is about renewing what 'media studies' means. It is about an approach which emphasises the knowledge of makers—the recognition that you develop critical insights into things by participating and creating in

those areas yourself—and the responsibility that we have to do something, and to do something useful.

## An aspirational media studies

My work has always tended to be rather aspirational—often concerned with how things *could be* rather than how things *are*; in particular since the first edition of *Web Studies* (2000), a book prepared in the late 1990s, when we suddenly started to see the blossoming of everyday creative media activity that people could quite easily make and share with each other, rather than generally only being able to consume the work of media professionals. (Of course, people have always been able to make things, but getting them seen by people outside of your locality was previously a big problem).

Unsurprisingly, I like the aspirational approach, which doesn't assume that we are all doomed, and has some faith in humans to make their own positive futures. But being 'aspirational' can also be a point of criticism—that the researcher is unrealistic and has failed to grasp the grim realities of the present situation. I feel, though, that being constructive and optimistic is a pragmatic choice, being preferable to despairing pessimism, which doesn't actually get you anywhere.

Readers who were hoping that a book about 'The creativity turn in media and communications studies' might offer a textbook-like account of this historical turning-point, with descriptions of its many practitioners, may be disappointed, because to be honest this too is aspirational: the 'creativity turn' is something we can see several seeds of, and which I am willing into existence by making it the subtitle of a book. But it hasn't necessarily happened yet. If it's going to happen, we're going to have to do it *together*.

## Origins of this book

This volume was originally going to be rather different to the book you are reading now. In 2011 I had published a short Kindle book, *Media Studies 2.0, and Other Battles Around the Future of Media Research*, which drew together some of my previous articles (and a smallish amount of new stuff) which hadn't previously been in a book. A significant part of the motivation for doing that was because I simply wanted the experience of making and distributing—via the Kindle platform—my own electronic book.

The economics were interesting—because Amazon pays the author 70 per cent of the price paid by the customer, whereas conventional publishers tend to pay around 7.5 per cent of the sum received by the publisher (which itself may be as low as half the cover price), this means that a self-published Kindle book priced at just £2.00 is likely to bring the author more money per book than a £20.00 book from a conventional publisher.

The book did OK, but I think I discovered that the world is a bit suspicious of £2.00 academic Kindle books—maybe it seemed oddly cheap; and/or perhaps the marketing power of conventional publishers actually does add something; or maybe the world wasn't that excited about a David Gauntlett book called *Media Studies 2.0, and Other Battles Around the Future of Media Research* after all. Or some combination of these and perhaps other factors.

Then Mary Savigar at Peter Lang publishing said she'd be interested in publishing a revised and expanded version of my Kindle book, and so that's what this book was going to be.

But then as I worked on it over 2013–14, I chucked out old things and replaced them with new things. And it took on new shape around the idea of *Making Media Studies*. But I still thought of it as this remix of my Kindle book. And when people expressed interest in my 'new book' I felt a little embarrassed that it was not truly a new book even though I was writing and adding lots of new bits. It was as late as July 2014, two months before the book deadline, that I realised—whilst waiting for a train, I can still picture it—that actually the only thing that this book and the Kindle book now have in common is the 'Media Studies 2.0' article—just 3,000 words. So it *is* a proper book after all! Well, you can be the judge of that. In music terms, it's not quite a whole new studio album, but it's not a mere cash-in remix album either. It is, at least, a quite generous mini-album. (You still have mini-albums, don't you? At least I didn't call it an 'EP').

Now. My son Finn is seven years old, but has been making stuff for years. (His sister Edie also loves to build, and she is three). Someone observed recently, about what Finn plays with, 'He's just much happier with things you can make something out of'. And I thought, ah yes, and that applies to me too. And that's the explanation for why, in this book about 'media', you will find things about the online world, and even about LEGO, but very little about the traditional 'media' things like television and newspapers. The reason is that we're just much happier with things you can make something out of.

So to be clear—I'm not claiming that television, say, is not a creative medium. But the way that television works is that 99.999 per cent of us are meant

to be merely television-watching people, admiring the creative work of the 0.001 per cent, the television-making people, so that fact alone means—for our purposes here, at least—that it's not really worth talking about. You see: we're just much happier with things you can make something out of.

## Media as triggers for experiences and making things happen

If we are taking an alternative approach to what media studies means, perhaps it would help to have a different way of thinking about media. So here's a thought. Let's put it in a box, just for emphasis.

> We should look at media not as channels for communicating messages, and not as things. We should look at media as triggers for experiences and for making things happen. They can be places of conversation, exchange, and transformation. Media in the world means a fantastically messy set of networks filled with millions of sparks—some igniting new meanings, ideas, and passions, and some just fading away.

The simple word 'media', of course, encompasses a vast range of interesting things—different technologies, publications, games, and tools, numerous types of content and conversation, and more *stuff* produced by humans than we could ever list or comprehend. It would, therefore, seem reckless to try to pick out one reason for being interested in all of them. Nevertheless, I hope that the assertion in the box perhaps offers a *starting point* for thinking about media in a different way.

Like most ideas, this is not really new. Indeed the first bit is only a minor adaptation of two related things said by Brian Eno, the musician and artist: 'Stop thinking about art works as objects, and start thinking about them as triggers for experiences' (Eno, 1996: 368), and '… the other way of thinking about art, is not that it's a channel for communicating something but that it's a trigger; it's a way of making something happen' (Eno, 2013: 23). I've shifted the subject from 'art' to 'media', but the provocative point is the same. Eno himself immediately attributes the 'triggers for experiences' idea to his former art tutor, Roy Ascott, and of course this is really just a neat way of encapsulating a point about art which has been around for literally thousands of years. Aristotle, for instance, some 2,350 years ago, suggested that works of art

should offer something that would give rise to ideas and sensations, with the example of music in particular being upheld as something which, by its nature, cannot offer depictions of things, or even of emotions, per se, but which can stir or trigger feelings in the listener (Aristotle, 335 BC; Eldridge, 2003: 29). Clearly, it is not new to say that art prompts something to happen in the person experiencing it, rather than being an inherent quality of the art object itself. But Ascott's and Eno's way of expressing it—art as a 'trigger' and 'a way of making something happen'—is a little more emphatic and active: a sort of 'push' model of making, where you intend that the thing you have made will make a difference in the world, although you don't aspire to predict what that difference will be.

So let's go back to my opening paragraph and take it sentence by sentence.

*We should look at media not as channels for communicating messages, and not as things.*—It is common, and understandable, that media would often be thought of as sets of objects, produced by institutions, for particular purposes, including the transmission of ideological messages. This approach was more adequate in the past than it is today (as discussed in the two following chapters), but has always been somewhat limited. In media studies, the idea that you can learn much about media in society through 'content analysis'—i.e. counting or recording the appearances of things in a media product—was always both dreary and wrong. You can't learn about the role of a medium in the world merely by staring at that medium. And more generally, thinking about media as just 'content', made by others, was always the least exciting way to consider these phenomena. So let's press on to the more positive points.

*We should look at media as triggers for experiences and for making things happen.*—This view assumes an assertive and interventionist orientation to media: we make and share things because we want to *do* something, we want to bring about a change in the world. This doesn't need to be a *big* thing—it would often be on a tiny scale; the intended change might just be, for example, to make one friend smile for a moment. Conceiving of media as things that we *do stuff with* offers a powerful sit-forward alternative to the chilling passive approach within media studies which is centred around ideas of victims, exploitation and delusion. (As I've indicated already, I think we *really should* be concerned about issues of surveillance, and the corporate world hijacking what should be a free and open internet, but part of the solution to those grim scenarios is to build and use alternatives. The abuse of our data is not an inherent or inevitable part of internet technologies; we have to try to make our own futures, and compel governments and businesses to behave more ethically).

*[Media] can be places of conversation, exchange, and transformation.*—As a result of the big obvious change that happened over the past 20 years—which for most people was within the last 10—media have changed from being primarily about watching, listening, and reading, to being most significantly—or at least most interestingly—about creating, and discussing, and so bringing about change in people, ideas, and culture, and how these things are valued and developed. The former watching/reading mode still exists alongside that, of course, and is fine, but if we want to attend to the significant things that are going on—and which have the most potential value for the future of our societies and cultures—then we are bound to want to look at conversation, exchange, and transformation.

To take another seed from the art world, I have long admired Martin Creed's frank, thoughtful approach to why he creates artworks. He seems to find this question difficult, but says it's about emotion, self-expression, and 'wanting to communicate and wanting to say hello' (Creed interviewed in Illuminations, 2002: 101). This everyday drive—'wanting to say hello'—is perhaps key to a lot of today's valuable communication, because we want to make a connection, but need to do so in a useful way, via doing something else. Studies (summarised in Gauntlett et al., 2012) have shown that busy learning communities online—from the *New York Times* comment discussions to thriving DIY sites such as Instructables, Craftster, and Ravelry—are successful because people actively want to help each other, to share and gain inspiration, to feel more involved in the world, and to develop their own understanding through supporting others. So: conversation (of any kind), exchange (of ideas and inspiration), and transformation (of self and ultimately society) are vital, and we should be thinking about how media systems can be designed to encourage these qualities.

*Media in the world means a fantastically messy set of networks filled with millions of sparks—some igniting new meanings, ideas, and passions, and some just fading away.* The proliferation of social media and online platforms means that there is a really *incredible* amount going on. The sea of traditional media content was really vast, of course, but it seemed at least *potentially* quantifiable—a set of countable objects being output in one direction (more or less). Now, there are millions of these sparks, these potential triggers for experiences, every day. They are not *all* going to have a very noticeable impact, and we would not expect them to. We have moved away from the era of big things which are meant to have big impacts. When you've spent 18 months producing a whole documentary, say, or a whole exhibition, you need it to have big results. But

in a world of networked DIY media, with convivial sparks leaping in all directions, the expectation upon each of the bits is lighter, but positive connections and inspirations can happen very frequently.

## What this means in practice

There are various implications which flow from this kind of approach.

*Implication #1*: It means that our main question is not 'what do the media do to us?', but rather 'what can we do with media?'. If our primary interest is in what 'the media' do to us, we assume from the start a kind of victim mindset. It's not necessarily a wholly passive stance, because we might be trying to look at what some of these media do to us so that we can make complaints or protest about it. However, it's still a position of being on the back foot.

But if our primary approach is to ask 'what can we do with media?', we are on the front foot, seeking to engage, looking for ways to make society better—or at least looking for ways in which technologies, or the things you can do with technologies, can be used to support people to shape culture and society in a positive way.

*Implication #2*: This approach therefore means that we would expect to find the most relevant ideas and knowledge in different places. Scholars in 'media studies' or 'communication studies'—with a background in psychology, say, or literature—do not necessarily become redundant, but may be only partially useful. This front-foot approach means that we would have designers working with sociologists and anthropologists—as well as artists, architects and anyone else that would like to join in—to make tools that would enable people to create, exchange, converse and collaborate, in ways that felt natural to them. This *doesn't* mean that technologists or technology companies would be in the driving seat, because we don't *actually* live in a binary system with critique on one side and capitalism on the other. Instead we're talking about collaborations where people with different kinds of insights about media, and what people do with media, could develop constructive innovations.

*Implication #3*: The emphasis on 'experiences' reminds us to think of media in a multi-modal way—in other words, that we shouldn't just assume that media use involves looking at screens or paper, but can be a range of different ways of engaging with ideas, through *doing* things with different kinds of material or materials and using sight, sound and touch (and possibly, though less commonly, taste or smell). It's partly to underline the significance of different kinds of media that this book includes a chapter about LEGO. If you can't tolerate

the idea of having a chapter about LEGO in a media studies book then fine, don't read it, but the fact that it's there might hopefully remind us that media, the plural word for medium, can refer to any of the things that humans use to express and share ideas, and (ideally) to develop them together.

*Implication #4:* If media are places of conversation and exchange, then we need to have open and shareable media content—which mostly we do, on the side of homemade media, and typically we don't when third parties and companies (and even universities) are involved. This doesn't mean that the fruits of creative labour have to be made available with no reward for the creator, but rather that we need to develop systems which could, where wanted, direct some of the economic surplus back to the people who have made the music or ideas or software from which we are subsequently benefiting.

*Implication #5:* This approach would encourage us to build a different kind of education system, with a corresponding sit-forward, hands-on approach to building and critiquing knowledge. We would have to get rid of the testing of memorised facts, and adopt a much more tinkering, experimental and conversational approach to seeing how the world works and what we think about it, where students would develop hypotheses together and try them out, and communicate them, through making and doing. (That could absolutely be done, although it's quite a change from what is done in most education systems right now. And just to make it seem slightly more difficult, we note that for this playful and creative approach to education to really work, it would probably have to be matched by a corresponding similar shift in how adults work too, with a greater emphasis on playful experimentation, and appreciation of provocative challenges and the possibility of learning through failure).

*Implication #6:* A further consequence of this approach could be a more artistic and experimental approach to media-making, on both professional and non-professional sides. If we turn again to Brian Eno, he has often spoken about leaving space for the viewer or listener to have to engage and think; for a work to be provocative but not to offer too-easy answers. 'Triggers for experiences' wouldn't work by telling you what to think, but rather by giving you something to engage with.

> The most important thing in a piece of music [or, we could add, any other creative form] is to seduce people to the point where they start searching. If the music doesn't do that, it doesn't do anything. If it just presents itself and just sits there, if it either declares itself too clearly or is too obscure to even appear to be saying anything, then it seems to me to have failed. So I think that sitting on that line is very interesting. (Eno, 1981)

And if the network is to be filled with the sparks of creative conversations, these of course are more likely to flow from thought-provoking conversation-starters. So then it follows that media-makers have a responsibility to think about different and curious ways of doing things, to challenge others, not simply to be 'distinctive' but rather because of a responsibility to cultivate innovation, questioning, and surprise.

Those are just six of the implications which the approach gives rise to. Others appear every day as people make use of the myriad potentials of networked media, of course. Left to their own devices, people continually try out new things and new ways to share ideas and have an impact on each other, and that's the beauty of it.

## A note on hacking and making

It is common, these days, for people to talk about hacking and making in the same breath, often to mean the same or similar things. The series editor of this book, the brilliant Steve Jones, noticed that I don't use the term 'hacking', and asked for a bit of explanation about why I was choosing to sideline the term. In fact, I hadn't really made a conscious decision *not* to mention hacking—it's just that I see hacking as one of the activities, like tinkering and re-making and re-mixing, which are all part of 'making'. So to keep things simple, I say 'making' to mean all kinds of creative activity where we make something new—whether things or ideas—in any way, whether from 'raw' materials or by modifying, combining or transforming previously-made things.

## Outline of this book

The book is divided into four parts: 'On Media Studies', which looks directly at the state of media studies itself; 'Making Conversations', which highlights the productive power of conversation by featuring some dialogues with others; 'Making Collaborations', where the ideas have developed out of working with particular creative organisations; and 'Thinking about Making', which is about making things—often, but not always, in the context of a digital, networked environment.

Because half of the chapters started life as self-contained articles elsewhere, there might be a little bit of repetition—for which, apologies—but on the other hand, this means that each of the chapters should stand alone, so that you can dip into whichever chapters you might fancy.

So, following this introduction, we begin the first part, 'On Media Studies', with chapter 2, in which we zip back to 2007 for a re-run of my short article 'Media Studies 2.0', which seems as relevant as it ever did, more or less. Or at least it shows that I've been banging on about this kind of thing for some time now. It's here because it was the first building block of what would become *Making Media Studies*, although I didn't quite realise it at the time. Then chapter 3, 'Further reflections on Media Studies 2.0', offers some new thoughts on the state of the field, and how it could make a difference.

In Part 2, 'Making Conversations', we have two interview chapters about creativity and making in a media studies context, a conversation with Henry Jenkins in chapter 4 and a new crowdsourced interview in chapter 5. In Part 3, 'Making Collaborations', chapter 6 reflects on three different projects which were meant to foster user creativity on digital platforms, and chapter 7 offers a positive but heartfelt evaluation of LEGO as a tool for thinking, and as a sort of exemplary resource, for creative communities.

Finally, Part 4, 'More Thinking about Making' begins with chapter 8, 'Creativity and digital innovation', which looks at ways in which people's creative uses of the internet have disrupted both media industry practices and academic research. chapter 9 is called 'The internet is ancient, small steps are important, and four other theses about making things in a digital world', which is long but hopefully self-explanatory. And then chapter 10, the Conclusion, seeks to tie things together.

As the book is, of course, inevitably, written by me, it offers some suggestions about a more creative version of media studies derived from my own interests and prejudices. It is not meant to be a comprehensive account, and certainly not a prescription, of what this field would look like. I just hope it contains something to think about—or, indeed, some thoughts that might prompt you to *make* something.

# PART 1
# ON MEDIA STUDIES

# · 2 ·

# MEDIA STUDIES 2.0

The 'Media Studies 2.0' article was first presented on my website, Theory.org.uk, in February 2007. Over the years I've added a few bits and bobs. Because it still seems relevant as a precursor to the creative turn, this chapter gives you the original article, plus some of the bits and bobs, and is followed by chapter 3, which offers some new comments.

It's perhaps worth mentioning that the 2007 article caused something of a stir in Media Studies circles (you can look up 'Gauntlett "Media Studies 2.0"' in Google Scholar to see some of the disparaging remarks). I mention this not out of pride, nor shame—in either case, causing 'a stir in Media Studies circles' is hardly the highest form of human achievement—but simply because it seems so odd. This is what I wrote in another introduction to the piece, in 2011:

> The discussion about 'Media Studies 2.0' tends to baffle me slightly, because my argument seems, to my own eyes, to be perfectly benign, rational, and unsurprising. When I hear people saying how outrageous it is, or how angry it has made them feel, I sometimes regret that I must have said some crazy things in order to provoke an argument. But when I look at what is actually written in the original 2007 'Media Studies 2.0' article, it seems to me to be a modest attempt to refocus the subject on a number of significant phenomena which have already arrived and which have already changed the nature of what 'media' studies, if taken seriously and done properly, must be

looking at. So the argument is basically 'let's acknowledge these significant changes, rather than ignoring them'—which sounds like the basis for a pretty lame debate, because who on earth would be on the side of 'yes, let's ignore them!'? Well, as I have found, the answer to that is quite a lot of people. (Gauntlett, 2011b)

Things have probably settled down a bit since then. Media studies has largely accepted that the internet is central to everything—although it has mixed feelings about that, and quite often seems nostalgic for the 'good old days' of elite media. Should this brief manifesto for a 'Media Studies 2.0' ever have been controversial? See what you think.

## ORIGINAL ARTICLE (2007)

In a recent interview about the newly popular concept of 'Web 2.0', following a spate of mainstream media coverage of Second Life, Wikipedia, and other collaborative creative phenomena in autumn 2006, I found myself mentioning a possible parallel in a 'Media Studies 2.0'. Although I would not like to be introducing a new bit of pointless jargon, the idea seemed like it might have some value—for highlighting a forward-looking slant which builds on what we have already (in the same way that the idea of 'Web 2.0' is useful, even though it does not describe any kind of sequel to the Web, but rather just an attitude towards it, and which in fact was precisely what the Web's inventor, Tim Berners-Lee, intended for it in the first place).

In this article, I thought it might be worth fleshing out what Media Studies 2.0 means, in contrast to the still-popular traditional model.

## Outline of Media Studies 1.0

This traditional approach to Media Studies, which is still dominant in a lot (but not all) of school and university teaching, and textbooks, is characterised by:

- A tendency to fetishise 'experts', whose readings of popular culture are seen as more significant than those of other audience members (with corresponding faith in fake-expert non-procedures such as semiotics);
- A tendency to celebrate certain key texts produced by powerful media industries and supported by well-known critics;

- The optional extra of giving attention to famous 'avant garde' works produced by artists recognised in the traditional sense, and which are seen as especially 'challenging';
- A belief that students should be taught how to 'read' the media in an appropriate 'critical' style;
- A focus on traditional media produced by major Western broadcasters, publishers, and movie studios, accompanied (ironically) by a critical resistance to big media institutions, such as Rupert Murdoch's News International, but no particular idea about what the alternatives might be;
- Vague recognition of the internet and new digital media, as an 'add on' to the traditional media (to be dealt with in one self-contained segment tacked on to a Media Studies teaching module, book or degree);
- A preference for conventional research methods where most people are treated as non-expert audience 'receivers', or, if they are part of the formal media industries, as expert 'producers'.

## Outline of Media Studies 2.0

This emergent alternative to the traditional approach is characterised by a rejection of much of the above:

- The fetishisation of 'expert' readings of media texts is replaced with a focus on the everyday meanings produced by the diverse array of audience members, accompanied by an interest in new qualitative research techniques;
- The tendency to celebrate certain 'classic' conventional and/or 'avant garde' texts, and the focus on traditional media in general, is replaced with—or at least joined by—an interest in the massive 'long tail' of independent media projects such as those found on YouTube and many other websites, mobile devices, and other forms of DIY media;
- The focus on primarily Western media is replaced with an attempt to embrace the truly international dimensions of Media Studies—including a recognition not only of the processes of globalization, but also of the diverse perspectives on media and society being worked on around the world;
- The view of the internet and new digital media as an 'optional extra' is correspondingly replaced with recognition that they have fundamentally changed the ways in which we engage with *all* media;

- The patronising belief that students should be taught how to 'read' the media is replaced by the recognition that media audiences in general are already extremely capable interpreters of media content, with a critical eye and an understanding of contemporary media techniques, thanks in large part to the large amount of coverage of this in popular media itself;
- Conventional research methods are replaced—or at least supplemented—by new methods which recognise and make use of people's own creativity, and brush aside the outmoded notions of 'receiver' audiences and elite 'producers';
- Conventional concerns with power and politics are reworked in recognition of these points, so that the notion of super-powerful media industries invading the minds of a relatively passive population is compelled to recognise and address the context of more widespread creation and participation.

Clearly, we do not want to throw away all previous perspectives and research; but we need to take the best of previous approaches and rework them to fit a changing environment, and develop new tools as well.

## History and emergence of 'Media Studies 2.0'

Media Studies 2.0 is not brand new and has been hinted at by a range of commentators, and connects with a range of phenomena that have been happening for some time. The above attempt to specify 'Media Studies 1.0' and '2.0' is merely an attempt to clarify this shift. Its emergence was suggested, for instance, by comments I made in the introductions to the two different editions of *Web Studies*, back in 2000 and 2004. In the first edition, under the heading 'Media studies was nearly dead: Long live new media studies', I said:

> By the end of the twentieth century, Media Studies research within developed Western societies had entered a middle-aged, stodgy period and wasn't really sure what it could say about things any more. Thank goodness the Web came along. (Gauntlett, 2000: 3)

I argued that Media Studies had become characterised by contrived 'readings' of media texts, an inability to identify the real impact of the media, and a black hole left by the failure of vacuous US-style 'communications

science' quantitative research, plus an absence of much imaginative qualita-tive research. In particular, I said, media studies was looking weak and rather pointless in the face of media producers and stars, including media-savvy politicians, who were already so *knowing* about media and communications that academic critics were looking increasingly redundant. (The full texts are available at www.newmediastudies.com). I concluded:

> Media studies, then, needed something interesting to do, and fast. Happily, new me-dia is vibrant, exploding and developing ... New good ideas and new bad ideas appear every week, and we don't know how it's going to pan out. Even better, academics and students can participate in the new media explosion, not just watch from the side-lines—and we can argue that they have a responsibility to do so. So it's an exciting time again. (Gauntlett, 2000: 4)

In the 2004 edition I reviewed these earlier arguments and noted that:

> Most of these things are still true: you wouldn't expect old-school media studies to reinvent itself within three years. But the arrival of new media within the main-stream has had an impact, bringing vitality and creativity to the whole area, as well as whole new areas for exploration (especially around the idea of 'interactivity'). In particular, the fact that it is quite easy for media students to be reasonably slick media producers in the online environment, means that we are all more actively engaged with questions of creation, distribution and audience. (Gauntlett, 2004: 4–5)

Soon after that book was published, the phrase 'Web 2.0' was coined by Tim O'Reilly (2006a, 2006b). 'Web 2.0' is, as mentioned above, not a replace-ment for the Web that we know and love, but rather a way of using existing systems in a 'new' way: to bring people together creatively. O'Reilly has de-scribed it as 'harnessing collective intelligence'. The spirit of 'Web 2.0' is that individuals should open themselves to collaborative projects instead of seeking to make and protect their 'own' material. The 'ultimate' example at the moment is perhaps Wikipedia, the massive online encyclopedia created collectively by its millions of visitors. (Other examples include craigslist, del.icio.us, and Flickr).

The notion of 'Web 2.0' inspired me to write the above sections defining Media Studies 1.0 and 2.0. Soon afterwards, I checked Google to see if any-one else had tacked '2.0' onto 'Media Studies' to create the same phrase. This revealed an excellent blog produced by William Merrin, a lecturer in Media Studies at University of Wales, Swansea, called 'Media Studies 2.0' and start-ed in November 2006 (http://mediastudies2point0.blogspot.com). The blog mostly contains useful posts about new media developments. The first post on

the blog, however, makes an excellent argument that Media Studies lecturers need to catch up with their students in the digital world.

―――――――

*In 2007, I added this 'update' note:*

A couple of critics have said that the Media Studies 2.0 model that I proposed above is primarily concerned with 'audience and reception studies'. But my argument is precisely that the whole idea of media 'reception' is rapidly collapsing around our ears (and was always rather patronising). If I was not able to make this clear, I suggest this excellent article: *Blogging and the Emerging Media Ecosystem* by John Naughton (2006). Naughton shows that, even if you are not interested in media audiences/users/participants (or whatever you want to call them), the changing nature of engagement with media—where more and more people can and do make their own—forces the whole system to adapt. So some changes on the audience/user side of things (people making their own stuff as well as consuming material made by traditional media companies, and other individuals) leads to a change in the whole 'ecosystem'.

―――――――

*In 2011, I added this 'new introduction', placed at the top of the original article:*

I haven't really felt the need to update this article in the past four years, as it still seems straightforward and speaks for itself.

In particular, I haven't seen any criticisms of 'Media Studies 2.0' which don't accidentally destroy themselves upon the blunt sword of their own arrogance and complacency.

For example, I have seen it said that traditional 'Media Studies' and 'Cultural Studies' developed a wonderful set of tools, over 50 years, for understanding the media, and that therefore we should just stick with those, not throw them away! This view can be made to sound wise and sensible. Unfortunately, it is lazy and disingenuous nonsense.

Those tools, such as they were, were designed to address an entirely different landscape based on a simple model of broadcasters/publishers and consumers. They just don't work anymore. (Okay, to be fair, they work if all you want to do is produce yet another 'analysis' of a film or television programme, or if you want to consider how the industry worked 30 years ago. And the old version of 'Media Studies' is bound to be attractive to the kind of person who wants to shore up their own 'expertise'—although they sit, proud and pompous, on a castle made of sand).

I have also seen it said that 'Media Studies 2.0' as a theory is 'hollow and empty'. That's because it's not a theory as such, it's a way of approaching the subject—although it highlights one set of theoretical tools which are going to be much more useful than the old set.

The critics of 'Media Studies 2.0' seem happy to dismiss or disregard the rise of everyday creativity online, presumably because they are more comfortable with the old models of communication, where media producers were always powerful institutions and so you could wheel out tried-and-tested critical discussions of power. It was easy to demonstrate your progressive credentials in the old days—but that's not a good reason for wanting to pretend that nothing has changed. Is it really progressive to cling on to a model which remains true in some cases and is useless in others—and to want to ignore the creativity of previously marginalised people and groups?

Obviously, it was both fun and important to show how those big media barons are evil. And sure, they still are, and are probably getting worse. But if 'Media Studies' is a discipline which can *only* talk about that, and patronising ideas of 'media literacy' and things like the boring fruitless notion of 'genre', then, I'm sorry, but what's the point?

Media Studies should not simply sing in praise of particular kinds of technology, any more than it should always be gratuitously critical of everything it sees. That's why we need an intelligent and sophisticated Media Studies which helps us to properly and critically understand the media of today. But you don't get that by clinging onto the old models, especially when the very thing you're looking at is changing so much.

For those who say that 'Media Studies 2.0' is little more than a slogan or a couple of blog posts, I would say that—being an orientation to the subject, rather than a single theory—you can find it rich in detail, complex and critical, in a number of books which have started to appear about the relationships between online media, other media, creativity, and everyday life.

My own contribution, in the book *Making is Connecting* (see www.makingisconnecting.org), seeks to link everyday creativity, both online and offline, with a number of critical theories and political themes. It's not meant to be 'the book of Media Studies 2.0', but it is hopefully one way of showing how this orientation is both critical and relevant today. [More about the arguments of *Making is Connecting* appear in later chapters of this book, notably the conversation with Henry Jenkins in chapter 4].

*In 2011, I also added these updates at the end of the piece:*

(1)

Perhaps I should clarify that I did not intend to suggest, in this article, that Media Studies teachers and lecturers had absolutely nothing to teach their students. What I was objecting to was the idea of Media Studies teachers as the bearers of God-like insight and wisdom, which had to be transferred into the otherwise empty minds of students so that they could see the world 'correctly'.

Of course there is a substantial body of theoretical ideas which students benefit from engaging with and perhaps arguing with, and also there is a lot of factual stuff to be understood, about how technologies and businesses work, for instance, without which it is difficult to engage fully and critically with the subject. And then there are lots of things you can learn, for example, about television's storytelling techniques—such as the ways in which news programmes construct a story to highlight some elements and leave other issues invisible—which are worthwhile in themselves, and also tend to be applicable to the online world. It's vital to understand, say, how Google works, both in its visible operations and in more 'back end' terms, and how organisations of that kind make their money. And, of course, there are many other issues, topics, and critical perspectives. Students are not born with knowledge and understanding of this information and these approaches, so there is much for teachers and lecturers to do in supporting and facilitating their learning and exploration of these issues and ideas.

(2)

Sometimes, too, I think the enthusiasm for getting Media Studies teachers and lecturers to try to match the online behaviour of their students can go a bit too far. David Buckingham has made fun of William Merrin's argument by suggesting that it is all about 'pimping up your Facebook profile and getting down with the kids' (spoken comment in discussion at the Media Education Manifesto Symposium, London, 10 June 2011). This is unfair, because Merrin's arguments overall are much more sophisticated and nuanced. But I accept that proponents of 'Media Studies 2.0' should avoid giving opportunities to be misunderstood in this way—even though our opponents almost always seem to take bits of argument out of context, and then both exaggerate and deliberately misunderstand them.

(3)

Another mode of attack has been to criticise the argument by picking on things we didn't actually say, and then mushing it together to create the impression of a coherent criticism. For instance, part of Buckingham's critique of Media Studies 2.0 involves decrying the notion of 'digital natives'—the argument propagated by Don Tapscott and Marc Prensky, amongst others, that the younger generation have abilities unknown to older adults, and can multitask in a way which seems to suggest that they represent a whole new stage of human evolution. Now personally, I find that argument simplistic, unhelpful, and rather nauseating. The abilities of individual human beings vary considerably, and it is true that the experience of those who have grown up with digital technologies pervading their everyday lives is different, in some respects, from the experience of people born before that could be the case, or those who have had different experiences. But the idea that they are like a new breed of superpeople is absurd, and does not help us with understanding anything except on a very simplistic level of what kinds of media people are possibly more likely to feel more comfortable with.

(4)

Another odd response appeared in the journal *Media, Culture and Society*, where Everitt & Mills (2009) managed to spend a whole article discussing the meaning of the '2.0' suffix, and laid out a rather humourless set of reasons why you might not want to throw away 'Media Studies' in favour of 'Media Studies 2.0' just because it sounds shiny and new. This was diverting but rather pointless, as the term was always deployed with some irony anyway—and with some caution: as you have seen above, the second sentence of the original article says 'Although I would not like to be introducing a new bit of pointless jargon, the idea seemed like it might have some value—for highlighting a forward-looking slant which builds on what we have already'. So it's not like we wanted to block out all previous work and then launch 'Media Studies 2.0' as an entirely fresh enterprise. At the same time, this '2.0' was intended to quite carefully mirror the '2.0' development of the Web—in other words, not a replacement for what has gone before, as such, but a valuable and challenging new extension built around collaboration and creativity by everyday users.

# · 3 ·

# FURTHER REFLECTIONS ON
# MEDIA STUDIES 2.0

Essentially, 'Media Studies 2.0' was the siren sounding on the deck of a sinking ship. It shouldn't have come as a complete surprise. There had been early-warning signs—some of them are mentioned in the original article. So then the discipline whacked into the iceberg and powered down through the waters quite quickly. What hadn't necessarily been anticipated was that it whirred, clunked and clicked, *Transformers*-style, into a stealthy submarine, picking up bonus communicators, weapons, and robot arms, and swooshed forth in a new guise, beeping, zapping and creating things along the way.

Well, that's the optimistic version.

There is also the reality, which is that after the ship had sunk, a substantial zombie version continued to lumber over the waters, putting on conferences about TV shows and 'celebrity' and other 1990s nonsense. The version of 'media studies' taught in schools also continued, as an odd mix of redundant old approaches combined with a healthy side portion of punk DIY media-making (which had long been part of the school version of media studies).

What had really happened? What was the iceberg?

The iceberg was basically the switch from receiving to creating, from passive to active. It's the switch to DIY media as viable, easy, and expected.

Another way of saying it is this:

- *Before*, media studies was about what mass media do to us.
- *Now*, media studies is about what people can do with creative tools and systems which enable widespread distribution and conversation.

We can clarify a bit more by noting:

- *Before*, it wouldn't have made sense to be talking about creative tools and conversations, because that was not something enabled by main-stream media technologies.
- And *now*, it doesn't make sense to only talk about 'media' as a set of ex-ternal forces, when media clearly refers to things we can use and create with ourselves.

There is also the new surveillance dimension that we have to acknowledge:

- *Before*, media systems did not, and were not able to, watch over us—or not to any worrying level of detail.
- *Now*, all the mainstream online tools and platforms are part of a system of surveillance which stores and analyses mountains of data about what we get up to, primarily, we are told, for 'national security' purposes.

Most of the time, we can assume, this makes little difference to what anyone does, but the not-quite-private nature of our online interactions casts a long and strange shadow over today's media lives. As at other points in this book, I'm going to note this disorienting variable, but not dwell on it so much, as these issues are very capably discussed by others (Fuchs, 2014; Andrejevic, 2009b; Greenwald, 2014; Harding, 2014). So that's a very disappointing di-mension of networked media, and it's easy to be distracted by that, and to get stuck on that as the one frightening, and therefore important, issue. But actually the creative opportunities—the arrival of make-it-yourself culture as common and popular, and what we expect people to be doing with media—are, in most people's lives, the most significant real difference.

The significance of DIY media is not just a matter of the individual pleas-ures associated with making and sharing, but the significance of this shift across the whole system (as explicated in Gauntlett, 2011a). When people *expect* to be making culture themselves—when they assume that they will be in a 'writing' or 'making' mode just as much as a 'reading' or 'consuming' mode—it potentially makes a huge difference, not just in communication

and entertainment, but in education and politics and social organisation. As Kevin Wehr notes, about DIY phenomena in general:

> At its best, DIY means that people are connecting the micro and macro levels of their lives using what C. Wright Mills called the *sociological imagination* (Mills, 1959). DIYers are using their sociological imagination to find a solution to alienation, mystification, and loss of control. (Wehr, 2012: 57)

If we can steer the development of technologies, and their infrastructure, so that they *support* creative conversation, exchange and collaboration, *without* vast programmes of mass surveillance and secret storage of personal data, that would be really positive. The dismal impact of surveillance, and the way that certain commercial forces are potentially distorting or destroying the open and equal values on which the best parts of the internet—most obviously the World Wide Web—were built, are quite obvious and are well documented. My job seems to be to remind people that, yes that's all true, but it is not the only issue in town. We need to embrace online media as makers, as people with a worthwhile voice, so that we can develop a more creative and sustainable society.

## 'Media' expands

The creativity turn in media studies also means we need to think more broadly and inclusively about what we mean by 'media'. Media studies managed to bring about a situation where students and scholars felt comfortable writing essays which said that 'the media' did this or 'the media' was responsible for that. I used to do it myself. A quick zip around the internet reveals that, for instance, as recently as 2008, the blurb for the second edition of my book *Media, Gender and Identity* begins carefully, asserting that '*Popular media* present a vast array of stories about women and men' (emphasis added). This is true—they do. But a couple of sentences later the blurb promises 'new ways for thinking about the media's influence on gender and sexuality' and discussions that show 'how the media play a role in the shaping of individual self-identities'.

'The media'! Oh dear. Of course, it sort of makes sense, 'the media', being a plural, describing all those different kinds of things which carry some ideas about gender and identity—which they do. The problem with saying 'the media' is that they come to seem too singular—'the media' as a *thing* containing a set of propositions about the world, rather than 'media', plural, as a vast, diverse, utterly inconsistent array of different voices.

Now that anyone is *potentially* a creator of this widely-distributed 'media', any sentence which talks about 'the media' needs to make sense if you replaced that phrase with 'people'. So if you say, for instance, that 'the media shape what we know about politics' you're basically saying that '*people* shape what we know about politics'—which is true, but not a very insightful observation. You need to bring in some detail about which voices speak the loudest, and have most impact, before you can begin to make sense of it; but you can't just look at the big voices and ignore the 'long tail' of diverse other messages and conversations around them, because they add up to something significant too. And to take a different example, if you say that 'media content is usually simplistic and unimaginative' then you might as well be saying that 'what people say is usually simplistic and unimaginative'—which is surely too harsh. Whatever you think of this 'media', *we* are implicated in it.

Today, as suggested above, 'media' are more things than we used to think. In the 1980s/1990s version of media studies, 'the media' meant basically broadcast or published things like television, radio, newspapers, magazines, and cinema. Now that these media also include personal things like blogs, tweets, homemade videos and music, it becomes more likely that we might also count in paper and pen, collage, LEGO, pottery, a piano, or whatever you like that might be used to communicate something.

But then bringing in all these everyday objects and everyday practices does something else: it potentially changes and displaces the centrality of 'media' in 'media studies'. When the 'media' that 'media studies' looked at were strange goods sent from afar, it perhaps made more sense that the focus would be on those things themselves. But even back then, writers such as David Morley (1986) and Ann Gray (1992) highlighted the ways in which those media were embedded in everyday lives and practices, and everyday sexual politics. Today, the same David Morley and the ethnographically-minded media theorist Shaun Moores are leading the development of a 'non-media-centric media studies' (Morley, 2009; Moores, 2012; Krajina, Moores & Morley, 2014).

This approach does not dispense with media altogether, of course, but considers media in sensibly contextualised ways—as part of everyday lives and practices, and as technologies operating within government and business systems, and connected to things like relationships and ethics. This means that the *content* of these media is of some significance, perhaps, but would not usually, rationally, be the focus, in the same way that the significance of butterflies in an ecosystem is not primarily to do with the pretty colours and patterns on their wings. Moores argues (in Krajina et al., 2014: 9):

There's a common misconception that media studies are simply about studying media, but I've been arguing that media studies are, or certainly should be, about much more than this, that it's always necessary to situate media and their uses in relation to a range of other technologies and practices (Moores, 2005, 2012). When I came across [David Morley]'s notion of non-media-centric media studies (Morley, 2007, 2009), it seemed […] to be a helpful name for the sort of things that some of us in media and cultural studies have been up to for a while now.

Morley is careful to say that this non-media-centric media studies would not turn its back on the study of representations, and Moores concurs there would be a place for such activity, although he says that 'the concept of representation has been too central in media studies' and that we need to think about media in the world in other ways (Krajina et al., 2014: 13).

This connects with the work of Nick Couldry, who argues in his outstanding book *Media, Society, World* (2012) that we should think of media as 'practice', an approach which directs attention to what *people* are *doing*, with and around media, rather than focusing on media content itself (initially proposed in Couldry, 2004). This approach was partly embodied in some of the old 'everyday life' studies of the experience of television in the home, such as Hobson (1980, 1982), Morley (1986) and indeed Gauntlett & Hill (1999)—which drew upon diaries kept by 500 people over 5 years, gathering information about all aspects of everyday life in order to consider both the practical place of media in their lives, and the role of media in thinking and reflection. But Couldry's focus is broader, considering the media uses of groups and institutions as well as individuals, and, of course, concerned more with a 'media-saturated' world than any particular medium, or bit of content (Couldry, 2012: 37–38). This approach becomes especially rich and meaningful in the context of everyday digital creativity. It is also helped greatly by the sophisticated and eloquent argumentation of Couldry, who emphasises the *variety* of practices rather than insisting on the importance of any particular type.

A practice approach to media frames its questions by reference, not to media considered as objects, texts, apparatuses of perception or production processes, but to what people are doing in relation to media in the contexts in which they act. Such a media sociology is interested in actions that are *directly oriented* to media, actions that *involve* media without necessarily having media as their aim or object; and actions whose possibility is conditioned by the prior existence, presence or functioning of media. (Couldry, 2012: 35)

Couldry identifies a number of practices which are distinctive in the digital era. These include *searching and search-enabling* (the acts of finding things,

and helping things to be found, online); *showing and being shown* (the ways in which people make aspects of their lives and interests visible to others); *presencing* (the ways in which individuals, groups and institutions sustain an always-available public presence); *archiving* (the trail of expressions that we leave across time in social media); and *commentary* (the discussion of all kinds of issues, events, news and culture). Treating each of these activities and others as 'practices' frames them nicely as relatively thoughtful and deliberate, but also habitual, aspects of being in the contemporary world.

David Morley, meanwhile, in a recent discussion of 'non-media-centric media studies', goes perhaps further in reconceiving media and communications studies. Asserting that he does not want to dismiss the former core activities of media studies, Morley nevertheless expands the notion of 'communications' in a striking way. As he explains (in Krajina et al., 2014: 6–7):

> In the 1990s Kevin Robins and I were talking about the emergence of 'electronic landscapes' (Morley and Robins, 1995) … For me, though, the problem is that nowadays people working in media studies and communication studies too often focus exclusively on the virtual dimension. That's why I've been suggesting a return to the more 'classical' notion of communications that was developed by Karl Marx and Friedrich Engels in the 19th century, which involves a broader understanding of communications as the movement of information, people and commodities (see Morley, 2009, 2011). This definition is very rich as a starting point for investigations in our field. What I'm interested in doing is not replacing the study of material geographies with the study of electronic landscapes or virtual geographies. Rather, it's the changing relations between them that's significant, and the ways in which the one is now overlaid on the other. To pick out just the virtual and to focus only on that doesn't make any sense to me.

To be enlarging 'communications' to the extent that it takes in transportation systems and human migration might seem surprising, but it makes real sense, and is *at least* valuable as a thought-provoking corrective to the simplistic notion that most communication now takes place online. It doesn't *necessarily* mean, I think, that everyone in media and communications studies has to shift their gaze to a macro systems kind of level which resembles a mesh of human geography, transport and telecommunications studies but at least remembering that that is the context we're working *within* is important.

Where Morley wants to stretch media studies across a broad social plane, Moores (2013) seeks to expand its reach on the personal level, to include embodied activities as well as mental experiences. Drawing on Maurice Merleau-Ponty, he is concerned with 'the relation between […] body and things' (Merleau-Ponty ([1964] 2004: 36). Very crudely, this is about the

obvious but often neglected fact that we do not encounter media—or anything else—as mere brains, but through the apparatus and experience of being in our bodies in the physical world (see also Gauntlett & Holzwarth, 2006). Moores is interested in how this plays out in everyday bodily habits—ordinary physical practices that we take for granted, such as the tapping and swooshing that our fingers do without much conscious effort while interacting with electronic media—which contribute to our sense of 'dwelling' with familiar media. In my own work, I have drawn upon the same Merleau-Ponty ideas, emphasising the significance of the body (Gauntlett, 2007, 2011a), for different reasons—turning the spotlight not on the movements we take for granted, but quite the reverse—on the conscious, deliberate bodily activities involved in making things. But in either case, there is an expansion of media studies from 'things received by brain' to 'things experienced or made through the body (thoroughly entwined, of course, with the mind)'.

If we take in the combined Morley, Moores, Couldry and Gauntlett extensions of media and communications studies, we find that we are looking at a complex system, with elaborate and intertwined things happening at all levels. It is a subject which takes in global networks of exchange of information and goods and ideas whilst also embracing the understanding of bodily and cognitive personal practices and experiences which make this real and meaningful for individuals—including our ability to hand-make new experiences for ourselves. The challenge is to keep all of these levels in play at once—to deal meaningfully with the big picture whilst remembering the personal and creative levels—and vice versa.

## Media studies, quietly frustrated

On 29 January 2014, the UK's current affairs TV programme *Newsnight* included an item based around a new book by Alain de Botton, *The News: A User's Manual* (2014). The feature and subsequent discussion were based around the notion—as the book's blurb puts it—that 'The news occupies the same dominant position in modern society as religion once did, but we rarely consider its impact on us'. The author and commentators all agreed that the news is very important, but that nobody really studies it or even thinks about it, and that perhaps children should be taught about it in schools.

The next morning, the email discussion list of the UK's Media, Communication and Cultural Studies Association (MeCCSA) lit up in anguish. How could it be that this well-known author, and this flagship BBC news

programme, had completely ignored the decades of media studies scholarship which explores and challenges the concept, production and reception of 'news'? Scholars on the list were outraged and talked about making a formal complaint (although it is unclear if they ever got around to it).

Now. Of course, in many ways, they're not wrong. In a world where the *Daily Mail* and other newspapers are frequently appalled that school children are 'wasting their time' doing media studies, it is extraordinary that Alain de Botton can pop up and wonder aloud why school children are always being taught about literature, art and music, but are never prompted to think about the origins and the meanings of the news. And the BBC researchers, as well, do seem to have been unusually ignorant. Kerry Moore, in a largely sensible and witty blog post, noted: 'It was as if Richard Hoggart's *The Uses of Literacy* (1957), McCombs and Shaw's *The Agenda Setting Function of the Mass Media* (1972), the entire works of the Birmingham Centre for Contemporary Cultural Studies (1964–2002), and all other seminal works inspired by such then and since had never happened' (Moore, 2014). You would indeed think that de Botton and the BBC *Newsnight* team should have been aware of such classics—if not already, then at least after five minutes on Google and Wikipedia. Nevertheless, you will notice that these works are not the primary, or recent, output of media studies academics.

You can see why the complainers would say 'How can we be living in a world where the whole large body of media studies scholarship is so routinely ignored?' It's a good question. The answer is either that all the people who aren't media studies scholars are doing something very wrong—or that the media studies scholars *themselves* need to consider why they have so little impact.

I can't tell you which of those is correct but it's probably one or the other. And blaming *everyone in the whole world* for their foolishness in failing to listen to one's important message is not normally an attractive position.

I don't want to join the ranks of those saying that Media Studies is always a waste of time, but it must be possible, within a discipline—so that it may reflect, and grow—to note when it doesn't seem to be doing very well in terms of its impact and usefulness. So let's consider for a bit what media studies might be meant to be doing.

In a meeting at university, recently, I was lamenting the lack of innovation and originality in media studies. You get people plodding on doing the same kinds of studies, churning out more and more descriptions of things in the world, but media studies is rarely a source of newness and innovation, I said. Well!—said someone else—you should do a study comparing the use of

Twitter in the UK with Weibo in China! This proposal was meant to be new and innovative, I guess, because it combines digital media with an international agenda, both of which are sort of new in media studies, which means that we've only really taken them seriously for 10 years or so. But actually a project like that is just another describing-things-in-the-world study.

Sometimes, of course, aspects of the world are *revealed* to us which we were not aware of—Edward Snowden's revelations about the extent of government surveillance of personal communications are a striking example. Snowden worked with investigative journalists and the courageous editors of *The Guardian* and the *Washington Post* to get this information into the public domain. This is a case where revealing-things-in-the-world made a huge difference. But that is quite different from the describing-things-in-the-world done in most academic research projects, which largely organise and write down things that are already part of some people's experience.

Of course, I am not saying that gathering information about what happens in the world isn't useful. It is vital for the development of arguments about the how and why of things. But that kind of ordinary world-description is rarely the *groundbreaking* work in a field—the kind of writing that leads you to see social existence in a whole new light. The key works of Michel Foucault, Anthony Giddens, Shulamith Firestone, Ivan Illich, bell hooks, or other outstanding social and cultural thinkers, were not based on organising their own surveys of human behaviour, although they may have drawn on data gathered by administrators, charities, companies, governments and researchers. It's good that data is gathered, but we don't live in a world short of data.

In short, we are back to the need for *transformational* research, rather than merely *documentary* studies (to use Tim Ingold's terms, mentioned in chapter 1). The work of academics in the social and cultural spheres should, I think, primarily be about producing new ways of understanding, and developing and enabling models of social change. That's a tall order, which can seem too big for any one individual to do, but the solution is to work with others towards that goal—not to duck out of doing it altogether.

## Avoiding a proper engagement

I feel that media studies ducks out of doing serious things more than most—typically via one of two routes. The first is to engage in unnecessarily detailed analysis of bits of media content, which are too singular and transitory to be worth spending much time on. Media content does make a difference in the

world, but should, I think, be considered in terms of swathes of stuff experienced and considered year after year, not in terms of individual items. That approach is too narrow and essentially anecdotal to be of great use.

Also, if media and communications are interesting because they are triggers of experiences, as we asserted in chapter 1, then you do want to be looking at what people *do* with media, but there's not usually any *particular* point in hearing about what one person found engaging about one bit of media content. Of course, it might be pleasant enough, just not significant or worthwhile in terms of knowledge, philosophy, and how we understand the world. For instance, it might be very enjoyable, in conversation, to hear from a friend about a cake that she enjoyed this morning. Indeed, the point of cakes in our culture is not merely their conspicuous function as things to be eaten, but also their role in social interaction—sharing and chatting about cakes is a good way to connect with people. That does not mean, however, that there is a need for anyone to get a PhD in talking-about-cakes and to put their most 'important' thoughts about specific cakes into a book.

Having said that, I do actually think that there is some value to having a small number of brilliant, thoughtful discussions of particular TV drama series, or striking bits of news coverage, or a specific blog. However, these things come along infrequently and unpredictably, and are not always best left to academics. Is it good when, say, Netflix produces the intelligent and compelling drama series *House of Cards*? Yes. Is there a place for a thought-provoking couple of articles in *The Guardian* or the *New York Times*, published around the same time, reflecting on the qualities of the drama, and discussing the new distribution model? Yes, that can be interesting too; and we don't have to rely on professional critics—there might also be a couple of worthwhile blog posts, the quality of which is noticed by friends-of-friends in social media and comes to our attention that way. But then do we need, two or three years later, a longwinded academic piece saying the same sorts of things but with added jargon and less precision? Sorry, but of course that's a no. Of *course* it's a no. Sorry.

So then the second way that media studies ducks out of doing serious things is, ironically, via the heavily 'serious' guise of being 'critical'—which often means complaining from the sidelines, and doing so to an audience of other media studies scholars. Again, this is not *always* the case, and this kind of work is almost always more valuable than pointless textual analysis studies. The main problems here are: first, getting things wrong on a technical level; second, failure to offer practical solutions; and third, failure to address a broad

audience. Getting things wrong on a technical level, whilst embarrassing, is actually the least serious. In later chapters I will complain about books such as *Misunderstanding the Internet* (Curran et al., 2012) getting methodology wrong, getting the internet wrong, and taking an unnecessarily polarised approach to whether or not the internet is a 'good' or 'bad' thing. But such concerns are actually not very important whilst such academics are failing to offer solutions and are only really addressing other academics.

The failure to offer solutions is a self-evident problem: scholars unhappy about things in the world but unable to say quite how we can make them better. And the failure to address a broad audience is not uncommon among academics, but is more especially disappointing when the message is something which is supposed to be for and about everyone. The triple whammy—where an article is slightly wrong on a technical or methodological level, fails to suggest any solutions to our predicament, and anyway buries these insights in an obscure and mostly-inaccessible academic journal—is frequently achieved.

## Some alternatives

So what could we possibly do instead? Well, I've mentioned some suggestions already. To recap briefly, we could:

- Build collaborations between sociologists and designers—and artists, architects, anthropologists and others—to make new kinds of knowledge, tools for thinking, and platforms that would enable others to exchange insights and new kinds of inspiration.
- Develop new ways of understanding media systems and their role in society and culture, and then use these insights to develop and enable models of social change which draw on the creative potentials of the tools available to us.
- Think about media as triggers for experiences and for making things happen; and then *actually use* different kinds of media, in a range of ways, for those purposes.
- Use multi-modal media, embracing all the senses (or at least, not just the normal one or two); extend our expectations of 'media'; and foster conversations.
- Rethink education to adopt a tinkering, experimental and conversational approach, which is about exploring ideas and making new things, rather than memorising facts.

- Find new ways to do media studies research (and/or any kind of research), and to communicate and exchange ideas about it, which draw people into creative knowledge-building exercises.

Obviously this is not an exhaustive list—it's just a start. These thoughts connect the still-relevant agenda of 'Media Studies 2.0' with the kind of approach to the world suggested by my previous book, *Making is Connecting*, and give us the thrust of *Making Media Studies*. To stir some *Making is Connecting* points into this book's argument, the next chapter is a conversation with Henry Jenkins around those themes.

# PART 2
# MAKING CONVERSATIONS

# · 4 ·

# CREATIVITY AND
# PARTICIPATORY CULTURE

## A Conversation with Henry Jenkins

In August 2011, I had a written-down conversation with Henry Jenkins, Professor of Communication, Journalism, and Cinematic Arts at the University of Southern California, which he published on his blog in three parts. I asked him if we could reproduce it here. 'It's always nice to be asked,' he replied, but pointed out that his whole blog is published with a Creative Commons—Attribution license, which means we didn't even need to bother asking, as long as we credit him. Good.

Although conducted back in 2011, the discussion is hopefully reasonably timeless. The only rather dated bit is that we talk about 'Web 2.0', a term which I don't really use any more, simply because the things which that phrase pointed to—online platforms for creative exchange and collaboration, basically—are now just an ordinary part of what we mean when we talk about online networks and social media. (I also like to be precise about what's the Web and what's the internet, and many social media activities are nowadays done via closed smartphone and tablet apps—which are not the Web. I do love the spirit of the open World Wide Web, as invented in 1990 by Tim Berners-Lee, and therefore don't want to use terms which suggest it is thriving more than it is[1]).

---

1   The World Wide Web is an endlessly open and linkable system of information and data, which runs on the internet. Mobile apps also send and receive information over the

So, this piece begins with Jenkins's introduction:

*The expansion of participatory culture and its relationship to the emergence of Web 2.0 is a theme which has run through my recent work, but it is also a key concern for researchers thinking about everyday creativity in all of its historical and contemporary forms. Over several years, British scholar David Gauntlett has been asking researchers to think more deeply about the nature of "creativity" and its place in our everyday lives. Gauntlett's exploration is central to his book,* Making is Connecting: The Social Meaning of Creativity, from DIY and Knitting to YouTube and Web 2.0, *which I read recently with a sense of encountering a kindred spirit with whom one can have productive disagreements (as surface later in this exchange) and from whom one can draw core insights.*

*Part of the richness of this book is its expansion well beyond the sphere of things digital to place grassroots creativity and DIY tinkering in a larger historical and philosophical context, one which will be valuable in helping to further clarify the core point that Web 2.0 is simply one model for thinking about what happens when more people have the capacity to produce and circulate media and other cultural materials.*

*Let's start with something very basic—the title of the book,* Making is Connecting. *What do you mean by making? By connecting? What do you see as the relationship between the two in an era of networked computing?*

Well, I'm using these words in their recognised senses—I don't believe in making up new words, or jargon, for things that can be expressed simply. So, by 'making' I simply mean people making things. This can be with new technologies, or ancient ones, and can be on the internet, or offline. So it refers to James knitting a scarf, Amira writing a poem, Kelly producing a blog, Marvin taking photographs, Michelle making a YouTube video, Jermaine doing a drawing, Natasha coding a videogame, or hundreds of other examples like that.

And 'connecting' means social connections—people starting conversations, sharing reviews, providing information, or making friends. But also it refers, for me, to a connectedness with the world which we live in. So I say 'making is connecting' because you put together ideas and materials to make something new; because creativity often includes a social dimension, connecting you with other people; and because I think that through making things, you feel more of a participant in the world, and you feel more a part

---

internet, but they are more like closed boxes, and they are not using the Web. See Anderson (2010), Jeffries (2014). An excellent book-length introduction to the potentials of the Web, and the internet, and the difference between the two, is Naughton (2012).

of it, more embedded—because you are contributing, not just consuming, so you're more actively engaged with the world, and so, more connected.

I think this is almost always the case, regardless of what technology is being used, and was the case for centuries before we had a global wired network. But in an era of networked computing, which you mentioned, I think that these benefits are amplified, and many new opportunities and connections are enabled. Creativity didn't begin with the internet—far from it. But in an obvious and well-known way, the internet enables people to connect with others who share their interests, regardless of where they live in the world—whereas previously, geography, and the practical difficulties of finding people, made it far more difficult to have conversations with others who shared niche interests.

Having easy access to people who share their passions means that individuals can be inspired by each other's work and ideas—which can lead to a positive spiral of people doing better and better things and inspiring more and more activity by others. This could happen before the internet, in clubs and societies, but it would tend to be slower, and the inspiring inputs would most likely be fewer, and less diverse.

*Across your past couple of books, you have been working through a definition of "creativity." What is your current understanding of this concept and why does understanding creativity seem so urgent at the present moment?*

Well I never wanted to get bogged down in arguments over a 'definition' of creativity. But in *Making is Connecting* I do put forward a new definition, basically to provoke a conversation around how we think about creativity, and to shake up the consensus which seemed to have formed which casually accepts and cites the definition put forward by Mihaly Csikszentmihalyi about 15 years ago (in Csikszentmihalyi, 1997). That definition emphasises that creativity is some kind of novel contribution or innovation which makes a visible *difference* within a domain of expertise, or in the wider culture. So it's a definition of creativity which requires us to focus on the *outputs* of a creative process; and then it actually goes further, and says that those outputs don't really count for anything unless they are recognised and embraced by a significant or influential audience.

Now, Csikszentmihalyi developed this definition for a particular purpose, for use in his sociological study of the circumstances which enable creative acts to be recognised and to flourish. So it's fine for his own purposes, and he clearly didn't mean any harm. But now, because Csikszentmihalyi is a well-respected expert in more than one area, widely cited in academic papers and

featuring strongly in Google searches in this area, his definition pops up in all kinds of other contexts where someone wants a definition of creativity to put into their talk, article, or presentation.

So the unintended consequence is that creativity is increasingly likely to be understood, these days, as the generation of innovative products which become popular, or at least widely recognised. Now, that is one kind of creativity, but as a definition it seems much too narrow.

One problem is that it runs counter to our common-sense understanding of 'creativity', because it is far too demanding. I'm sure you can think of quite a few friends or colleagues whom you would say were 'very creative'—and you would really mean it—and yet they have not invented a new process which has revolutionised the field of architecture, and have not written a novel which sold over a million copies, nor done anything else which goes over the very high bar set by Csikszentmihalyi. But you still really believe that these are creative individuals. So that's one difficulty.

Another problem is that this now-standard definition is focused on outputs. Indeed, you can *only* assess creativity in this way by looking at the outputs of a creative process. I wanted to shift the conversation about creativity so it was more about the process, not the outcomes. But I also thought it was weird that this Csikszentmihalyi perspective on creativity meant that you literally *could not say* if something was creative or not without consulting an external system of experts or publications. Someone might show you an amazing work of art, or an invention, or a new way to do something, and you might exclaim 'oh that's very creative!', but in strict Csikszentmihalyi terms that would be inaccurate, unless this thing had already become influential or successful.

I talk about all these issues at some length in the book. But I arrive at a definition which emphasises the *process* of creativity, rather than outcomes, and prioritises *feelings* rather than levels of external success. It's a bit long. It says:

> Everyday creativity refers to a process which brings together at least one active human mind, and the material or digital world, in the activity of making something. The activity has not been done in this way by this person (or these people) before. The process may arouse various emotions, such as excitement and frustration, but most especially a feeling of joy. When witnessing and appreciating the output, people may sense the presence of the maker, and recognise those feelings. (Gauntlett, 2011a: 76)

I also did a shorter one, trying to make it a single sentence:

Everyday creativity refers to a process which brings together at least one active human mind, and the material or digital world, in the activity of making something which is novel in that context, and is a process which evokes a feeling of joy. (Ibid.)

This shorter definition is OK, although for the sake of brevity it misses out some bits that I thought were quite important. But in both cases you can see I have emphasised emotion—even the word 'joy', which comes through strongly in interviews with makers. They are not filled with joy all the time of course—creative work is often experienced as hard and challenging—but you get moments of pride and accomplishment which make it all worthwhile.

Understanding creativity is perhaps no more or less important today than at any other time. But we do see, I think, an explosion of visible, accessible, shareable creativity online, which it is interesting and important to study and understand, and which is so diverse, and done by people just *because they want to*, that I wanted us to have a working definition of creativity which embraced the key dimensions of this work—rather than sniffily dismissing it because it had not yet won awards, gone global, or made an auditable impact.

*In particular, I was very taken by your claim that "creativity is something that is felt, rather than something that needs external expert verification." Can you spell out a little more the internal and external dimensions of everyday creativity? On what basis, from what perspective, can it be appraised?*

Well as you can tell, I'm not so bothered about an understanding of creativity which can be counted or quantified. So it's a bit like 'happiness'. On the one hand, as economists and social scientists have found quite recently, happiness is perfectly measurable—you can do large-scale surveys which ask people to say how happy they are with their lives, on a scale of one to five, for instance, and then you can compare with other data and variables, and build up a picture of the self-reported levels of happiness in different groups or areas, and the factors which are correlated with them. Those statistics are really interesting—and indeed I use some of them in *Making is Connecting* to show the importance of personal relationships and creative projects. But of course, this data doesn't tell you anything about what happiness *feels* like.

I think creativity is in the same boat. The most important thing about it is what it does for the person doing the creating—the sense of self-esteem, the sense of doing something in the world, being an active participant, feeling *alive* in the world—these are all feelings which are reported by people who make things in the physical world and, with striking similarity, by people who make things online. But the things they make are also important—those are

the things which, at first, connect us with others, which say something about ourselves, and which perhaps contain ideas or inspiration which will make a significant difference to our own or other people's future experiences of the world. So the internal and external dimensions of creativity are both important, but I would say that the most important thing is just *doing* it.

*You suggest early on that the key question you want to answer is "Why is everyday creativity important?" I'll bite, why is everyday creativity important?*

I think there is a tendency to think of everyday people's acts of creativity as 'nice', on an individual level, but insignificant, in social or political terms. So it may be personally pleasing, or emotionally rewarding, for someone to make a toy for their child, or to maintain a blog about their everyday experiences, or to make some amusing YouTube videos, or to record and share a song—these all sound like 'nice' things, and nobody would really want to *stop* them from happening—but they are not considered to be much more than that.

And as you know yourself, Henry, there are people who work on the more obvious, formal 'political' issues in media and communications studies—government broadcasting policies, or the business practices of multinational corporations, or the impact of political advertising on public opinion—and they would not recognise an interest in everyday creativity as part of serious or proper critical study.

But I think these acts of everyday creativity are extremely important. You can cast them as just 'a nice thing' for individuals, and normally they *are* a nice thing for individuals, but they are much more than that. Every time someone decides to make something themselves, rather than buying or consuming something already made by someone else, they are making a distinct *choice*, to be an active participant in the world rather than an observer or a shopper in the world. And through the process of making, they get to enjoy, as I've said, that sense of purpose and connection, and satisfaction.

Taken one by one these are all small things, seemingly insignificant moments; but when more and more people make more and more choices like this, and then also when they go online to amplify and inspire further activities, it builds up to something really big, and powerful.

*One of the real revelations in the book for many readers will be in how directly the ideas of John Ruskin and William Morris speak to contemporary issues in the Web 2.0 era. What do you see as the key value of re-examining their work now? What do you see as the most important continuities and discontinuities between their conception of craft and contemporary DIY culture?*

I'm glad you liked that part. I just thought it was very striking that these English Victorian critics, whose philosophy inspired the Arts and Crafts movement, who were writing 120–160 years ago, seemed to really chime with the spirit of Web 2.0, or at least the best part of it. By which I mean: fostering and encouraging everyday creativity, and giving people tools which enable them to share, communicate, and connect. And seeing the importance of things being made by everyday, non-professional people—and the power of making, in itself—rather than us all being mere consumers of stuff made by other people. That's what Ruskin and Morris's most exciting writings are all about.

And, of course, I like making these connections between things that at first look very different. What, for instance, could medieval cathedrals have to teach us about the ecology of YouTube? Well: John Ruskin was passionate about the gargoyles that you find on medieval cathedrals. They are often quite quirky and ugly, and rather roughly-done—not at all like 'fine art'—but that's precisely why Ruskin cherishes them: because you can see in them the lively spirit of a *creative* human being. And you can sense the *presence* of the person who spent time making it.

Then if you carry that way of seeing over to YouTube: there again you have quite a lot of quirky things, often roughly-done, and not like the kind of professional stuff you would see on TV; but that is what makes them so special, and exciting, because what you see there is people making things, and sharing them with others, just *because they want to*. They've got something they want to communicate. You can often sense that personal presence, and enthusiasm. So Ruskin's passion for one kind of craft really helped me to build an argument about the importance of another.

Then if you look at what William Morris did with Ruskin's ideas—Morris was more concerned with societies and communities than Ruskin, and he added a vision of communities connected through the things that they make: people filling their lives with the fruits of their own creative labour. It was especially important to him that people should be creators, not (only) consumers.

Morris felt you had to *make* things to understand them fully, which is part of the *Make* magazine positive-hacker ethos that is enjoying a revival today. Morris was a maker himself, and mastered a dazzling number of craft and construction techniques. So he was both a writer and a maker, but these were not two separate tracks in his life; rather, his writings and the things he made can be seen as two sides of the *same* project: 'visionary accounts of an ideal world'.

In ways that seem very relevant today, Morris argued that the route to pleasure and fulfilment was through the collection and dissemination of knowledge; communication between people; and creating and sharing expressive material. That's like a manifesto for Web 2.0 right there. So I think the continuities between these old arguments and our present situation are strong; and the discontinuities are the things that put us in a stronger position today, because today we have much wider access to tools to make and share things, which were denied to non-elite people in the past. Not everyone, of course, has access or the necessary skills, and the tools are often owned by big powerful companies, as we will discuss below; it's not perfect.

But I hope these ideas from Ruskin and Morris are therefore shown not to be just some kind of nostalgia, which just shines a little light upon our present situation; rather, they offer very relevant manifestos for what we should be doing today.

*You write at several places about the "messiness" of everyday creativity as in part a virtue and not a flaw—the point which begins with Ruskin's gargoyles. Yet, our classic notions of crafts include the "value of a job well done." How might we reconcile these two claims about craft?*

Well I'm less concerned about the approach to craft which is about doing the same thing repeatedly until you can achieve a very high level of 'polish'. But I think a lot of makers are very concerned to make something to the best of their ability. And I think the 'value of a job well done' can refer to how well something connects with others, or how effectively it communicates a message or an idea. The 'value of a job well done' can be about the self-esteem that comes from having made something which has touched someone else. So you could have something quite 'messy' which is still very successful in this other sense.

*Some of your examples come from very traditional kinds of craft production, such as weaving, stitching, etc. How has the introduction of new media changed the practices of such communities? What has remained the same?*

Craft people have taken to the Web with great enthusiasm. The essence of what they do often remains unchanged, but today they talk more, share more, and find it much easier to find other people who share their passions. So they get more feedback, encouragement, and inspiration. Often in the past, individuals had to be quite resilient to stick with their craft or maker interests, because their families and friends tended not to understand or be very sympathetic to their strange 'hobby'. Being able to find others who share their interests, online, has been an extraordinary source of support and encouragement for many of these people.

*In talking about* Star Wars Uncut, *you touch on an issue very important to my own work—can we build creativity onto borrowed materials? Does it matter if those raw materials are physical objects (recycling of trash or driftwood, say, as the basis of new artworks or fabric scraps as the basis for quilting) or media content (as in many forms of fan productivity)? How would you situate fan culture within the larger logic of DIY Media?*

Ah, this is interesting—this is where I think my priorities might be a bit different to yours, Henry, perhaps. Of course there's lots of lovely, amazing stuff out there made by fans. I talk about *Star Wars Uncut* in the book as one of the things that led me to reflect that the kind of tangible joyfulness involved in the process of creativity, which you can get a sense of in its outputs, is more important than the empirical originality of the outputs. *Star Wars Uncut* is a project by fans to remake *Star Wars* in 15-second chunks. There's a huge amount of inventiveness on display in the many different kinds of animation and recreation which fans have used to produce this amazing patchwork, and it's the funny little homemade details that make it especially touching.

But the thing that I don't like about the emphasis on 'fans' as the new generation of creators is that they are inevitably positioned as, to some extent, subservient to the producers of the big, mainstream (or at least industrial or professional) media thing or things that they are fans of.

So on the one hand, the fans do very clever, very creative things within their fan practice. But at the same time, they are not the 'ultimate' creators, but instead take their inspiration from the successful professional media producers who are, in this sense, the 'ultimate' creators. So it seems a bit of an odd emphasis to me. There's so much wholly original stuff out there in the DIY/online creative world, and I think the focus on 'fans' may tend to feed the egos of professional media producers who feel they are the rightful creators of original content—the kind of authentic creative work that ordinary mortals could not make and which such mortals could, at best, only be 'fans' of. Do you know what I mean? As advocates of a new, alternative participatory culture, I don't think we should always pick examples that are derivatives of, or in some way dependent upon, the offerings of the traditional established media.

*We may have to agree to disagree on some of this. Yes, fans are not the only form of participatory culture out there and part of what I love about this book is that you really engage with a broader array of DIY practices. For me, participatory culture would refer to any form of cultural practice which is open to a broad range of participants who have access to the means of cultural production and circulation.*

*My own work has focused primarily on fans because this is a form of cultural production I have been tracing—and engaging with—for more than thirty years, but in my forthcoming book,* Spreadable Media *[Jenkins, Ford & Green, 2013], we deal with a much wider array of participatory culture communities. Sites like YouTube and Flickr and Etsy have certainly increased the visibility of these other sites of grassroots production. Fans interest me because they inhabit the intersection between the old media culture and the new and thus they illustrate the contradictions of a moment of media in transition. But I am not saying that they are more creative than any of a range of other communities who are similarly transitioning from the pre-digital to the digital.*

*That said, I do not see fans as "subservient" to commercial media, any more than I see any artist as "subservient" to the raw materials out of which they construct their art. So, let's imagine a range of different DIY makers. One of them works within a genre and builds on its established icons and their encrusted media. One reconstructs historical artifacts and thus builds on the crafts of the past. One works within a tradition and thus starts from a set of practices inherited from other crafters. One remixes existing media content and thus builds upon the meanings and associations contained there. One takes discarded coke bottles as physical material out of which they construct something new. For me, there is nothing fundamentally different about these processes. All are working with the resources they draw from the culture around them to create something new and distinctly theirs.*

*I am purposefully avoiding assigning high or low cultural status to these practices because any of the above could end up in a gallery space or a crafts fair or fan convention in the current context and any could be posted online. Cultural hierarchies work both to make fan production "less valuable" than, say, the work of a postmodern artist dealing with the same materials or "less authentic" than a traditional craftsman doing, say, "primitive" art about Biblical characters.*

*As critics, we may be interested in these objects from many different vantage points. A media scholar might be interested in what the fan work says about the program to which it responds, but I might also be interested in the relations between the fans and leave the commercial producer out of the equation altogether. I might, for example, be studying how different DIY communities pass along craft and knowledge from more experienced to newbie participants, and in that study, the sources of the raw materials are going to be less important to my analysis than the sources of the knowledge being exchanged between participants. But in terms of whether the participants are being "creative" or not, these differences in source materials are not that important to me.*

Yes, you're right of course—everything builds on some things that have come before, whether it is ways of using materials, or styles and genres of creative work, or the elements and practices of storytelling. I certainly did not mean to suggest that fans who make stuff within an already-existing narrative are 'less creative' than other makers. It was just that it means that the grand narratives, or the powers to create original story universes, remain in the hands of traditional media. But no matter. As you say, creative fans are just as interesting as creative anybody, and working at the 'intersection' between old and new media can be especially revealing.

*I was struck by the passage you quote from Ivan Illich: "A good educational system should have three purposes: it should provide all who want to learn with access to available resources at any time in their lives; empower all who want to share what they know to find those who want to learn it from them; and finally, furnish all who want to present an issue to the public with the opportunity to make their challenges known." It struck me that you could swap out "educational system" with "communication system" and come up with a pretty good definition of what I and others call participatory culture. By these criteria, how would we evaluate the current state of web culture?*

I agree, it's a good aspirational definition of participatory culture, or for the Web in general. We are not there yet, but the potential is still there. Some commentators write as though the Web has already been entirely taken over by the big commercial companies, such as Google, or that Web 2.0 has been entirely absorbed by them as a profit machine. I would really hate for that to happen. But to act like it has *already* happened is, in a way, giving up, I think; and reveals a lack of awareness of what's really going on.

*Yes—you offer some sharp criticisms in the book of some contemporary critical studies work which has seen Web 2.0 largely if not exclusively as a form of exploitation. How would you situate your work in regards to current debates about "free labor" in the digital economy?*

Well basically I argue that those people who are only interested in saying that Web 2.0 is about the exploitation of free labour are making a category error, and using an exclusively economic lens where that actually isn't the best way of understanding what's happening. Someone who makes an original music video, say, to share with their friends, and with anyone else who wants to take a look, and who chooses to do so by putting it on YouTube, a convenient and free platform, is hardly being 'exploited' in the way we would normally use the term in a Marxist analysis of labour. Obviously those services do seek to make profit from the advertising revenue, and from the value of the

user data that they capture, on the back of stuff provided for free by users. But users themselves see it as a decent bargain—the site hosts your material for free, and enables you to engage with a community around it, and in return it gets to keep that associated revenue. In most cases, the value associated with any particular video or other piece of content will be very small, and it is only when it is multiplied by millions of other bits of content that it becomes a viable business.

These arguments create confusion about what Web 2.0 is about. A really great, archetypal example of Web 2.0 in action would be if there were an encyclopedia which was entirely written by users around the world, writing about the things that interest and engage them, and collaboratively editing it to make it get better and better. And it would be owned and run by a non-profit foundation. What an outrageous and unlikely idea! But that already happens, of course, and it's called Wikipedia.

Another archetypal example of Web 2.0 in action would be if an international consortium of organisations—such as, say, a collaboration between the Library of Congress, and the British Library, and perhaps the BBC, and some of the great European museums or cultural institutions—would set up and support, but not interfere with, a non-commercial platform for creativity, along the lines of YouTube, where people could share their creative works, comment and rate the work of others, and form supportive groups and communities of practice. That one hasn't happened yet, but there's no reason why it couldn't.

Web 2.0, or participatory culture, is not *inherently* commercial, and it might be healthier and more reliable in a non-commercial environment. One of the best things about non-commercial Web 2.0 services is that they make those comments about 'exploitation of labour' immediately redundant. The critics of the commercial services are not entirely wrong, but they are missing the most important thing that's going on.

*You have discussed, in your work, theories of education. What kinds of educational practices and values do you think will best prepare people to participate in the world you are advocating?*

Well, unsurprisingly, I favour educational processes which are about students exploring for themselves, asking questions, being curious, tinkering, and learning through making things. One inevitably thinks of that point made by Ken Robinson, in his very popular TED talk online, that we are meant to be preparing young people for the future but not one of us knows what that future will look like. What we do know is that people need to have powerful 'learning muscles', as Guy Claxton has put it, which means that they need to

be creative, and questioning, and they need to be resilient—which means that when things go wrong then they are not crushed by this event, but instead know that things going wrong is a normal part of life and something which you can learn from. As educators we should model learning—in other words, show that we ourselves are learning all the time and are engaged in any number of 'learning projects' at once.

## · 5 ·

# ON MAKING MEDIA STUDIES—
# A CROWDSOURCED INTERVIEW

Back in 2009, I did a 'crowdsourced' interview for a book called *Mashup Cultures*—which is a fancy way of saying we invited people to send in questions via Twitter and email, and then I responded to a selection of them. That seemed to go quite well, and I was intending to include that interview in this book. But, as I explained in a May 2014 blog post, 'I looked at the interview just now, and to be honest it's all a bit old really. The reading public deserve better! Or at least—newer!'.

So I invited people to send in new questions, via my blog, or Twitter, or email. They did, and asked some great and challenging questions, so here's a new interview, produced in 2014.

## On 'making media studies' and the 'creativity turn'

Graham Meikle, via email: *Here's a question I've always liked but rarely find the right time to ask. This seems like a good time. What kinds of knowledge do we need now?*

Oh that is a good question. I expect there are many ways to answer this, and I'll offer just one. I'll assume the question doesn't mean 'in general'—to

which the answer would, I guess, have to be 'all kinds of knowledge'—but in terms of media, communications, and digital culture. And then, one obvious answer is 'All the things we don't know that we don't know'—because every so often, as with the Edward Snowden revelations about mass surveillance, we discover that there are huge things about modern technological life that we were just not aware of.

But, sticking closer to the themes of this book, here are the three things which occurred to me straight away. The three kinds of knowledge that we need now are:

- How things work (technical and economic knowledge)
- How things feel and fit (emotional and embodied knowledge)
- How to make a difference (creative and political knowledge)

These three are in ascending order of importance, but build on each other. So knowing how to make a difference is more important than knowing how things work, but if you don't know how things work you're not *really* going to know how to make a difference. (Incidentally, I'm not saying these are three kinds of knowledge which I have myself. This is aspirational!)

Let's take them one by one:

*How things work (technical and economic knowledge):* This is the basis for all critical understanding. You need to know what technological and/or economic systems make possible, what you can and can't potentially do with them, if you're going to develop any kind of really informed critique of how things are currently done and the ways in which they should be done. Obviously one person is unlikely to understand the 'how it works' of everything, but when you are making arguments about things it's really important to try to understand how those things actually work.

This point is, I suppose, a transplant of my longstanding bugbear about academics writing about online culture but not playing any kind of creative role in online culture, and (consequently) getting things wrong. The situation was probably worse when I complained about it in *Web Studies*, 15 years ago, but it's similar today (see remarks about critical-but-ignorant scholars in chapters 8 and 9).

*How things feel and fit (emotional and embodied knowledge):* This is about the need to build knowledge about the relationship between physical and material things, and digital items (content and software), and human ideas and feelings. The connections between these things are far from simple or straightforward. The physical and material things are important because

although many things are now intangible and digital, many more things are not, and we still live in our physical bodies in a physical world—but this is thoroughly entwined with our experience of digital content and services, and our personal feelings and experiences—and all of this is mixed together in complex ways.

*How to make a difference (creative and political knowledge):* Then, on top of those two bodies of knowledge, you need the ability to come up with brilliant ideas and implement them effectively in the actual world that we live in. That may sound more like a 'skill' than a kind of 'knowledge', but really, knowing how to make things, and to make things happen—to organise, orchestrate and lead creative practices effectively—is a vital and uncommon form of knowledge.

This body of knowledge includes all kinds of capacities: How to make things; How to collaborate effectively; How to organise events; How to create a movement; How to lobby governments, companies and organisations; How to work with organisations which are not like you to make things happen; and several more.

It's much easier to create lists like this than to actually do stuff; but thinking about these things is an important step on the road to getting things done. So thank you for that question.

Andrew Clay, via Twitter: *What are you connecting when making media studies, and is 'making media studies' also a transformative process of the self akin to creativity?*

Oo, there's a curious, interesting, unexpected question. To answer the second bit first, well, 'making media studies' would be a creative process and therefore, yes, would bring the benefits of creativity. It's not something 'akin to' creativity but would actually, simply, ideally, be creative. So that was quite straightforward.

The first part asks what is being connected—in fact the question says 'What are you connecting', but it's really a matter of what *we* are connecting in the evolving process of making media studies. And the answer is people and ideas and technologies. And it's a list of areas that includes design and creativity and technology as well as sociology, politics, economics, business, art, and other areas. And it's about putting these things together to form the three kinds of knowledge discussed in the previous answer.

Mike Gunn, via website: *Given the creative potential of new media technologies and the entrepreneurial spirit of the Internet, why do you think that successive governments seem to dismiss the study of the media in schools and universities? Why do you think that the same views are taken in the mainstream media?*

Well, I don't want to upset the well-meaning teachers of media studies, but I don't think media studies can or should be 100 per cent defensive, or just be cross and annoyed that great swathes of politicians, journalists, employers, parents and others simply 'don't understand' what happens in media studies. What if these are actually intelligent adults, who have seen some of the things on the media studies curriculum, and have come to the considered conclusion that not all of these things are incredibly valuable?

I think media studies sometimes shoots itself in the foot by trying to defend everything that is done in its name. The question here highlights 'the creative potential of new media technologies and the entrepreneurial spirit of the Internet', before asking why media studies is often denigrated. But I don't think most people think of media studies as being about creative and entrepreneurial use of technologies. They think of it as rather lame 'semiotic' discussion of popular films and soap operas, that kind of thing—and they are right to feel a bit dismayed, I think. (See the discussion in the opening chapters of this book). But maybe media studies mostly isn't like that anymore. In which case I'd like it to get on the front foot and say so!

When media studies is about critically considering the role of media and technologies in society (including politics, culture, economics and business), and when it is about developing creative materials, networks, and collaborative ideas, then it is really strong. If it built a really solid identity around those things—and if, therefore, people knew that was what it was about—then it wouldn't be subject to these attacks.

## On optimism, pessimism, and exploitation

Jan Løhmann Stephensen, via website: *As you state in the introduction to your upcoming book* [i.e. this book; an extract was posted online], *there are two sides to media studies and the phenomena it studies: one 'inspiring and optimistic', the other 'troubling and pessimistic'. In extension of your decision to study mostly the positive aspects—a fair, yet also slightly controversial choice, one might argue— I would like to ask, whether the ideas of 'creativity', 'participation' and 'making' solely belong on the sunny side? Or put in slightly more explicit terms: haven't these notions—and thus perhaps also some of the practices these notions refer to—become so entangled with particular contemporary economic and socio-political agendas, that looking at them in only a positive light could be somewhat problematic? See for example the so-called Mercurial Career of Creative Industries Policy pointed out by Andrew Ross a few years back.*

The simple answer is to restate that I am indeed saying that there are two sides—not just one positive side, but two sides, both the positive and the negative. It's true that governments, and to a lesser but significant extent companies, can store and track and analyse what you do online, which affronts our sense of privacy. And it's true that companies that you allow to publish your creative work online for free then make money from running that service, typically through advertising (although for most people *this* fact is neither a secret, nor a big deal; they weren't creating this content for economic reasons anyway). At the same time, it's true that sharing creative materials and ideas online, and having engaging conversations about it, is good for people at an individual level, and ultimately is really valuable for society (the argument made in *Making is Connecting*, and elsewhere in this book too). The positive points being true doesn't show that the negative points are false, or vice versa.

The reason I talk more about the positive aspects is because the negative arguments are already well covered by other academics. The world doesn't need one more person exploring the negatives—well not me, anyway. Whereas I do feel I may have some role exploring the power of making in everyday life, because—whilst it is hardly a new or secret point, having been well known to parents, artists, and many other people for thousands of years—there's still a message to remind people of there.

Now here, the question is saying aren't they intertwined. In some ways they are, yes of course. In other ways—not so much. We could certainly have all the benefits of sharing creativity and knowledge online without having the surveillance and capitalist money-making—they don't necessarily go together. In the present world these things do often go together, but (a) I'm not denying that, and (b) I'm thinking about a world where that's not the case.

It's not as though all online communications are *inevitably* subsumed under Facebook and the like. In exchange for a smallish amount of money for a domain name and webhosting—£2 a week would get you a good service (that's 3 US dollars or 3 Euro)—you can have a self-hosted Wordpress website, and present all your stuff online—and have conversations about it—in a completely non-commercial space, with no advertising. (Wordpress is a free and open-source tool for making blogs and sites). You might, if you wish, make more connections using Twitter, which is a commercial product but which—so far at least—has been reasonably low-key in its use of adverts and promotions. And it's normally handy to put videos on YouTube, where you might choose to let a little bit of advertising money be potentially made out of your video; or Vimeo, where you could even pay to upgrade to a high-quality

no-advertising service. (On Vimeo, the cost of their most feature-packed service, Vimeo Pro, which guarantees that no adverts of any kind will be placed on or beside your videos, is £3 a week [UK price as of December 2014]).

In other words, your creative work doesn't have to be 'exploited' by corporations. Unfortunately the mass surveillance point remains true—your online activity will be visible to state surveillance agencies, such as the US's National Security Agency (NSA) and the UK's Government Communications Headquarters (GCHQ). It *is* really wrong that, say, peaceful activists can be spied on in this way, and whatever checks and balances the governments claim are put in place, it's not overly cynical to take mass surveillance for granted now. As noted previously, this dismal, Orwellian situation is liable to weigh on the mind, and is a high price to pay for online connectivity. But actually the arguments about the value of positive connections and communities online remain true.

The question mentions Andrew Ross's argument that the thrust of creative industries policies pushed by governments around the world since the 1990s has meant that jobs in cultural sectors become increasingly like those of artists—piecemeal, unstable and precarious (Ross, 2006). In the present context I suppose the point is that this 'creative' work is unlikely to have made these people happy, because of the insecure nature of their employment. That may all be true, but doesn't really line up with my own arguments, which are about the value of everyday creativity—people doing and making things *because they want to*, not as part of their work or for money, but just because they want to make things together, because they want to learn and they want to connect.

So overall I'm saying that we should try to hold in mind both the positive and negative aspects of digital media and their associated cultures; and that, basically, although academics score more points for their 'critical' awareness of non-positive things, it's worth thinking about the positive things as well, because we can use the power of those things to do some good.

## On creativity and digital media

Dave Clemow, via website: *Is there a danger that digital media limits our definition of creativity?*

That's interesting. I guess the answer is 'no' as long as you remember that creativity is not something confined to the digital world—and most people are

aware of that, I think (!). Indeed, a lot of interest in online experiences these days is about how we can link the digital back to physical activities and real-world local things. And, the rise of the internet in general, enabling people who are enthusiasts for something to easily connect with like-minded others, has supported a boom in handmade and non-digital creativity. The creative activity itself remains offline, but the internet means that people can chat, organise, share ideas, arrange meetings, and inspire each other with pictures, videos, and other shared material, all of which may have been sort-of possible previously, but was somewhere between difficult and impossible for activities which were not very popular and were distributed thinly around the world.

Stewart Paske, via website: *Do you think children should get creative with new media technologies at an early age? A good example of this happening is the video game Minecraft, with many children using the LEGO-like digital world to create any number of weird and wonderful creations. Many then go on to share these creations in YouTube videos, or on forums.*

Well yes, of course, and Minecraft is a very good example (and is discussed a little in chapter 8). There are also nice apps for even younger children, such as Toca Builders—where different kinds of cute machines can be used to build with brightly coloured blocks and paint—and the other games from the Swedish company Toca Boca, which describes itself as a maker of 'digital toys'—which means they are open-ended and have no particular goals or competitive element [http://tocaboca.com]. A lot of other digital games are problem-solving and playing-with-physics, rather than fully creative opportunities to make whatever you like, but those can still be excellent games of course.

The indie game scene—video games made by independent creative people rather than the big companies—is incredibly rich and interesting. People have been observing for 20 years that video games are underestimated as a site of creativity, and as an economically significant business, and that's still true. I spent my teenage years programming games on our family Commodore Vic 20 home computer—in the early to mid–1980s—but then, after that, came a period when computers were all, for most people, locked boxes. In general you used professional software on them, and that's all you did. And video game consoles were the same. Since 2008, though, there have emerged a set of places where small developers can sell their games digitally: the XBox added an indie game area to its online platform, PlayStation followed suit later on, Apple's App Store was launched, followed by the Android equivalent, and you already had indie game platforms like Steam for the PC. So over the past few years we've seen the rise, again, of home-made games made by individuals

or small teams, with limited budgets, but with—in the best cases—innovative ideas and more personal or quirky stories.

So there has been this extraordinary growth of interesting indie games, and alongside that, more people, especially children, are learning to code, thanks in part to innovations like the Raspberry Pi—the £25 programmable computer—and campaigns such as the Hour of Code (http://code.org) and Code Week (http://codeweek.eu). The Hour of Code tutorials, for instance, are aimed at 'Age 6–106' and offer user-friendly, drag-and-drop, snap-together tools, through which users learn the basics of coding (specifically, that one uses Blockly, which is a variation of Scratch, developed by Mitch Resnick at MIT—a key colleague and collaborator in my work with the LEGO Foundation.[1] It's a small world). So there are new and accessible opportunities to learn to code, and to be inspired by incredible amateur creative work, in this independent game-making scene, and it's potentially very fruitful.

Clare Twomey, via website: *The digital and the tactile world of materials still seem to be viewed as different places. These two states of creativity seem to have different followers—this may be a huge generalization—and in both camps the strengths of activity are based on strongholds of knowledge. I am curious about the fluidity between these two states of creativity: how can creativity begin to super connect? Is it all still a bit lumpy? Or is this disconnect what makes us collaborate?*

Very interesting! I think about this kind of thing a lot.

It struck me recently that when I was young, like up to the age of 10, I used to like making physical things, especially in LEGO. (Attentive readers may not be surprised). So that was all very hands-on.

Then for Christmas 1981, when I was 10, as I just mentioned, we got a Commodore Vic-20 computer and I very quickly started making things digitally—in this case, games, mostly, written in the computer language BASIC. I spent loads of time on the computer and everything was now not physical but digital.

And so at Christmas 1981 I switched from one to the other, but then, the thing that struck me recently was, maybe this is my story—that ever since then I've been looking for the way to bridge the two. And, of course,

---

1    For instance, Mitch Resnick has made valuable comments on all of the LEGO Learning Institute and LEGO Foundation reports that I have worked on, and—as mentioned in chapter 9—together we presented a talk called 'Six Amazing Things about Making' at the World Maker Faire in New York, September 2013; video at: http://fora.tv/2013/09/22/six_amazing_things_about_making

I've been trying to do that over the past few years with LEGO—I mean the company rather than the product, but also this involves the product of course—so there's a kind of circle there.

The question that arises, very obviously, from LEGO is that many people love the hands-on experience of LEGO building, but we also like to do everything digitally and online these days, so how do you bridge the two—not in a corny way but in a sensitive, intelligent way which gives you the benefits of both? The most obvious thing, which is also the most obviously disappointing thing, is to create software so that people can design LEGO constructions on a screen. This kind of program has been widely available online for almost 20 years. But you've immediately lost the tactile, hands-on experience that made LEGO building so appealing in the first place, and you've also lost the serendipity of putting things together and seeing what happens. And you've, in your very first step, surrendered to the dominance of the screen. So that's not very clever.

The more organic way that LEGO and digital technologies work well together is the same way that lots of crafts and handmade things work well with technology now, which is simply by keeping the handmade stuff pretty much as it is, but having brilliant networks and communities online which enable practitioners to share ideas, learn from each other, and inspire creativity, all of which works terrifically well (Gauntlett & Thomsen, 2013; Antorini, Muñiz & Askildsen, 2012; Taillard & Antorini, 2013). So here the solution is not to make the physical craft 'go digital', but to share and inspire about it, in ways that were not possible before.

(There is, in fact, a middle-way thing you can do, which is that rather than making it so that things are designed on a screen, instead you make it so that physical objects become an interface into the digital experience. In LEGO terms this would mean that, rather than designing a model on screen and outputting it as a set of bricks (the facility that the LEGO Group offered online from 2005–2012), you would make a model by hand using real bricks, but would then be able to zap it into the computer in order to share or play with it in a different space, and it could interact with objects from around the world. We suggested this principle in *Defining Systematic Creativity in the Digital Realm* (Ackermann, Gauntlett, Wolbers, & Weckstrom, 2010) and it became real in products such as LEGO Life of George (2011) and LEGO Fusion sets (2014). But this is more straightforward, and more desirable, when you are talking about LEGO rather than, say, ceramics or embroidery or woodcarving).

So to return to the question, yes, computer-based and more physical forms of creativity do often still seem very separate, and are based in somewhat

different bodies of knowledge, but there are things that connect them too. There are notions of shared space and collaboration, and making and hacking, which are very important for tech companies and technology enthusiasts but which are about physical coming-together and making-together, using tangible materials. So there's something there. For example the book *Make Space* (Doorley & Witthoft, 2012) is full of ways that people can design things together, and it anticipates a design school and Silicon Valley kind of audience, but would be just as relevant to a range of handcraft makers. Although that thought breaks down if you're talking about very solitary making. The stereotype of the 'computer geek' imagines them isolated and lonely, tapping away at a keyboard, but the artisan maker is often just as much (or more) of a solitary figure. And in either case, that's fine, of course, and the internet gives them opportunities for sharing and exchange if they want them.

In fact perhaps the best answer was contained in the question—that the disconnect between the digital and the physical can be a driver for interesting collaborations. Of course it's 'still a bit lumpy' but this lack of straightforwardness can lead to interesting things.

Amy Twigger Holroyd, via website: *As you have pointed out in the past, maker culture is great in terms of encouraging a culture of playful learning and experimentation. However, a lot of maker culture seems to involve churning out a lot of pointless stuff—when we're already suffering (in environmental, social and personal terms) from having too much pointless stuff already. Can this be reconciled? Or does the end justify the means?*

Well, when people are making digital things, the environmental impact is not bad. It's not nothing because all those air-conditioned server farms use a lot of energy, but it's not much per person. And, if we think about the makers of physical things, in 'maker culture', well I think they tend to make things quite slowly and carefully rather than 'churning out'—and they also tend to be rather strong on recycling of materials.

But I think here you're basically talking about 3D printing. And yes, we can see that as moderately affordable 3D printers are now available, a lot of people have got excited about 3D printing, and are understandably, playfully, churning out lots of bits of plastic. There was never a problem which is being solved there—insofar as nobody ever said, 'ooh, I do really feel the shortage of bits of plastic tat in my life'. But more positively, these people are getting the chance to design a 3D object on a screen and then instantly—well, sort of instantly—generate it as a physical thing, which is a novel opportunity.

At the moment the cost of 3D printers and materials means that the 'churning out' of stuff is unlikely to really be a huge problem—although that may change when the price of those things drops further. So I recognise what you mean, within limits. But the reassuring point, I think, is one made by Douglas Rushkoff, who suggests that at the moment, it's the very early days of 3D printing, so it's like the early days of the World Wide Web: there are a lot of messy, playful, banal things, people trying stuff out, and it's not always impressive, but we need to have this phase of experimentation and mucking about, before we *then* move to a more mature phase with more carefully developed applications and activities. That sounds like it makes sense to me.

## On teaching and learning

Silke Lange, via email: *What pedagogy—practices of teaching and learning—do you envisage using to initiate the creativity turn?*

Unsurprisingly, it's all about making things. We continue to do discussing and writing, but if you have the hands-on experience of making things about, or connected with, whatever it is that you're interested in, then—for one thing—the discussing and the writing is more grounded and of higher quality.

The 'making things' here is not so much about learning the practices of professional media production, as such—although that may be part of it—but rather about the ability to create something interesting, which engages with some ideas, in a range of forms—or in a medium you've never used before—ideally in a thoughtful but swift process, a sort of prototyping method, so that ideas can be shown and exchanged, and then developed further.

I also like it when students not only do a creative task, but also that the brief for the creative task itself has been created by those students. So—to put it in chronological order—we might first of all talk about a thing of interest to us, maybe starting with the seed of an idea, or object, or video, or phenomenon; and then we'd invent the specification of the task—which is a design challenge in itself, to create a suitably sized, meaningful, not too easy but not impossible task. Then after that, of course, the students have to actually do the task; and then look at what's been made and find intriguing differences, or maybe see if we can combine ideas or use parts of ideas together to end up with something even better.

This way of working doesn't require lots of immediate preparation by the tutor, because the students are doing much of the work—but of course, that's best for learning. The tutor still needs to be a good facilitator, create a suitable

atmosphere, ask good questions, and have some expertise for when it might be needed. It's about *leading* the development of creative ideas and experiences, rather than transmitting knowledge. You still end up with knowledge—more of it, I think, and more deeply felt—but it's built rather than received. (At the same time, you're still going to have tutors who like to make a nice presentation with lots of pictures, who want to communicate some of the most interesting ideas they have ever heard, and want to engage a class with that body of stuff. I am one of those people too. So, we do both. We do a mix of things in fact. We go on trips. We meet other people and have conversations. Variety is good).

Silke Lange, via email: *What role does interdisciplinarity play in the creativity turn in media and communication studies?*

The more interdisciplinary the better, basically. Media and communication studies shouldn't really be left to itself to imagine that it is a 'discipline'. It has been developed, over time, by people who come from a range of disciplinary backgrounds, and that's a very good thing. It's always most interesting when people are coming at questions from divergent angles.

## On social institutions

Marie James, via email: *Is there a political/public framework to support this DIY revolution? And does it need one?*

That's interesting. The spirit of DIY would mean the answer should be no—we obviously don't need governments or institutions to take it over. But at the same time, the maker movement, or the 'DIY revolution' suggested by the question, comes with an agenda for social change which is very much to do with wider society and its institutions—most obviously in education, where the movement is continually showing, in implicit and explicit ways, the vital importance of hands-on engagement with learning: making things as a way of learning about things, learning by doing and exploring and trying things out. This is essentially a political position, and it sits in opposition to many of the prevailing trends in education—or at least, education provided by the state in schools—in most countries, where there is typically a dismal emphasis on doing standardised tests with right and wrong answers, and therefore, inevitably, also a lot of time spent training students in how to do well in these tests. Nobody especially thinks these tests are good for learning, but meanwhile it is common for people to want to be able to monitor and compare the standard of schools, and this is achieved by wasting the students' time with interminable tests.

At the same time, though, these same governments are quite noisily in favour of innovation and enterprise. July 2014, for instance, saw the first White House Maker Faire (see http://www.whitehouse.gov/maker-faire), where President Obama proclaimed 18 June 2014 to be a 'National Day of Making'. He said 'I am calling on people across the country to join us in sparking creativity and encouraging invention in their communities'. The White House Blog (2014) recorded that the president was 'encouraging dreamers across the country to become Makers of things, not just consumers of things, and calling upon Americans in every corner of the nation to host programs and activities to mentor and empower a new generation of pioneers in design, manufacturing, and engineering'. So, contradictorily enough, this suggests the maker movement is being embraced at the highest level. They do put a particular slant on it, of course—highlighting STEM subjects (Science, Technology, Engineering and Mathematics) and 'manufacturing', more than dimensions such as craft, culture, art, or activism—all of which are also part of the maker movement—but nevertheless, when the US president is saying that people should be 'makers of things, not just consumers of things', it is at least a positive shift. And there are many more such cases, of course: the take-up of maker ideas by some public libraries and museums, for instance (see for example the transformation of Derby Silk Mill in the UK (http://remakemuseum.tumblr. com) and the library-based maker initiatives collected by Sharona Ginsberg (http://library-maker-culture.weebly.com)), and initiatives which bring together groups involved in making to influence civic policy and planning (such as Oakland Makers, in California (http://oaklandmakers.org)).

So the maker or DIY movement presents a challenge to educational practices, and how we organise learning—which is a huge thing—and would in turn benefit from such a change; and the movement is seen, by some politicians, as offering some kind of partial solution to economic recovery and promoting innovation, and is associated with change in other public institutions. This doesn't amount to a supportive 'political/public framework' as such, but perhaps all we really need is for more and more people to have opportunities to experience the power of learning by doing, and making solutions to problems, and being a part of inspiring creative communities. To some extent, they do it themselves anyway. So far the maker movement, and the revival of craft activities over the past 10 years or so, has been driven by networks of individual enthusiasm and self-organisation. More formal support would be great, and a transformation of education would be wonderful, but, as ever, it's a circuit, and these things will only change on the macro level as people change

on the micro level, through everyday experiences. So, quite simply, what that means is that we have to make more of those everyday experiences happen.

## And here's some for you

I received several further questions which are very good *questions* but I don't feel I have distinctive or worthwhile answers to them. Here are three of them, that I thought I'd mention here in case you'd like a go.

- Jen Ballie noted that 'Our world is suffering due to the mass production of consumer goods, and maker culture offers an alternative by advocating and supporting participation'. She wonders how we can build and sustain engagement with these activities. 'There seems to be some kind of magic in the process of making that captivates and enchants people but as we grow we tend to forget or lose touch with making. How can we nurture the 'magic of making' from a young age?' My thoughts, expressed elsewhere in this book, are to do with transforming attitudes in education and in society generally, which will probably come from inspiring leadership, and role models—when people see the power of making themselves, they're much more likely to give it a go.

- Mary Kay Culpepper says: 'In children, creativity often springs from play; in adults, problem-solving is usually the impetus. Is this a continuum? Is there middle ground? How might it be found and mapped?' I think it's kind of a continuum. The research on children's play suggests it is certainly, already, a way of dealing with issues or 'problems'— although not always—whilst adult creativity can often be like play— for open-ended pleasure and for its own sake. So I don't expect these are separate phenomena.

- Katie Smith wrote: 'In the introduction to your book *Making is Connecting* you discuss moving towards a 'making and doing' culture in schools. Whereas there are many excellent examples of schools embracing new media to teach and learn creatively, often young people's independent explorations of these technologies are dismissed as play. How can we encourage schools to rethink how they value this "play" and to acknowledge its potential to enhance learning across the curriculum and beyond?' Again this seems like a very good question that I don't have the definitive answer to. I guess people and systems change when they can see the *value* of that change, so again it's a matter of inspiring

individuals or groups doing things differently—often in the face of some disdain or resistance—until they get to the point where they are able to *show* the *results* of what they've done, and then a growing number of positive voices mean it's easier and more likely for other people to climb on board.

Thank you to all the people who kindly sent such thoughtful questions.

# PART 3
# MAKING COLLABORATIONS

## · 6 ·

# ACADEMIA—INDUSTRY
# COLLABORATION AND INNOVATION

### Three Case Studies, and Eight Principles, for Fostering People's Creativity on Digital Platforms

First, a note on the origins of this chapter. I don't tend to write journal articles, due to a quirky personal view of academic journals as unreasonably slow, pretentious and plain weird. But as an academic, one feels a kind of peer pressure to give it a go once in a while, and it struck me that I had unintentionally amassed a body of experience—working with three different organisations on projects that had some things in common—that I could draw upon to write a journal article. The idea felt neat and self-contained—not something that should really be a book, but just right for an article.

So I wrote it, carefully crafting it over a few months, and trying to use a less personal style than normal because journals don't like authors to have much character. (You might notice this slightly different tone in the chapter below). Then I sent it to a journal and they had it anonymously peer-reviewed, as is the normal way with journals, and so some anonymous academics anonymously attacked it for spurious reasons, as is the normal way with journals, and so I was not exactly surprised, but I was disappointed as I had really tried to fall in with the conventions of the genre and do a proper journal article.

Now, journals sending articles back for 'further work' in response to spurious or random objections is, I gather, completely normal in academic life, but I couldn't be bothered with this, partly from ordinary impatience, and

partly because academic journals seem fundamentally pointless in the modern age. I've long advocated for the notion of post-publication peer review, i.e. a model where people would prepare articles to a point where they are happy with them, then publish them online, and so rather than having a gatekeeper wall of editors and anonymous reviewers who select (and interfere), you have a filtering process that happens naturally, as people rate and share and make use of articles that they have found to be good, interesting or useful. But this model has not caught on yet (see Fitzpatrick, 2011; Gauntlett, 2012b).

So rather than get dragged into a boring process of changing my article in ways I didn't agree with in order to get my article into a kind of publication I didn't like, I just put half of it online (the eight principles mentioned in the title). And sure enough, these eight principles have been cited and made use of in a few places (James & Brookfield, 2014: 202–205; James, 2012; Twigger Holroyd, 2012) despite only being on a blog. And here, for the first time, is the whole thing (lightly revised and updated).

## Introduction

Media organisations today are increasingly expected to embrace and support the creativity of the general public. This may be referred to as 'user generated content,' engagement with 'audiences' or user communities, and other terms. It is related to the rise of social media—the development of easy-to-use online platforms which enable everyday users to share their ideas and creativity, and collaborate to build a place which becomes better the more people there are using it.

This chapter draws upon the experience of working in collaboration with three rather different organisations—the BBC (the world-famous public service media organization), S4C (the smaller Welsh-language public service broadcaster), and the LEGO Group (the international producer of toy and learning products). In each case the collaboration involved the idea of enabling people to contribute their own creative expressions within a structured environment, via different kinds of digital platform. The motivation for this varied somewhat in each case, but the initiatives were united by the general assumption that this would be socially valuable, good for individuals, and would involve some degree of informal learning. In each project I was, as it were, an outsider, a university-based academic researcher invited to work with the insiders in the hope that our collaboration would bear fruit of some value to the industry partner (and possibly for the academic partner as well).

This chapter necessarily draws upon my own observations and reflections from working with the three organisations. It could be described as a reflective participant observation method: I am writing about academia–industry collaborations based upon the fieldwork experience of having led a number of such projects, accompanied by evidence such as emails and notes, as well as more formal meetings and reports. Of course the three cases will not be representative of such collaborations with organisations in the creative and cultural industries in general; indeed, we could not even expect them to be representative of collaborations with different parts of the *same* organisations. Nevertheless, by looking across experiences and observations from projects with three different organisations, I assume it is reasonable to draw some tentative conclusions. For each case study I have supplemented my experience with an interview with one other external collaborator, who in each case has engaged with the same organisation but on a different project.

In the following sections, I will introduce the three organisations and projects in a little more detail, and then discuss the ways in which their different approaches to openness, collaboration and innovation affected the outcomes of the projects. Then I will outline a set of eight basic principles regarding the design of digital platforms, which follow from observations about those projects.

# Case #1: The BBC

## 1. The organisation and its engagement with user creativity

The BBC is the largest broadcasting organisation in the world. It is funded primarily by the UK licence fee to provide television, radio and online services to 'educate, inform, and entertain' the public—as the famous motto has asserted since 1922. The BBC was relatively quick to adopt the internet as its 'third arm', opening its BBC Online website at bbc.co.uk in 1997, and quickly building the site's reputation for breadth and depth of content in news and many other areas, including entertainment and activities such as cookery and gardening.

The BBC was one of the media organisations which showed an interest in the notion of 'user generated content' (UGC) at a relatively early stage, with the phrase becoming especially conspicuous around 2005.[1] However the

---

1  In particular, the London bombings of 7 July 1995 were seen as a watershed moment for UGC within the BBC—albeit in terms of newsgathering rather than user creativity—as

corporate interest was generally about getting content from 'users' to include within broadcast TV and radio programmes, and therefore retained the BBC's traditional top-down approach.[2]

Indeed, that use of the phrase 'user generated content' could be seen as a rather condescending device, especially as deployed by the BBC, marking out the amateur territory which is distinct from its own professional ('proper') media content. The BBC's use of UGC in those earlier years was generally cautious and predictable, such as use of mobile phone footage of unpredicted events where there were no other pictures available, and the use of comments submitted by viewers by SMS or online in *response* to BBC stories (Wardle & Williams, 2008). Over time, the interest in UGC evolved into an engagement with some aspects of social media. In particular, as Claire Wardle explains (in Thornham, 2014), the BBC realised, around 2008–11, that their assumption that people would primarily want to send material *to the BBC* wasn't really working; people were certainly making and sharing stuff, but they were doing so on social media platforms. So the BBC has taken steps to be able to make use of certain kinds of material from social media, but still typically in support of BBC-led initiatives. The BBC is, then, a large and well-established organisation with well-developed digital interactive offerings alongside television and radio, but which has been relatively conservative when it comes to opening up to user creativity.

---

the corporation received significant amounts of photo, video and text material soon after the incidents, which were central to the subsequent reporting. See Torin Douglas, 'How 7/7 "democratised" the media', BBC News, 4 July 2006, http://news.bbc.co.uk/1/hi/uk/5142702.stm

2    This adherence to the broadcast model was illustrated, for instance, by the 6 March 2007 edition of the BBC's internal magazine *Ariel*, which contained a substantial but highly inaccurate presentation to staff about 'Web 2.0', described as being characterised by 'more video' and 'better signposting' for users. The feature managed to wholly ignore the two-way model—the opposite of the BBC's familiar broadcasting model—which was actually the defining point of Web 2.0. This could perhaps be explained as merely poor reporting by *Ariel*'s writers; but this particular edition of *Ariel* was presented as a carefully planned intervention by the Future Media & Technology department to 'educate' the rest of the BBC, and so it seems unlikely that this odd reinterpretation of Web 2.0 could be explained as a misunderstanding within *Ariel*'s production process.

## 2. The particular project

The BBC's collaborations with academia for *research* purposes had generally been relatively ad hoc (although not necessarily insubstantial) over the years, until the UK's Arts and Humanities Research Council and the BBC launched a modest joint funding venture, the 'AHRC & BBC Pilot Knowledge Exchange Programme Scheme', in 2007. This led to eight funded projects, one of which was 'Audience and producer engagement with immersive worlds', with myself as Principal Investigator and Lizzie Jackson as Researcher.[3]

This project stemmed from the suggestion by a colleague in BBC Children's that we might be interested in the development of a virtual world for children, which was to be produced by that department—a service called *CBBC World* in its early days, and launched in 2008 as *Adventure Rock*. Our study worked with 90 children in the target age range, 7–11, from ten schools in England, Wales, Scotland, and Northern Ireland, to consider their use of similar existing services; and used creative methods to enable them to communicate their feelings about, and aspirations for, online worlds. It also followed their engagement with a beta version of *Adventure Rock* as they got to know it over a four-week period. The parents or guardians of the children were also asked to complete a questionnaire about their views of the service, and their child's experience.

The findings of the study were discussed in two reports (Jackson, Gauntlett, & Steemers, 2008a, 2008b). The insights into what children said that they wanted from virtual worlds were of some value, and the parents' responses were not especially surprising, but worth recording. We were able to identify eight orientations to *Adventure Rock*—simplified archetypes representing the different ways in which children engaged with this world—such as 'Self-stampers', who wanted to make their mark on the world through self-expression; 'Social climbers', who were interested in ranking, and wanted to be visibly doing better than other players; and 'Nurturers', who wanted to care for characters in the environment. These archetypes were enthusiastically taken up by executives in BBC Children's, who subsequently used them when discussing new product ideas.

---

3    The research project 'Audience and producer engagement with immersive worlds', was funded by the AHRC & BBC Pilot Knowledge Exchange Programme Scheme (Ref: AH/ F006756/1), and ran from 1 July 2007 to 30 June 2008, extended in 2009 with additional 'Knowledge Infusion Funding' (second phase January to April 2009).

Ultimately, the production of *Adventure Rock* was competent, but the project was based on a poor premise (Gauntlett, 2014). It can be seen that the BBC was eager to boast at media industry conferences that they were preparing a '3D environment' for children which would 'promote creativity, ICT skills, positive contribution and collaboration' in 'a virtual world actually peopled by its audience', as Jana Bennett, then the Director of BBC Vision, told an audience at Cannes in April 2007. But the product itself was disappointing. Not only did it *look* rather like the kind of game you would buy on a CD in the mid-1990s, it functioned in that way as well, suppressing the possibilities of the network in favour of a more top-down, readymade approach. Ironically, although the project appeared to represent the BBC moving away from a 'broadcasting' remit, the paternalistic values of the broadcaster remained quite intact.

An online world typically has the distinction of bringing diverse users together in a shared virtual space, but *Adventure Rock* made players invisible to each other. Whilst thousands of children may have been accessing *Adventure Rock* simultaneously, each player appeared alone on separate, parallel versions of the same island. Although the BBC had understandable concerns about the risks of allowing children—or adults pretending to be children—to socialise online, other systems such as the popular *Club Penguin* had already demonstrated that this could be done in a carefully limited way, so that users could have fun, communicate and collaborate together, whilst not having the ability to exchange contact details or have 'inappropriate' conversations.

The creative opportunities offered by *Adventure Rock* were also limited—mostly to do with rearranging readymade elements, or simple drawing or music-making. Such simple tools were fine, but again failed to take advantage of the potential social network, and did not enable users to creatively transform the *environment*, or the ongoing conditions of the game itself.

## 3. On the organisation's collaboration style

We should note that, as the BBC is a sprawling mass of different groups and departments, it is usually inaccurate to say that one has been part of 'a collaboration with the BBC'—as indicated above—since any such relationship is inevitably with a *bit* of the BBC. That bit is not necessarily representative of the rest of the organisation, and the collaboration with that bit, even if apparently relevant to several other bits, will not *necessarily* have impact elsewhere.

In the *Adventure Rock* project, we worked with people from BBC Children's, and people from BBC Future Media and Technology (known as FM&T).

We gathered from informal conversations that the staff in BBC Children's were proud of being producers of 'actual' content, and tended to feel that FM&T staff didn't seem to 'do anything' apart from generating futuristic jargon. Conversely, the FM&T staff believed that, in working on the BBC's relationship with the future of media technologies, they were doing some of the most crucial work in the organisation.

The main problem in our 'collaborative research project' was that the 'collaboration' began at such a late point in the development of the service that our function as researchers was more like 'evaluation' of a Beta trial. This was made more frustrating by the fact that it did not seem to occur to those we met at the BBC—although they were pleasant and professional individuals—that a more valuable collaboration with universities should involve a meeting of minds at the very earliest stage of any given project. The BBC seemed, in short, to be happy that it already had plenty of expertise in the things that it wanted to do, and 'research' was equated with market research and product testing.

This could appear to be the gripe of one disappointed researcher—but we found that other academics in the AHRC–BBC scheme often had similar experiences, although they did not generally wish to risk future research opportunities by saying so in print (see Popple & Thornham, 2014). However Claire Wardle, a researcher from one of the *other* BBC–AHRC funded projects, has said in an interview (Thornham, 2014: 159) that the project strikingly revealed the lack of meaningful connection between academic researchers and 'industry' (meaning the BBC):

> The barriers between academia and industry are quite upsetting really, and while [the BBC staff I worked with] were far more reflexive than I thought they would be, they still had absolutely no desire to read academic research, and they had no knowledge of research that was pertinent to their areas, so it was about trying to find [ways of talking to each other]. So we didn't have enough time during the project to think about how the relations between academia and industry could be improved.

To be fair, it is typically the case that the BBC usually *does* have a lot of expertise in the things that it wants to do—certainly, left to its own devices, the organisation often routinely turns out carefully-crafted and effective products. But there is a reasonable argument to be made that perhaps the BBC's decisions and definitions regarding the projects that it initiates might benefit from external input and collaboration; and the growing body of literature on open innovation (Chesbrough, 2003, 2011; Chesbrough, Vanhaverbeke & West, eds., 2008) would suggest that it is usually unwise of an organisation to

assume that the best ideas and ways of doing things are already within their own walls.

# Case #2: S4C

## 1. The organisation and its engagement with user creativity

S4C is the Welsh-language public service broadcaster. Based in Cardiff, it functions as a publisher-broadcaster, commissioning TV programmes from small production companies across Wales. Its role in maintaining the Welsh language gives it a distinctive cultural mission. The 2011 Census found that 19 per cent of people in Wales could speak Welsh (Office for National Statistics, 2012). The language is not necessarily in decline—for instance, this figure is slightly higher than in the Census of 20 years earlier. The continuing output, since 1982, of S4C is likely to have played a role in sustaining the language.

S4C is much the smallest of the three organisations discussed here, with 127 full-time employees compared to the BBC's 21,282 (2013/14 figures). As we will see below, S4C has largely operated as a conventional one-way television broadcaster, and so has not engaged much with the creativity of online users.

## 2. The particular project

In 2011 I had a sequence of meetings and interactions with S4C's New Media Forum, a committee of mostly external stakeholders who had been charged with developing S4C's digital future. In my first meeting with the Forum at S4C, attended also by the acting Chief Executive, I explained that I had some proposals about the role that everyday people in Wales—the people that S4C typically regards as 'audience'—could play in building the range and diversity of Welsh-language media. To show how these proposals were a necessary part of what S4C should be doing, I had looked at the organisation's corporate aims and vision, expecting that they would say something about engagement with audiences and fostering creativity, as most broadcasters say in their aims these days (regardless of what this means in practice). I had been surprised to find that S4C only had written-down aims saying that they should (a) make a certain number of good-quality television programmes, and (b) that these should reach an audience: a very traditional model of television broadcasting.

It was striking that these corporate aims expressed no particular social aspirations or values. To make this point at my first S4C meeting, I contrasted these goals with the mission statement of the LEGO Group: to 'inspire and develop the builders of tomorrow'. This simple, memorable line describes a particular aspirational purpose which can be used—and is used—within the company as a tool to evaluate new initiatives, assessing how they may contribute to this goal.

I suggested that an S4C aim for the future might be 'To foster and celebrate all forms of creativity in the Welsh language'. When this received a positive response, I developed it into a three-part list of aims proposed for S4C:

- To educate, inform, and entertain the Welsh people, in both established and innovative ways;
- To cultivate the creative capacity of Welsh-language producers and makers of all ages and abilities;
- To celebrate the culture, traditions and imagination of Wales.

This text was adopted and proposed in the strategy report produced by the New Media Forum, which was delivered to S4C's governing Authority and Management Team, and published in November 2011. The report incorporated suggestions—which the Forum already had in mind—building on this theme: that the company should do much more to support non-professional Welsh-language media content wherever it was to be in found, which in practice means video and audio made by enthusiasts and shared on online platforms. A potentially strong support for the Welsh language could come from communities of people making and sharing their own media, since much stronger engagement comes from creating oneself rather than merely receiving material handed down from 'on high' (Gauntlett, 2011a).

In October 2012, S4C published a new statement of corporate aims and values, which was directly influenced by this dialogue. The new publication stated that the organisation's role was to 'nurture and celebrate creativity in the Welsh language'—a pleasing vision, and a striking contrast to the previous corporate goals.

## 3. On the organisation's collaboration style

Although this collaboration was the least intensive of the three cases considered here, I found S4C to be relatively open to external input, and happy to collaborate on thinking about the future. This view was confirmed by Dyfrig

Jones, who works in the School Of Creative Studies and Media at Bangor University, and was asked to chair S4C's New Media Forum. Interviewed in November 2011, he said:

> During the past 12 to 18 months, S4C have demonstrated a real appetite for change, and have shown that they are open to new ideas. This is epitomised by the New Media Forum, which is made up of individuals from outside the institution who have been given genuine freedom to work on S4C policy. The first report is going out to consultation in the next few weeks, and it is hoped that a significant number of its recommendations will become policy.[4]

The views of this forum of practitioners, producers and academics fed into the top level of S4C management, who appeared to welcome their potentially disruptive input.

# Case #3: The LEGO Group

## 1. The organisation and its engagement with user creativity

The LEGO Group is primarily recognised as one of the world's leading toy producers, specialising in construction products based around the LEGO brick, launched in 1958, a key symbol at the heart of their globally recognised brand. The LEGO Group is perhaps not thought of as a media company at all, although the brick is a medium for creativity and communication, and, more conventionally, the company has produced and licensed several TV series and films, and—since 1997—various computer programs, games, and digital tools, from early software such as *LEGO Racers* to the hugely popular *LEGO Star Wars* and *LEGO Harry Potter* series, and the expensive but short-lived massively multiplayer online game, *LEGO Universe*. The LEGO website offers 3D digital design tools, galleries to share creations, and an online social network.

The LEGO Group has engaged with the creativity of its users since the 1960s, and this has grown considerably in the past 10 years, so that now the company is recognised as one which has an usually rigorous connection with its user base, including the many Adult Fans of LEGO (known as AFOLs) as well as younger enthusiasts (Antorini, Muñiz & Askildsen, 2012; Antorini & Muñiz, 2013; Taillard & Antorini, 2013). It supports various fan

---

4     Interview, 9 November 2011.

activities, such as events, networks and publications, and has launched an open innovation platform, LEGO Cuusoo—later reinvented as LEGO Ideas—where any user can submit designs for sets that they would like the company to produce; these designs are then voted for by the community. It also has, for instance, a LEGO Ambassadors program, which gives volunteer ambassadors, representing different international LEGO user groups, greater access to the company.

## 2. The particular project

My relationship with the LEGO Group has involved a number of projects, with different (related) parts of the organisation, and has changed over time. It began in 2004, when I was contacted by Per Kristiansen, the then Director of LEGO Serious Play. I had been developing research methods in which people *made* things—such as drawings, collage, or videos—as part of the process, and he saw a connection with LEGO Serious Play, which is also a process in which adults make things, typically in order to illustrate and explore their relationships within and about organisations. In this case, they build exclusively in metaphors, using LEGO bricks, a process which I found to be highly effective. I started doing research about and with LEGO Serious Play, which was partly supported by the company, including a study of the use of this method for considering social science questions (Gauntlett, 2007).

This research association continued, although as time went on, the company was unable to maintain support for LEGO Serious Play as a commercial prospect. Its former closed model of paid-for training and licensing was abandoned, and in 2010 LEGO Serious Play was released as an Open Source process (for which I co-authored the information and instruction document). The process continues to be used by several consultancy companies around the world, working with large corporations and small organisations.

In 2007 I was approached by Cecilia Weckstrom, Head of Consumer Insight & Experience Innovation within the LEGO Group, to help restart the LEGO Learning Institute, a programme of collaboration with university academics which had been largely dormant for a few years. This led to an ongoing programme of research, based around annual projects with externally-published reports: *Defining Systematic Creativity* (Ackermann, Gauntlett & Weckstrom, 2009), *Defining Systematic Creativity in the Digital Realm* (Ackermann, Gauntlett, Wolbers, & Weckstrom, 2010), *The Future of Play* (Gauntlett et al., 2011), and *The Future of Learning* (Gauntlett et al., 2012). During this period the lead

academic participants were based at the University of Westminster, University of Cambridge, University of Edinburgh, all in the UK, and Massachusetts Institute of Technology (MIT) in the US. In 2013, the LEGO Learning Institute became part of the LEGO Foundation, the foundation which owns 25 per cent of the LEGO Group and which aims to embed playful learning and creativity in societies worldwide. The first research report from the reconfigured Foundation was *Cultures of Creativity* (Gauntlett & Thomsen, 2013), which was produced with input from a newly formed network of experts from around the world. (To finish the list: I have also written and produced videos about our projects; worked with LEGO Education on products derived from LEGO Serious Play principles; and co-produced a Systematic Creativity training pack and workshop, which has been used by all new employees at the LEGO Group in Denmark since 2009.)

These projects have each involved discussion of digital platforms which would enable users to play, learn, and share. A key question for LEGO concerns how hands-on building with LEGO bricks can be combined with digital tools or games to enrich the experience in an intelligent way, which goes beyond merely replacing physical play with an on-screen simulation. The reports have discussed the ways in which creativity and learning can be fostered, and sought to identify the combinations of human qualities and support, and physical and technological tools, which together can help to unlock the creative potential of children and adults.

There have been some more immediate impacts. The work on systematic creativity made explicit the value of the interconnecting system which had always been at the heart of the LEGO System, and so this understanding was included within a training pack given to all new employees at the LEGO Group headquarters in Denmark, communicated via a LEGO Serious Play building exercise which we devised. Furthermore, the study of systematic creativity in the digital realm argued that LEGO bricks could be used as an *interface* for digital devices, rather than computers being used merely to *represent* LEGO objects, or make plans for subsequent models. In other words—as mentioned in chapter 5 above—physical LEGO bricks could be an input for digital LEGO systems, rather than the more common process the other way round. This contributed to inspiration for the team who went on to develop LEGO Life of George, a commercial product released in 2011 which brought together physical bricks and a digital game in this way. The game combines a set of bricks and an iPhone app, which sets challenges for the player to build, and is then able to scan the bricks with the phone's camera, and respond to

the result. This is an early form of the kind of 'hybrid reality' application discussed in our report.

## 3. On the organisation's collaboration style

I found that the LEGO Group was keen to embrace and support a network of academic experts, working on questions (such as 'the future of play' or 'the future of learning') which are obviously related to their business, but which also have much broader application. This work was published publicly and available free from the LEGO and/or LEGO Foundation websites. As well as funding and collaborating on research, the LEGO Learning Institute and LEGO Foundation were eager to engage with academic researchers at conferences and other events, and to find other ways to support research. Critics might see this as an inappropriate mixing of the particular interests of the commercial world with the more 'pure', non-commercial interests of the academic community. Indeed, I—in common with other academics working with LEGO—were wary of appearing to be 'bought' to produce research which merely recounts the educational, psychological and/or social value of LEGO products. However, our experience has been one of apparently genuine interest and openness. Our contacts at the LEGO Group are clearly pleased to see lines of research which support the usefulness of the LEGO system, but their primary interest is in future trends and in ideas from research which might add to the value of future LEGO products, or their uses, which would genuinely support the development of creativity and learning. These are goals I had no problem with: we already live in a world filled with toys, games, tools and services aimed at children and adults; aiming to produce better quality, more thoughtfully designed kinds of such products, to support creativity and learning, can be seen as a relatively noble pursuit. (These concerns have also become somewhat easier since our research has more recently moved into the LEGO Foundation, which is non-commercial and has positive social and educational goals).

The LEGO Group also appears to successfully work within an ethical code which requires a responsibility for producing products of high quality for children, in particular, and of fairness and respect for employees and customers. This ethos is much stronger than I have seen at any other commercial organisation. A kind of academic rigour is also expected. Roland Harwood, co-director of 100% Open, an open innovation agency which completed a project for the LEGO Group in 2011, observed that his contacts with senior management were characterised by a surprisingly direct and honest engagement

with academic research, and an uncommon insistence upon the highest quality in products, services and relationships.[5]

## Looking across the three organisations

If we look at the BBC, S4C, and the LEGO Group together, all three can be broadly characterised, in the spirit of their everyday operations, as commercial with a public service ethos. It may seem odd to label the BBC as 'commercial' since it is famously not so, but the Corporation has to justify its existence through gaining audiences and users of its services, and so in its everyday business it ends up behaving in a broadly commercial manner—with a public service ethos. This makes it surprisingly similar to LEGO, a commercial company which operates with a self-imposed 'public service' approach which has become central to its respected and trusted brand.

However, in the comparison implied by the above discussion, based on the experiences of this researcher at least, the LEGO Group was much better at collaborating with academic researchers in ways which might benefit both the company and its users. The BBC was found to be rather more arrogant, and concerned with appearances rather than real benefits.

All of the above can be rather crudely summarised as follows:

Table 6.1

|  | Size of organisation | Experience with digital media | Embrace of user creativity to date | Collaboration style |
|---|---|---|---|---|
| BBC | Huge, 21,282 FTE employees | High | Quite low | Rather closed, interested in looking good |
| S4C | Quite small, 127 FTE employees | Low | Low | Becoming more open |
| LEGO | Very large, 11,755 FTE employees | High | Quite high | Rather open, interested in making more beneficial products |

Employee numbers are for 2013/14, from each company's Annual Report (BBC, 2013; S4C, 2014; LEGO Group, 2013). FTE is full-time equivalent.

---

5    Interview, 5 August 2011.

## On collaboration and innovation

The experiences of collaborative research relationships between university-based researchers and commercial or public-service companies, discussed above, suggests that these relationships are not always best organised to foster innovation, and sometimes even tend towards its suppression (as in the BBC case). This is not necessarily surprising, because the expected role of academics in such collaborative research is unclear. For instance, the UK's Arts and Humanities Research Council (AHRC) published an aspirational report in 2009, 'Leading the World: The Economic Impact of UK Arts and Humanities Research', designed to make the case—primarily to government, and other interested stakeholders—for its continued existence and funding. Here, academic researchers were surprisingly positioned as intellectual *observers* of culture, but not as creators or innovators. This role was even illustrated in a diagram, which showed 'culture' as a substantial circle at the top, and then put academic researchers in a separate blob below that and off to one side, apparently doing 'professional reflection on culture'. (Parallel to this was 'popular reflection on culture', which presumably indicates the work of music and movie magazines, and fan websites). Unlike university-based scientists, who are expected to be the originators of innovation in their field, the UK's university-based arts and humanities practitioners were positioned—by their own funding council—as rather lame bystanders, whose role involved the critical appreciation of creative things done by others.

The AHRC's case was supported by a detailed celebration of the economic importance of popular culture and cultural events, but failed to show how academic *observation* of such phenomena would make a significant difference to that economy (Gauntlett, 2009a). An assumption that academic researchers are imaginative people who understand their field, and therefore may have something to offer in the development of *new* things in that field, would have led to a quite different approach.

Of course, there are other views. Some have made a strong argument that all parts of a university should be drivers of innovation (Yusuf & Nabeshima, 2007; Etzkowitz, 2008; Thorp & Goldstein, 2010), but this may not always be appropriate or possible. John Steen, of the University of Queensland Business School, has suggested a kind of semi-optimistic third way, arguing that 'universities do matter for innovation, but this is because they can create a public space for the exchange of ideas' (Steen, 2011). That is certainly a good point, but shouldn't rule out more active development of applications for those ideas.

I would argue that academic researchers should certainly be able to be part of an innovation process, and that this is a desirable kind of activity. In the arts, humanities, and social sciences, it is perhaps best achieved through a positive version of the kind of collaboration with relevant organisations and industries discussed here.

Features of a fruitful collaboration are likely to include:

- A conversation which begins with the *conception* of a problem to be addressed, not after a plan, solution or product has been developed.
- A relationship of openness and trust.
- An understanding that key ideas may come from any of the participants, with neither side being subservient to the other.
- An understanding that 'research' people might have interesting ideas about business, innovation and organisation, and equally that the industry-side people might have interesting and surprising ideas about research and possible interactions with universities.

From these points it will be clear that a clear division between the 'funder' and the researcher, which might be preferred in some contexts such as medical or scientific evaluative studies, where researcher independence is vital, is not likely to add value to collaborations with the creative and cultural industries. Of course, academic researchers must maintain the very highest ethical standards. But a pompous attitude to the superiority of independent academic insight is not likely to support collaborative creativity and innovation.

## On designing platforms for creative expression

As noted above, all three of the collaborative projects discussed here were intended, in different ways, to produce, or contribute to the development of, digital platforms which would enable users to express themselves creatively, and to connect with others. Inevitably, this challenge was imbued in each case by the character of the originating organisation. The BBC project required fast delivery, plus an uncritical and showy public reception, and was gestated in the shadow of a great fear that the *Daily Mail* newspaper would produce a 'shock, horror' story about the BBC wasting licence-fee payer's money on expensive non-television projects (a type of story which did indeed frequently appear in that popular newspaper, contributing to a sense of vulnerability at the broadcaster). The S4C project would have to be inexpensive, rather worthy, and uniquely Welsh. And the LEGO projects have been built around a

strong belief in the values of creativity, play, and learning through experimentation and tinkering, with an emphasis on research-based development and thoughtful design.

Looking across the three collaborations, I have identified eight basic principles around the goal that they had in common—the design and development of digital platforms, which are intended to be of benefit to users in terms of the development of creativity and learning. The eight principles are:

1. Embrace 'because we want to'.
2. Set no limits on participation.
3. Celebrate participants, not the platform.
4. Support storytelling.
5. Some gifts, some theatre, some recognition.
6. Online to offline is a continuum
7. Reinvent learning.
8. Foster genuine communities.

These eight principles will now be explained in more detail.

## 1. Embrace 'because we want to'

In the research conducted for these projects and for the book *Making is Connecting* (Gauntlett, 2011a), it became apparent that perhaps the number one driving force behind online and indeed offline creativity and participation is the opportunity afforded to people to do whatever they like, whatever interests them, just *because they want to*. YouTube has filled up with millions of non-professional videos in just a few years, and similarly Wikipedia has been populated by millions of articles about so many diverse topics, just because the opportunity is there for people to contribute material which can be seen by others. These are, of course, particular systems, which like all technical systems enable some kinds of behaviour and do not foster other types of activity. But they are extremely un-prescriptive: they only provide a bare-bones kind of framework for guidance. YouTube doesn't mind if you upload a mini Western, a how-to video on first aid, or some animated singing vegetables. Wikipedia doesn't care if you're adding detail on the Higgs boson particle or on what Yoko Ono did in 1973.

These platforms largely accept whatever comes at them—although of course there is then curation, rating and filtration performed by the community of users, to varying degrees (in these examples, it's typically light in

YouTube, where responses are mostly via 'likes', ratings and comments, and stronger in Wikipedia, where material which does not make an encyclopedia-like contribution is likely to be removed, and any entry is liable to be rewritten and amended over time).

Many people are already eager to make and share material, so a digital platform has to support this and offer appealing tools to help this inclination to develop. The reasons *why* people want to do this are covered in some of the points below: the desires for storytelling, gifts, theatre, recognition, connection to the rest of life, learning, and communities.

In the cases covered above, the BBC *Adventure Rock* service did not properly embrace children's desire to be creative and to share that work with others, and this was one of its biggest failings. S4C had also not embraced the creativity of Welsh-speaking people online previously, but was interested in a future which would work with that creative desire in order to boost the visibility of the Welsh-language imagination. And the LEGO Group was already very experienced with creative tools—the famous LEGO brick system—but is continually looking for ways to *work with* what people are already motivated to do online. This includes, for instance, setting up an official but not overly branded portal to gather and help to amplify the 'user generated' LEGO material from around the Web; and trying to work out how to offer support to real-world and online fan groups without disrupting the self-motivated reason that they had been established in the first place.

## 2. Set no limits on participation

Online platforms should welcome all kinds of contribution and engagement. (There are typically a number of exceptions to this—such as pornography, bullying material and hate speech—but the prohibited list should be simple, rational, and unsurprising). The platform should not try to force particular forms of participation, but should support participants in following their preferences and interests. Platforms should undergird the self-efficacy beliefs of individuals: that is, their sense that they can make a difference in the world, and that this difference can be attributed to their own deliberate actions (Pajares & Urdan, 2006; Schunk & Pajares, 2011). These beliefs are likely to be fostered by platforms which enable users to make their mark, and which are designed to encourage constructive interventions from others.

Setting no limits on participation is not the same as not caring about what happens on a platform. These systems should be carefully designed in order

to encourage creativity and community (some indications of how to do this appear in the following principles). Setting no limits merely means that the creativity of users should not be constrained by pointless or arbitrary limits on what can or can not be done on the platform.

## 3. Celebrate participants, not the platform

In the same way that an overenthusiastic film director can ruin a movie by adding attention-seeking flourishes which detract from the performances and comprehension of the plot, so the designers of online platforms can stifle the self-expression and enthusiasm of users by adding branding, furniture, or other unwanted layers, which get in the way of unconstrained imagination.

Predictably, *Adventure Rock* illustrated this point in a number of ways: for example, by requiring each user to download a massive 230MB stand-alone program, rather than helpfully running in their Web browser; by refusing to allow users to communicate with each other, in spite of the 'virtual world' setting; and by not allowing users to customise their play experience in meaningful ways. In each of these ways, *Adventure Rock* communicated its sense of self-importance, and disregard for its mere players. As I have noted elsewhere (Gauntlett, 2014), the point of online platforms should be to support users to recognise their own potential—'Look what I can do!'—and to witness the power of collaboration—'It gets even better when I do it with others!'. The architecture, design and presentation of *Adventure Rock*, however, tended to suggest the opposite message: 'Look what we have done for you!'. This was reinforced by telling players that they had to unlock a narrative set by the game's producers—a point which leads us to the next principle.

## 4. Support storytelling

Storytelling is a powerful way in which people come to understand the world, understand themselves, and connect with each other (Ricoeur, 1984, 1985, 1988, 1992; see discussion in Gauntlett, 2007: 166–172). This is not necessarily through the telling of lengthy tales to each other, but through snatches of biography, and drops of narrative linking together information to make it meaningful. Blogs, YouTube videos, and even Twitter messages (especially when accumulated over time) can be different forms of storytelling enabled by online platforms. Stories can be deeply expressive, as long as they are told

in the characterful voice of a reflective individual, or the shared experience of a group.

As indicated above, one of the greatest flaws of the BBC *Adventure Rock* service was that it retained the notion of the broadcaster as storyteller; children were invited to 'discover the secret' of *Adventure Rock*, a narrative which, incidentally, had not been created at the time the product was launched. Whilst undoubtedly the invitation to uncover an existing story was appealing to some children, it was not an empowering call to share the fruits of one's own imagination.

In the S4C case, the broadcaster had also taken a thoroughly top-down approach to storytelling in the past, but at least came to be interested in the idea of storytelling as a platform for a diversity of Welsh narratives. At the LEGO Group, the idea of creating stories had always been at the heart of their products, and so the challenge was more to do with how these could be shared and extended in the digital realm—a problem which they have addressed with a number of approaches, some more successful than others. Ultimately perhaps the nicest solution is that which comes from self-organising enthusiasts themselves, as they share LEGO stories online using whichever tools they are comfortable with. These things happen without the company having to set up or organise anything.

## 5. Some gifts, some theatre, some recognition

Creative participation in online spaces is motivated by a range of factors. In previous work I have pulled together research on such motivations (Gauntlett, 2011a), and here highlight three: the sense of giving a kind of gift to others; the notion of the platform as a performative space; and the desire for some kind of recognition.

Since digital items such as videos and written texts can be replicated indefinitely, lacking any exclusivity, they can seem an usual kind of gift. But part of online sharing is, nevertheless, the giving of a gift, which is both the digital object and the careful creative intention which went into that object. Digital platforms should enable participation in this gift economy, where exchange of creative materials, and the prestige which can accompany such sharing, are central (Jenkins, Ford & Green, 2013; Jenkins, 2009; Hyde, 2007).

There is also the sense of a theatre of creativity—users are given a public stage upon which to present their creative selves, or at least an intended impression of such—and usually welcome the opportunity to interact with their

audience. In this theatre, material is presented in order to show off a particular set of interests and concerns, often using a carefully calibrated mix of the professional or formal, and the personal or informal (similar to the patterns of self-presentation on Twitter identified by Marwick & boyd, 2011).

Motivations for sharing online also frequently include a gentle but significant desire for some kind of recognition (Gauntlett, 2011a: 100–1). People like to show their existence and ideas in the theatre, but they often also want this to be *noticed*. This is a legitimate and rational wish to be recognised and accepted as a worthwhile contributor to a community of like-minded people. This can vary between users, of course, and between services: most platforms make contributing users quite visible, and typically organise content around their creator (as in the YouTube 'Channels' which bring together all the content uploaded by a user), but Wikipedia has become massive despite offering almost none of the rewards of recognition. Wikipedia contributions are merely listed by username in the 'History' tab, which is a faceless kind of listing, and which most readers will never look at.

In the cases considered in this chapter, all three organisations could get better at facilitating gift-giving, supporting the theatre of digital creativity, and enabling the presentation of meaningful kinds of recognition for creative participation.

## 6. Online to offline is a continuum

The digital realm is still often seen as a distinct online space, which people occupy in a different way, and separately, from the rest of their lives. However, the rise of social media is also associated with a greater integration of the online and the offline: social tools such as Twitter and Meetup foster connections between people who may then meet up in real life, and sites like Landshare, Ecomodo and Streetbank encourage people to meet and exchange things with their physical neighbours.

Online platforms can be most effective when they lay tracks from everyday interests and enthusiasms through to a set of value-adding tools and an engaging community (Orton-Johnson, 2014). The desires and concerns we have offline are part of who we are online, of course, and the reasons why people like to make and share things in the physical sphere of hands-on craft are strikingly similar to the reasons why people make and share online (Gauntlett, 2011a: 64–108). In the cases discussed in this chapter, the most powerful were those which enabled people to carry their established interests into an interactive

online space—such as the S4C idea to support any kind of Welsh-language media that people wanted to make, because any support for Welsh would be good; and the willingness of LEGO networks to reflect anything and everything that people wanted to build.

## 7. Reinvent learning

Learning has, of course, always occurred across all ages and in varied places, but today there are greater opportunities for informal, self-initiated learning, for people of all ages and across a diverse array of interests, supported in particular by online communities of enthusiasts who are willing to discuss, share ideas, and inspire each other. Innovation in learning is often associated with new technologies, whether at school (Selwyn, 2011; Facer, 2011) or university level (Christensen & Eyring, 2011; DeMillo, 2011; Krause & Lowe, 2014), but the particular opportunity here is to engage people's interest in learning away from established learning institutions. The internet gives people access to networks of other people who share their interests, dispersed geographically, and so individuals can support, inspire and learn from others, where previously this was difficult. The ubiquity of online social networks, regularly accessed via mobile devices as well as other computers, means that informal learning can be embedded in everyday life.

Well before the internet became accessible and popular, radical writers on education and learning, such as John Holt (1964, 1967) and Ivan Illich (1971, 1973), argued that learning is a natural process which flourishes when learners can follow their own interests, and explore whatever engages their curiosity. They suggested that a planned system of teaching destroys the natural joy of learning, and therefore that we should prefer informal learning that is lightweight, flexible, and spontaneous, and which involves processes where learners can make their own meanings and express themselves through action. Today, online platforms make these ideals much more possible (although the supportive quality of online communities cannot be guaranteed).

In line with the other principles, people should be enabled to follow their own interests and enthusiasms, not have their learning tasks determined for them; should be able to engage on a straightforward, unfussy platform with other learners; be able to exchange knowledge in a space where they can make visible, authored contributions and be recognised for them; and be supported to connect this learning with everyday offline life.

## 8. Foster genuine communities

The term 'community' is used quite freely to describe online gatherings of users, but a collection of people with an interest in common do not necessarily have the bonds of mutual respect, trust and support which are central to the more careful use of that term. Online platforms should be designed so that users are encouraged to give feedback to others, and to form bonds with identifiable users over time. This is not a process which happens at random—platforms can be *designed* to make supportive conversations more likely.

Clay Shirky has observed that the comments posted in response to You-Tube videos are often awful (although it varies by type of video, and therefore typical motivation of viewer), but that other sites are able to host civil, productive conversations amongst people with common interests (he cites programmers on StackOverflow, crafters on Etsy and Ravelry, and mathematicians on Polymath, amongst others). The difference between the constructive and the negative conversations can be designed for if we have an awareness of a number of variables, which include 'the scale of the audience, the commitment of the participants to each other and to shared enterprise, and the willingness and ability of the participants police violations' (Shirky, 2011). This does not mean, of course, that fostering an encouraging and supportive online community is easy (see also Gauntlett & Thomsen, 2013).

# Conclusion

From a review of projects with three different organisations, we have seen that there is no established way of running collaborations between academia and industry, and few common expectations or assumptions. The most successful are those which involve relationships and conversations which go deeply into the organisation and its future plans, and enable the partners to generate ideas together, rather than being mere 'evaluation' of things that have already been designed. There should be an assumption that the partners can learn from each other in a range of ways—not that expertise or credibility should be transposed from one place to another.

The eight principles for the design of online platforms for creativity, which follow from experience of and reflection upon the collaborative projects, show that such platforms should embrace and work with all the kinds of participation that people wish to engage in; should enable identifiable, authored contributions which can be recognised and responded to by others; and seek to

foster supportive conversations within communities of enthusiasts or people with shared concerns. Support for storytelling, and a flow between everyday offline life and the online sphere, is also helpful. In these ways we can hope to create digital environments which enable people to create, share and learn in new ways. The value of the network is always central: producers of a service have to trust that participants in their community can bring lively, insightful contributions which, in turn, make the network stronger and more creative.

# THE LEGO SYSTEM AS A TOOL FOR THINKING, CREATIVITY, AND CHANGING THE WORLD

This chapter looks at LEGO as a tool for supporting creative thinking, developing creative cultures, and contributing to processes which might make a difference in how the world works. My thoughts about these ambitious themes are not plucked from nowhere, and nor are they those of a passive observer, but they might be treated cautiously for a different reason, because they draw upon my experience of several years of close collaboration with the LEGO Group and the LEGO Foundation in Billund, Denmark. Some information about those activities appears in the previous chapter. More briefly: from 2005, I worked with the LEGO Group on the development of the consultancy process, LEGO Serious Play, and since 2008, I have worked with the LEGO Learning Institute and the LEGO Foundation exploring play, creativity and learning.

In this chapter I will begin by considering the LEGO System, and its reach as a cultural system. Then I will look at LEGO as a tool to support thinking and collaboration. I will introduce a model of creative cultures, which will be applied to LEGO communities, and then maker culture more generally, and consider how individual imagination and collaborative creativity can work together. Finally I will consider some ways in which LEGO products and communities might be said—as in the title of this chapter—to be 'changing the world'.

# The LEGO System

The LEGO System, as commonly understood, refers to the idea that any LEGO element, or any LEGO set, is not an isolated or complete object, but comes with the potential, and the promise, that it is part of a much larger whole. The system of interconnecting studs and tubes, patented by the LEGO Group in 1958, means that any LEGO object can be connected with others and almost endlessly extended. The System is good for users, since the value of their LEGO collection is increased as it grows—because they are able to do more diverse and more interesting things—and obviously this works well for the company too, providing customers with a rational motivation to make more purchases from the same range of products.

It was Godfred Kirk Christiansen, the third son of LEGO founder Ole Kirk Christiansen, who developed the idea of a system of play, rather than one-off toy products. The idea had been suggested to him by a buyer from Copenhagen's department store, Magasin du Nord, on a North Sea ferry, as they made their way to London's Toy Fair in January 1954 (Robertson & Breen, 2013). Captivated by the idea of a system, Godfred spent 'several weeks' working out the attributes of the system, arriving at six core features (ibid.):

1. Limited in size without setting limitations for imagination
2. Affordable
3. Simple, durable, and offer rich variations
4. For girls, for boys, fun for every age
5. A classic among toys, without the need of renewal
6. Easy to distribute.

These features refer to the product, but also suggest a human dimension which is not contained in the bricks themselves, with notions such as 'imagination', 'classic' and 'fun'. Inevitably, of course, the system is not just about objects but about what humans *do* with the objects. But I would argue that we can take this much further. Today, it seems fair to say that LEGO bricks are just one part of a complex and dynamic set of relationships, where LEGO products and the LEGO Group are clearly central, but are only as important as the numerous communities of LEGO users and fans, of all ages, and the broader elements of the ecosystem including parents, educators, retailers, and the many cultural contexts in which LEGO things are to be found. Flowing around the relationships in this system are the shared meanings and collective ethos fostered by use of LEGO products. Research by Yun Mi

Antorini and colleagues (Antorini, Muñiz & Askildsen, 2012; Antorini & Muñiz, 2013; Taillard & Antorini, 2013) has explicated the ways in which an ecosystem has developed around LEGO products—and in a sense LEGO ideals—in which the significant actors include all users, young and old, but especially LEGO fans and their communities; parents, educators, retailers, licensing partners, journalists; and of course the LEGO Group itself. The LEGO System is a system which includes all of these materials, and people, and online networks.

Furthermore, the LEGO System is built around ideas and principles, in a way that other creative or construction materials, such as modelling clay, are not. If the heart of the LEGO System is the notion that 'everything connects to everything else', which begins with the studs and tubes system, we can see that this then extends out across the broadly-understood system to embody a democratic philosophy of things fitting together, and empowering people to build. This is found in the values that people associate with LEGO products— an ethic of thoughtfulness, caring and playing together (Baichtal & Meno, 2011). This philosophy also accounts for the strong relationships between LEGO fans and the broader 'maker culture', discussed below. These values and networks are unusual—most other tools or toys or creative materials cannot claim them (perhaps the community of Linux developers comes closest, but is rather different)—so this notion of a LEGO System is actually both meaningful and distinctive.

In the very first of the LEGO Learning Institute projects that I was involved with, *Defining Systematic Creativity*, written with Cecilia Weckstrom and Edith Ackermann (2009), we set out a 10-point description of the LEGO system, which begins with physical attributes of LEGO bricks and pieces, but broadens out to include the System's ethos, which is just as important, although less tangible.

1. *An interconnecting set of parts:* Connections come easily and sometimes in unexpected ways.
2. *A low entry level for skills:* So that anyone can pick up LEGO bricks and make something satisfactory.
3. *A medium for mastery:* A developed level of expertise is also rewarded as the system can be used to create both very simple and very complex constructions.
4. *The ability to create something where previously there was nothing:* Imagination coupled with the lack of need for preparation and planning: as they say in LEGO Serious Play, 'If you start building, it will come'.

5. *An open system with infinite possibilities:* It can grow in all directions and the parts can be combined in limitless ways.
6. *A belief in the potential of children and adults and their natural imagination:* Anyone can make and express whatever they want to, through the system.
7. *A belief in the value of creative play:* A respect for play as a powerful vehicle for learning and exploration.
8. *A supportive environment:* Different ideas can be tried out and experimented with, with no negative consequences. On the contrary, it is common that one good idea leads to another.
9. *The LEGO System grows with the person:* From the youngest child to the adult user.
10. *The LEGO System also grows beyond the person:* At all levels of engagement with LEGO products, from Duplo to the world of the AFOL [Adult Fan of LEGO], LEGO bricks are a social tool, fostering connection and collaboration.

This ten-point list proved to be really valuable for later projects. When we produced later studies such as *The Future of Play* (Gauntlett et al., 2011, *The Future of Learning* (Gauntlett et al., 2012), and *Cultures of Creativity* (Gauntlett & Thomsen, 2013), the list offered a clear path to link our findings back to the LEGO system.

A number of these points reflect the notion of 'low floor, high ceiling, and wide walls' (Resnick & Silverman, 2005). The LEGO system has a low floor, which means it is easy for newcomers to get started, whilst the high ceiling means that more experienced users can work on increasingly complex projects. Most important of all are the wide walls, which mean that creativity and imagination can take a project in innumerable directions.

Our ten-point list takes this further by including the social—going 'beyond the person' to foster 'connection and collaboration'. But really it doesn't go far enough. The greatest strength of LEGO today is its place in networks of people with shared passions and values.

LEGO before the internet was rather like computers themselves before the internet. In the 1980s, we had home computers and had great fun tinkering with them and programming. They weren't connected to the internet—most people had not really heard about the internet at that point. So we didn't know what we were missing—I mean, we literally had no idea that we might be missing anything. Today, of course, the idea of a computer that doesn't link you to the internet is inconceivable. Similarly, LEGO toys have always

been great fun, and a box of LEGO has always been a self-contained source of pleasure. But today, it's hard to think of LEGO without its supportive universe of online LEGO enthusiasts. Over the past 15 years or so, the whole idea of LEGO has been fantastically boosted by its visible online interconnections with cultures of creativity, learning, and support.

# A tool for thinking

Before we proceed to discuss the LEGO System as an expansive and thriving culture, this section pauses at the individual and small-group level to consider LEGO as a tool for thinking. Clearly, LEGO bricks offer huge opportunities for imaginative play, which is what children normally do with them, and can be used to build cool or complex models of things—vehicles, buildings, or whatever—or they can form the basis for machines and robots, which is often the adult domain. Here, though, our focus is on using LEGO bricks to support the representation of ideas, and the organisation of thinking.

As the psychologist and cognitive neuroscientist Merlin Donald (2001) has shown, a central component of human evolution has been our ability to make tools and to externalise thoughts. Being able to communicate and store ideas, through innovations such as drawing and writing, has been a crucial plank in evolution. The individual human brain may be remarkable, but it becomes much more powerful through the use of tools which enable us to set out and review our thoughts and ideas. It can be difficult to hold all the parts of a complex argument or situation in mind at once, but once thoughts are put into 'external storage'—such as writing, a diagram, or a model—they can be shared, developed and worked on. Donald writes that 'We can arrange ideas in the external memory field'—by which he means, in the physical realm, when we have represented them somehow—'where they can be examined and subjected to classification, comparison, and experimentation'. He continues:

> In this way, externally displayed thoughts can be assembled into complex arguments much more easily than they can in biological memory. Images displayed in this field are vivid and enduring, unlike the fleeting ghosts of imagination. This enables us to see them clearly, play with them, and craft them into finished products, to a level of refinement that is impossible for an unaided brain. (Donald, 2001: 309)

It was this idea, that abstract meanings, feelings or concepts could be physically represented, and then manipulated and tinkered with, that was embraced within LEGO Serious Play.

LEGO Serious Play was a consultancy process developed by the LEGO Group, from the mid-1990s, and was an activity for groups of adults, guided by a facilitator, in which participants would build metaphorical models using LEGO bricks. The models would typically represent their experiences of activities, structures and communications within their organisations, and then, having externalised these things, by building them in LEGO, they would go on to combine and review their built meanings, and then to build ideas for initiatives or strategies, in response to this construction. Unusually, LEGO Serious Play invited people to build in *metaphors*—everything in metaphors. So, for example, a school would not be constructed as a building with doors and windows, but might be represented with interconnected metaphors such as an owl representing knowledge, flowers reflecting emotional support, a tower for leadership, and a staircase representing personal growth.

The central idea of LEGO Serious Play is not uniquely tied to business consultancy. It can be used to represent all kinds of experiences and feelings, and responses to things. From 2005, I worked with the LEGO Group on researching some aspects of this process, and I developed it as a social-science research tool. (My project which used LEGO Serious Play to explore how people thought about their own identities was published as *Creative Explorations* (Gauntlett, 2007)). In 2007–08, Anna-Sophie Trolle Terkelsen, a concept developer in LEGO Education, took the principles of LEGO Serious Play and created a self-facilitated version, which dispensed with much of the apparatus that had been built up around LEGO Serious Play. Her adaptation had the appearance of a board game—although it was not exactly a *game* as such—which prompted participants to move through a sequence of activities, picking up cards that would tell them what to do next. Different sets of cards could be used to prompt people to explore different concepts, themes or issues. This innovation made LEGO Serious Play much more portable and less labour-intensive. Others, including myself, also modified the process in different ways—often in response to the previously-established 'prescribed' version of LEGO Serious Play, which made heavy demands in terms of materials (specific collections of LEGO bricks in large boxes), time (one or two day sessions), and people (a fully trained facilitator required for every session). When Trolle Terkelsen and I were asked to produce the 'open source' release of LEGO Serious Play in 2010—the LEGO Group had basically decided not to continue trying to make money from the process in any direct way, and was happy to release it 'into the wild' instead—we included a lot of the very good and thoughtful original scripting and etiquette of LEGO Serious Play sessions

from the original manuals, but sought to balance this with a more flexible and 'lightweight' approach to its implementation.

In any case, these details about the complicated life of LEGO Serious Play are less important than the very different-to-normal use of LEGO bricks which it demonstrated. The process showed that LEGO could be used to represent abstract experiences, feelings or ideas—and then could be used to think through the implications of those things, and to build alternatives or solutions to what was shown, either as an individual process, or in groups (Gauntlett, 2007). Having a physical *thing*—representing, say, an organisation, or a relationship, or a challenging situation—means that its creator and others can examine, review and discuss the concerns that are represented, often raising provocative issues ("Wouldn't you expect [x] to be closer to [y]?"—or "The whole thing seems to be dominated by [z], and there is very little substance when you look round the back"—or whatever).

The physical building of such non-physical phenomena means that LEGO bricks can be a genuinely helpful tool for thinking, and is rather distinct from what you could do with other materials. Of course, it might seem that a similar process could be conducted with modelling clay, or pen and paper, but, having tried such alternatives, I can say that they are less pleasing and much less efficient for most participants. With LEGO, most people can assemble a range of meanings, and revise and combine them, rather easily. With other materials, I found, participants were much more anxious about their abilities—embarrassed that they could 'not draw' or could not make their model 'look right'— and everything was much slower, with single representations taking a long time to produce (Gauntlett, 2007, 2008, 2009b). So although LEGO is not wholly *unique* as a tool for representing ideas and concepts, and collaborating on their development, it certainly has affordances which make it significantly more useful than anything else I've seen.

## A cultural model—applied to LEGO cultures

LEGO Serious Play is, of course, a little-known fragment of the LEGO universe. The culture of LEGO products and users is broad and diverse. In the LEGO Foundation *Cultures of Creativity* report (Gauntlett & Thomsen, 2013), we adapted a model of culture which was proposed by Anne Scott Sørensen et al. (2010) as a way of thinking about creative cultures. (The LEGO Foundation does work around the themes of play, learning and creativity—clearly, very 'LEGO' themes—but it is independent from the company, and is not

primarily concerned with LEGO products). The model can be useful for thinking about the culture of LEGO, and LEGO within cultures, as well as creative cultures more generally.[1]

The model by Anne Scott Sørensen and colleagues, which we adapted, had itself drawn upon a number of previous models or perspectives on culture. This model recognises that culture always signifies both a context for experiences, and actual experiences themselves. So on the one hand, culture is a given—the culture, largely made by others, which we inhabit—and on the other hand, culture is being created and recreated, right now, through individual and social meaning-making and experiences, including our own. To put it another way, the model shows culture both as the already-existing site within which people are creative, and simultaneously as the 'live' space which influences, and is influenced by, their creativity.

The model suggests that culture is a system through which people build meanings, and develop community, through the four dimensions of *having, doing, being* and *knowing*. The creative mindset is supported when there are stimulating environments and resources (*having*), when there is a lot of inspirational activity and the engaging support of peers and mentors (*doing*), when there is an ethos which supports the passions of makers (*being*), and where there is a solid body of expertise and knowledge, and support for learning (*knowing*). These dimensions are all parts of culture, continuously in play together, and so they should not be considered as separate things. These four dimensions are driven by *playing, sharing, making* and *thinking*—the active processes through which people learn and form meanings together—and so these processes appear in between the four dimensions in our diagram (see figure 7.1), driving this windmill of continuous cultural creation.

If we consider the model in relation to the LEGO System itself, we can see that it maps on quite straightforwardly—underlining the sense in which the LEGO System is a kind of culture in its own right. The *having* dimension is about actual things, and so has the most straightforward connection to LEGO products. A culture is more likely to thrive if it has democratic, easy-to-use tools with which cultural meanings and understandings can be built and shared. Looking beyond the present—beyond just describing how things are—this dimension encourages us to consider how products and tools might be optimised, so that they could maximise opportunities to play, make

---

1   This section of text draws on some of the material that I wrote for the *Cultures of Creativity* report (Gauntlett & Thomsen, 2013). Reused/remixed by kind permission of The LEGO Foundation.

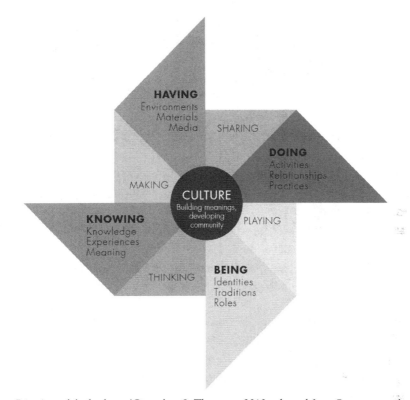

Figure 7.1. A model of culture (Gauntlett & Thomsen, 2013, adapted from Sørensen et al., 2010).

and share; and how we might enhance the environments, offline and online, where people might do these things—such as kindergartens, schools, libraries, art galleries, science and history museums, and cultural centres.

The *doing* dimension concerns the relationships and practices which are the lifeblood of a culture. In terms of LEGO culture, children are typically eager to exchange inspiration and stories around their creations, and this is supported by the LEGO.com website, YouTube videos, the LEGO Club magazine, LEGO's collaborations with museums, and so on. Communication and networks are vital to the *doing* dimension—especially for Adult Fans of LEGO (AFOLs), whose networks have exploded with the rise of the internet (and are typically independent of the LEGO Group). These cultures really take off when people are *doing* things together, sharing ideas and inspiration, and learning from one another.

The *being* dimension concerns the rituals, sentimental practices, and group characteristics and identifiers which bind together a culture. In LEGO culture,

this can refer to the collective practices of LEGO users and fans, and the general ethos associated with the company. As well as being helped by positive actions, this binding ethos could be disrupted by miscalculations—such as might occur if the major release *The LEGO Movie* (2014) had represented LEGO in an underwhelming or trivial way (which it didn't), or if a licensing tie-in were to associate LEGO with unexpectedly violent narratives (which the *Teenage Mutant Ninja Turtles* line perhaps does). The positive ethos can be sustained through the more timeless emphasis on the joy of building, which is supported by LEGO-affiliated products (such as books and the *Movie*), and also by the independent online communities of LEGO fans, who support and inspire each other. Research has shown that members of online maker communities like to both give and receive support (Kuznetsov & Paulos, 2010), emphasising an ethos of 'open sharing, learning, and creativity' rather than profit or self-promotion. This mutual sharing also helps to foster the collective identity of LEGO enthusiasts.

The *knowing* dimension highlights the knowledge and shared meanings that support a culture. In the case of LEGO cultures this dimension is well integrated with *doing* and *being*, which as we have seen, both involve networks of knowledge-sharing and mutual support. As LEGO cultures tend to be friendly and non-competitive, knowledge about products and techniques tends to be freely shared. Indeed, LEGO fans are often keen to share their achievements and passions with others, which drives the knowledge exchange within communities. As well as the active exchange of ideas, LEGO culture rests on a substantial body of more permanent materials, such as the several non-fiction books on LEGO building, techniques, and the company and its products, and huge online archives of LEGO history and innovative building methods, and vast inspiring collections of LEGO 'My Own Creation' models (MOCs) built by enthusiasts around numerous fictional and real-life themes.

In short, then, the dimensions of *having, doing, being* and *knowing* describe the forces which bind, sustain and grow the LEGO culture. The culture is continuously made and re-made, normally through the small actions which collectively make up the whole. Sometimes there is a bigger, more potentially disruptive intervention, such as the 2014 release of *The LEGO Movie*—mentioned above—which was a notable event in mainstream popular culture. Fans of LEGO were concerned that the movie, if misjudged, might be a corny cash-in, and perhaps generate negative associations with their cherished System. Of course, this concern—which I had myself—overlooked the fact that the LEGO Group typically take very good care of their brand, and could be expected to insist that it be a good reflection of LEGO values. Thankfully

the *Movie* paid due regard to the *having, doing, being* and *knowing*—the special products, relationships, sentiments and knowledge—that are associated with LEGO cultures.

## The cultural model—applied more broadly

The model of creative cultures described above works just as well for the 'maker movement', and communities of craft-making people and designers. I described aspects of this culture in *Making is Connecting* (Gauntlett, 2011a), with an evident particular affection for the arts and crafts community, and for digital media makers, such as bloggers and YouTube video makers. There is a 2013 book by Mark Hatch called *The Maker Movement Manifesto*, a title which struck me as a bit presumptuous, not least of all because Hatch is the CEO of TechShop—as it boasts on the front cover—and so might be expected to represent the interests of an engineering, technology and 3D printing sort of business better than the whole maker community (or communities). To be fair, TechShop seems like a nice idea—a membership organisation giving people access to workshops with tools and equipment to build their own projects. And, actually, Hatch does a pretty good job of representing broad maker-culture interests. The short version of his *Manifesto* (Hatch, 2013: 1–2) appears under nine keyword headings: 'make', 'share', 'give', 'learn', 'tool up', 'play', 'participate', 'support', and 'change'. His assertions under these headings are thankfully open and inclusive, and would generally apply just as well to lambswool cardigan knitters as to metal robot makers. For example, to pick just three of them:

> MAKE: Making is fundamental to what it means to be human. We must make, create, and express ourselves to feel whole. There is something unique about making physical things. These things are like little pieces of us and seem to embody portions of our souls.

> GIVE: There are few things more selfless and satisfying than giving away something you have made. The act of making puts a small piece of you in the object. Giving that to someone else is like giving someone a small piece of yourself. Such things are often the most cherished items we possess.

> SUPPORT: This is a movement, and it requires emotional, intellectual, financial, political, and institutional support. The best hope for improving the world is us, and we are responsible for making a better future. (Hatch, 2013: 1–2)

Hatch's nine keywords can be mapped quite easily onto our model of creative cultures (Fig. 7.1, above). Since all of the elements overlap and are part of

a whole, it doesn't make much sense to treat them separately. But we can see that our 'having' dimension would include 'tool up' and 'support'; 'doing' would include 'make', 'share', 'play', and 'participate'; 'being' would include 'give' and 'change'; and 'knowing' would include 'learn', and 'support' again. In fact most of them go with most of them.

So we can see that this model and this manifesto mesh well together—but to what end? Talk about creative cultures is full of these pleasant, kind words—'share', 'participate', 'support', and so on—but what is their significance? The answer is that making things, being creative within a culture, and supporting others to be so, are essential to the health of a society (see Gauntlett, 2011a). These activities might have attractive outcomes, and be fun to do, but their value is greater than these pleasures. Everyday creativity and the do-it-yourself spirit are vital and culturally necessary—otherwise we are a 'read only' society, a culture of consumers.

Ivan Illich, the philosopher most famous in the 1970s, makes a powerful case for the do-it-yourself approach to life and culture in his book *Tools for Conviviality* (1973). He outlines a distinction between 'industrial' tools, which are one-size-fits-all things that only convey the identity of the organisation that produced them, and 'convivial' tools, which are flexible to different people's needs, enable individual self-expression, and encourage conversation. Industrial tools often arrive as pleasant conveniences, but foster a terrible sickness within our cultures:

> Society can be destroyed when further growth of mass production renders the milieu hostile, when it extinguishes the free use of the natural abilities of society's members, when it isolates people from each other and locks them into a man-made shell ... Corporate endeavors which thus threaten society cannot be tolerated. At this point it becomes irrelevant whether an enterprise is nominally owned by individuals, corporations, or the state, because no form of management can make such fundamental destruction serve a social purpose. (Illich, 1973: xi)

Illich makes a powerful argument that people need to be able to shape their own environments, make their own stuff, and express themselves, rather than simply purchasing readymade alternatives to these convivial relations. Through building the meaningful materials of everyday life, we learn that we can make a difference to the bigger picture as well.

> Industrial innovations [—top-down, one-way, one-size-fits-all offerings—] are planned, trivial, and conservative. The renewal of convivial tools would be as unpredictable, creative, and lively as the people who use them. (Illich, 1973: 75)

The significance of LEGO cultures, and the maker movement, are that they operate at the convivial level, enabling people to create, communicate and connect. These might be supported by certain kinds of *industry*—such as The LEGO Group, or 3D printer companies, or craft retailers—but these are not (or should not be) doing the 'industrial'-scale imposition of meanings and identities that Illich deplores.

## Uniting individual and collaborative creativity

In *The LEGO Movie*, there is a tension between the celebration of individual creative imagination, and its other message about the importance of collaboration, working and playing together. This is nothing new—it is a tension we often come across in the discussion of creativity. It appears in Illich as well. *The LEGO Movie* nicely reflects the fact—supported by much creativity research literature—that distinctive and novel ideas arise when individuals feel uninhibited, encouraged, and supported (see, for example, Lanier, 2010, 2013; Csikszentmihalyi, 2002; Claxton, 2008). Personally I was quite moved when, in the middle of the film, Vitruvius tells Emmet: 'Don't worry about what the others are doing. You must embrace what is special about you'.[2]

On the other hand, individualism can go too far, of course, and the film also indicates that play and collaboration between people can often spark the best ideas, which is also a reality supported by a lot of research (for example, Sawyer, 2012; Kaufman & Sternberg, 2010; Csikszentmihalyi, 1997). The tension is not entirely resolved—which may not matter too much in a film, where we can accept both points. But if we seek a cultural theory of creativity, this contradiction presents a problem for our argument, and must be resolved.

A solution is offered by Gerhard Fischer, another of the experts we collaborated with for the LEGO Foundation *Cultures of Creativity* project. Fischer argues that individual creativity and collaborative making can be combined:

> Our work [in the Center for Lifelong Learning and Design] is grounded in the basic belief that there is an 'and' and not a 'versus' relationship between individual and social creativity ... By integrating individual and social creativity, support will be provided not only for reflective practitioners but also for reflective communities. (Fischer, 2013: 25)

---

2    A clip which contains this bit can be seen at: http://youtu.be/9VeUoVKiyhE

People are all different, and have different backgrounds, and different skills. This doesn't mean that we should leave them all to do creative things separately, though, Fischer suggests. On the contrary, these differences are an 'opportunity' to develop new insights and new ideas. He explains:

> The challenge to foster and nurture cultures of creativity is often not to reduce heterogeneity and specialization, but to support it, manage it, and integrate it by finding ways to build bridges between local knowledge and by exploiting conceptual collisions and breakdowns as sources for innovation. (Fischer, 2013: 26)

The most important thing for cultures of creativity is not the ability to access or learn *existing* knowledge, it is having opportunities to make new knowledge *together*, addressing issues of shared concern. The 'designer mindset' is fostered not by seeking and finding knowledge that is 'out there', but through the creation of new knowledge. Access to information—often cited as a key triumph of the internet—is 'a very limiting concept,' Fischer says. What we really need are environments and education systems that cultivate the development of the designer mindset 'by creating habits and tools that help people become empowered and willing to actively contribute to the design of their lives and communities' (Fischer, 2013: 27).

Harnessing the power of people working together on a shared enterprise is ultimately more valuable than well-informed, imaginative individuals doing clever things. But we can have both: people can be supported to be individually creative, and then these insights and achievements can be integrated with the insights of others in the next, collaborative step. This is what happens in LEGO Serious Play, where participants build individual models first, before combining their meanings into a shared model at a later stage; and it is also, really, what happens on Wikipedia, and on YouTube, where individuals plant flowers that become part of a vast and flourishing garden.

## ... And changing the world

This brings us to the transformative cultural power of LEGO. I could hedge around this bold notion by saying 'Of course, LEGO products are children's toys, and you would not really expect them to be world-changing phenomena ...', but that would not really be quite right, because actually LEGO products *are* intended to be world-changing phenomena—in my experience that is absolutely what the people at LEGO wish for their products and for their business. By fostering creative play and imagination in children, they

hope to contribute to a inventive, thoughtful society. The LEGO Group's stated company mission is to 'Inspire and develop the builders of tomorrow,' and in my experience, they definitely mean it.

That is not to suggest that the LEGO Group sits outside of capitalist business models as a purely altruistic, public-service organisation—but it does indicate that certain companies can be both money-making and socially useful. Indeed, the business book entitled *Brick by Brick: How LEGO Rewrote the Rules of Innovation and Conquered the Global Toy Industry* (Robertson & Breen, 2013) is very much the story of how the LEGO Group almost collapsed (around 2002–03) when it had diversified too far, and was producing toys and ventures which strayed away from the LEGO System and principles; and then how it turned the corner to be the incredibly successful business it is today, by focusing on the core LEGO identity, the joy of building, and the motto 'Only the best is good enough' [*Det bedste er ikke for godt*]—the phrase which Godtfred Kirk Christiansen carved and put up in his father's workshop in 1936, at the age of 16.

As well as feeding children's imaginations, I believe there are (at least) three central ways in which LEGO products and cultures contribute to a more creative and hands-on orientation to the world, potentially making it a better place:

- *Everyone can make something:* Building with LEGO is quick and straightforward for most people. Of course, some people become much more skilful over time (as we saw near the start of this chapter: 'low floor, high ceiling, and wide walls'). But LEGO building helps people step into the world of making, and this is a vital shift in terms of a person's sense of self in the world—being a creator, not just a consumer. These small steps are significant (see chapter 9) and contribute to a necessary shift in our culture towards a greater sense of creative ownership, and engagement with our environment.

- *Remaking and rebuilding:* LEGO play builds the sense in which things can be constructed, deconstructed, reviewed and changed, not simply by thinking about them, but by actually making them and changing them. The notion of rapid prototyping, foregrounded by IDEO and other design companies, has grown more influential in recent years (Coughlan, Fulton Suri & Canales, 2007; Brown, 2009), but people have been doing it with LEGO bricks for decades. More generally, LEGO creativity fosters familiarity with making and construction, and the sense of objects as things that are made, which leads to the sense that things can be made differently—an optimistic approach to change.

- *Supporting and sharing:* The LEGO ecosystem, as mentioned above, includes extensive networks of users eager to learn and exchange knowledge and inspiration. The striking phenomenon here is not produced by The LEGO Group itself, but flows from the self-initiated activity of LEGO enthusiasts (lightly supported by the company, which seeks to support but not to interfere). The networks of peer support and knowledge-sharing in LEGO communities serve as a model for other spheres (Antorini, Muñiz & Askildsen, 2012; Antorini & Muñiz, 2013), such as academic networks—where 'open access' principles have been variously embraced and rejected (Suber, 2012; Fitzpatrick, 2011)—and in the design community. The excellent anthology *Open Design Now* (Van Abel et al., 2011) shows how socially valuable design and innovations are generated through open sharing and collaborative practices, such as those which have been adopted—in a quiet, relatively unplanned, but powerful way—by LEGO users online.

Clearly, in conclusion, LEGO is not 'just a toy'; the LEGO System describes a complex web of products, resources, people and knowledge, which interact in powerful ways. Of course, these are things which have a place within a wider culture, and so, even if LEGO could 'change the world', it couldn't do it on its own. Nevertheless, whilst there is absolutely no need to apologise for the purely fun dimension of LEGO play, I hope to have demonstrated that it connects with some valuable social movements—such as maker culture and open knowledge sharing—and can help to build a mindset which is creative, optimistic, and willing to try out new things. It is this orientation that will be needed if we are to escape the gravitational pull of relatively passive media consumption and a purely 'consumer' approach to the world, which drag us towards ever more serious environmental challenges. Instead we can build a more energetic, do-it-yourself culture, where nature and human creativity can thrive together.

# PART 4

# MORE THINKING ABOUT MAKING

# · 8 ·

# CREATIVITY AND DIGITAL INNOVATION

This chapter is about how the internet can be an enabler and driver of people's creativity and innovation. Of course, people have been creative, and sought to do things in new ways, throughout history. To restate an obvious point, the digital world does not 'cause' more of that activity to happen, but it does *enable* people to make and—in particular—connect, in efficient and diverse ways which were not previously possible. Being able to be in contact with people from all around the world, who share your interests, and exchange creative material with them in order to inspire and generate new ideas, may have been *sort-of* possible before the late twentieth century, but the process was undeniably slow and difficult. The difference that high-speed internet connections make is not just a boost in convenience of communication, but represents a significant transformation in how those human beings who are online can share, interact and collaborate.

In this chapter I will use Clayton Christensen's model of disruptive innovation (Christensen, 1997; Dyer, Gregersen, & Christensen, 2011), or a version of it, to look at some ways in which the internet—or rather, people's uses of the internet—have disrupted both media industry practices and academic

research. Christensen's model has become well-known,[1] but perhaps more to business readers and scholars than to media and communications researchers. Put simply, the model describes the situation in any market where existing successful operators are liable to become complacent, and then can be surprisingly destroyed and replaced by feisty competitors who come in at the bottom end of the market—typically with rougher, cheaper, but more creative offerings. The incumbents have become used to their dominant position, and usually seek to incrementally improve their offerings to retain the loyalty of top-end 'power users', who are typically their most vocal customers. The young challengers do not look like a threat at first, because what they offer appears to be cheap and insubstantial. Soon, though, the innovative newcomer is able to drive up the quality of their offering and so become attractive to the large middle-ground of consumers, who may well like the simpler, affordable new thing more than the now overcomplicated, more expensive established offering.

The 'market' in this model would not necessarily have to be a commercial market but could refer to, say, the marketplace of ideas, or can be used a little more metaphorically to understand other spheres. For instance, the US administration of President Clinton used the model to interpret the shift in their antagonists from the Soviet empire—grand, established, and well resourced—to terrorist groups which were much more cheap, nimble, and unpredictable (Christensen, Allworth, & Dillon, 2012: 13). In this chapter I will look at three cases:

- Case #1: In which the everyday creativity of users disrupts the traditional professional media ecosystem;
- Case #2: In which the creative understanding of the potential of the internet disrupts the traditional critical approach of media and communications studies;
- Case #3: In which the everyday creative uses of online tools disrupt the dominant position of professional arts and humanities scholars.

To make it clear who is disrupting what, here:

- In case #1, 'ordinary people' disrupt professional media practices;

---

1    For instance, the *Thinkers 50* ranked Christensen at #1 in its 2011 global ranking of management thinkers (http://www.thinkers50.com).

- In case #2, academics who think carefully about the implications of the internet, and understand the technologies, disrupt the complacency and nostalgia of those who do not;
- In case #3, 'ordinary people' disrupt professional academic practices.

Of course these are general phenomena in society, rather than more closed 'case studies'. I here offer some evidence of their existence, and reflections on their implications.

## Case #1: Everyday creativity

This first case, in which the everyday creativity of users disrupts the traditional professional media ecosystem, is relatively uncontroversial, in that most commentators would accept that this has indeed happened, although there will be disagreement about the extent of this disruption. For instance, my book *Making is Connecting* (Gauntlett, 2011a) discusses this shift in some depth, and argues that it is significant, and indeed fruitful—or *potentially* very fruitful—for individuals, society, culture, and learning. But other scholars (such as Curran, Fenton and Freedman, 2012, discussed below; Miller, 2009) have insisted that the traditional or new-but-big media industries remain sufficiently powerful that we don't need to spend much time thinking about non-professional creators.

The argument here is not that home-made media products by everyday folk have *replaced* the professional material in most people's selection of things to read, watch and listen to on an average day. To date, that has not occurred. But this case is about how media made by non-professional people—produced by enthusiasts, typically, just because they want to—has *disrupted* the media *ecosystem*, which it clearly has.

The notion of media as an ecosystem has its roots in Neil Postman (1982, 1985), building on the work of Harold Innis and Marshall McLuhan, and has been helpfully developed by John Naughton (2006, 2012). In a natural ecosystem, each of the elements has a kind of dependency on each of the others, so that a change in one element—such as a decline in the amount of sunlight reaching a plant, or a disease affecting a specific animal—is not simply of consequence to that particular plant or animal but has knock-on effects throughout the system. So in media terms, the arrival of widely-available internet access, for instance, has numerous direct and indirect impacts on all of the other inhabitants of the complex ecosystem, including those that think they

haven't got anything to do with the internet. For instance, it offers new ways for people to spend their time, taking away from how they spent it before; it changes how media products can be distributed, by producers themselves, and by fans and by 'pirates'; it brings a more targeted model for advertisers, affecting the economy of traditional publications and broadcasters; it raises expectations about levels of 'interactivity' offered by media products; and so on.

Online creative productions by non-professional people have certainly emerged on a significant scale. For video material, for instance, we can look at YouTube, where roughly half of all videos are 'user generated,' rather than professional material.[2] Launched in 2005, YouTube quickly became very popular, hosting a vast array of videos; after less than seven years, YouTube was streaming 4 billion online videos every day, and 60 hours of video were uploaded to YouTube every minute (Oreskovic, 2012). In the UK, more than half of the adult population have uploaded video or photos to the internet (Ofcom, 2014: 39).

Statistics for the number of blogs in the world are often exaggerated by quoting how many blog accounts have been *started*, rather than how many are being actively used and updated. Because it is difficult to count numbers of dead versus active blogs, reliable figures are difficult to come by. A solution is to look at the numbers of actual blog *posts* being created. In September 2014, according to WordPress.com, which is just one of several blogging platforms, its users created 43.7 million new posts and 58.8 million new comments per month. If we consider the place of WordPress.com alongside other popular blogging platforms (Google Trends, 2014), and the fact that the Wordpress.com statistic does not include Wordpress-powered sites under other domain names (the popular 'self-hosted' Wordpress solution), it seems reasonable to assume that at least 120 million new blog posts were produced each month in 2014, or well

---

2    Establishing a precise and up-to-date figure for the proportion of user-generated material on YouTube is difficult. In 2007, Burgess and Green conducted a content analysis of 4,320 popular videos, and found that only 42 per cent of these came from mainstream, broadcast, or established media, whilst just over 50 per cent were original user-created videos; eight per cent were from sources of 'uncertain' status (Burgess & Green, 2009a). In Michael Strangelove's 2010 book *Watching YouTube* the author asserts that 'a whopping 79 per cent of YouTube videos are estimated to be user-generated content' (p. 10), although the source for this is a PhD thesis completed in 2009. As more and more professional media producers are putting content on YouTube—but also the number of amateur contributors continues to rise—it seems sensible to stick with the conservative formulation that non-professional material makes up 'roughly half' of the YouTube archive.

over a billion during the year. That's a conservative estimate. Of course these huge numbers tell us nothing about the quality or content of such blog posts, but you could discount, say, half or even three-quarters of them, for whatever reason you like—some of them will be basically marketing; some of them will be student coursework; or whatever—and you've *still* got massive numbers.

I could go on to detail quantities of 'user generated' audio, images, and so on, but the point is clear: there is a huge amount of home-made, non-professional media material about these days. So let's move on to consider its implications. The disruptions are both to the 'media world'—which is not really a singular and coherent world, but I mean the fruits of the media industries, and the time that people spend with them—and to the broader social and cultural world.

First, there is the straightforward impact, already mentioned, on how people spend their necessarily limited amounts of media-consumption (or media-engagement) time. In recent years, figures gathered by Nielsen in the US and Ofcom in the UK have tended to indicate that the hours spent by adults watching television has remained quite steady—although increasingly done via on-line services and devices (for instance, Nielsen, 2012; Ofcom, 2012). But the major 2014 reports from these organisations (Nielsen, 2014; Ofcom, 2014) show that the time spent watching television is in significant decline—especially for younger adults (in the 16–24 range). These studies also indicate a huge growth in time spent online doing other things. For instance, the Ofcom study found that YouTube had an audience of 40 million in the UK, almost two-thirds of the whole population, and the time per person spent on YouTube continues to increase year-on-year, with particular growth in mobile viewing (Ofcom, 2014). The material accessed online which is non-professional 'user-generated' content will only be a proportion of the whole, of course, but the popularity of social media reflects the appetite for communication between everyday citizens. The Ofcom report found that when 16–24 year olds were asked which media-technology activities they would miss the most, if they were unable to do them, only 13 per cent chose watching TV (recorded or live), whilst social networking, text messaging and digital creative activities were together selected by more than 30 per cent of this age group (Ofcom, 2014: 63).

Second, there is a shift in the psychological orientation to media material, once you know that to some extent you can do it yourself. When the sources of information and entertainment which were accessible to the general population were *only*, really, those operated by elites—when 'mass media' were the only media that most people received—then those media occupied a god-like

role, far away from the lives of 'ordinary people,' and largely untouchable by them. The dominance of 'mass media' underlined the status of almost every member of society as part of this 'mass'—an undifferentiated, undignified position. The rise of an alternative set of internet-based media which *potentially* enable any of us to *potentially* reach hundreds or thousands of our peers makes a huge difference to these perceptions, lifting the 'masses' out of their passive hole and undermining the superior self-perception of media professionals. This is the nature of the disruption, I think, even when it is the case that not everyone takes advantage of this opportunity to make and share media, and even if their audiences are relatively low. It shifts how all the players see the game, and so changes reality. Everyday users are elevated, and professional media are brought down a few pegs, in a way which is healthy for creativity and self-esteem in the general population.

Third, by changing what's available in the world, the internet brings a huge shift, the significance of which can be difficult to perceive at first. We might think—as do Curran, Fenton and Freedman (2012), discussed below—that adding to the ecosystem a large quantity of digital items which have small audiences cannot make much difference. It's a classic 'mass media' way to look at it: their audiences are small, so they are not significant. But this is to forget how numerous they are, and accessible to anyone else online. This was one of the most striking lessons contained in Chris Anderson's *The Long Tail* (2006). The long tail refers to the huge number of things which, in the offline world, are not in sufficient demand to be worth having around (taking up space in, say, shops or libraries), but in the digital world are worth having in a database because someone, somewhere, is bound to want them sometime; and that each of those incidents is unusual in isolation, but in aggregate adds up to a demand for items which is just as large, at any moment, as the demand for the most popular chart-topping items. As an Amazon.com employee put it: 'We sold more books today that didn't sell at all yesterday than we sold today of all the books that did sell yesterday'.[3] This is the disruption that almost slips under the radar, because we are used to the situation where there are a small number of things that are notable, because they have large audiences. But millions of things that are only wanted by a small number of people still add up to millions of things that are wanted by *somebody*.

---

3    This was a former Amazon employee, Josh Petersen, responding in January 2005 when Chris Anderson was crowdsourcing different definitions of the long tail on his blog. See: http://longtail.typepad.com/the_long_tail/2005/01/definitions_fin.html#comment-3415583

The fourth and final disruption is about connection and collaboration. It could be noted that the previous three points have treated the makers of non-professional media as potential competitors with professional media— like mini broadcasters. But perhaps the biggest shift is that all these new homemade media artefacts—unlike most professional media products – are nodes in networks and communities. Online videos, blogs, images and audio are typically hosted on social network platforms which emphasise comments and/or linkages between elements. YouTube flourished, for instance—as Burgess and Green have shown (2009a, 2009b, 2013)—when it shifted emphasis from being a video 'repository' to being a 'community'; it's not just a site where videos are hosted, it's a place where conversations and connections are developed between the human beings who go there. (At least, that's how it's meant to work. As noted in chapter 6, Shirky (2011) has observed the differences between networks for particular communities, such as Ravelry, a network of knitters where almost all comments are supportive and helpful, and more general services such as YouTube, where the lesser sense of common purpose seems to make it more likely that comments may be stupid or abusive. On areas of YouTube where there is more of a shared interest, such as around how-to and educational videos, we find the quality of comments is typically higher).

As I sought to establish in *Making is Connecting* (Gauntlett, 2011a), drawing on a range of arguments and evidence, creativity—whether offline or online—is absolutely crucial for the health and sustainability of a whole culture and society. Without the nutrient of everyday creativity feeding its roots, the tree of society begins to wither and fail. So here the disruption brought by homemade social media is enormously important because it comes to save the human population from the 'sit back and listen' mode which only really became the norm during a few decades of the twentieth century; most human history isn't like that. Looking across the history of any human culture, the situation where people sit watching a box for four hours a day is incredibly unusual. The disruption which puts 'ordinary people' back in the driving seat of storytelling and creativity is therefore a vital and fruitful one.

## Case #2: Academic critique

New technologies also open up a fissure between those academics who are able to comprehend the potential of online technologies and those who do not. This is not to say that it is scholars who take a critical view, per se, who do not understand the internet. On the contrary, there are excellent critical

scholars, who understand and use the internet, and from this position can view the activities of dominant commercial operations with informed disdain. For instance, Christian Fuchs offers a resolutely Marxist critique of the incorporation of online technology companies in contemporary capitalism (Fuchs, 2008, 2011, 2014). At the same time he has harnessed the internet for various activities, including the open-access journal *Triple C: Cognition, Co-operation, Communication*, which demonstrate the potential of open online networks when *not* subsumed under capitalism.

Elsewhere, however, media and communications scholars have offered a more knee-jerk rejection of online innovation because of an apparent failure to properly understand how online technologies work, and what they can do; and because of a surprising nostalgic attachment to media models of the past. This approach is worth considering here because it also rejects the argument of the previous case: it suggests that the creative potential of the internet has been over-hyped, and that the ways in which the companies behind popular social media platforms take the opportunity to profit from user data in general, and freely-provided content in particular, demonstrates that the argument that everyday creativity can disrupt traditional media operations is false.

The argument is, for instance, that people who make videos and share them with others on YouTube are being exploited, because YouTube typically keeps most of the money that it gets from placing adverts beside the content (Andrejevic, 2009a; Miller, 2009). The latter observation is true, but of course the argument only makes sense in purely economic terms, if you think that such videos are made as items of economic exchange. But clearly they are not, or their makers would not put them on YouTube, a platform where (in most cases) the video producers are not expecting to make money, but are there for other reasons: they want to share their ideas, knowledge or entertainment with others. (Evidence of people's motivations for making and sharing is discussed in Gauntlett, 2011a).

Similarly, there is no alignment between the observation that social media companies seek to profit from hosting material created by users, and arguments about whether these services can foster creativity, or relationships, or learning. The argument about economics cannot be used to resolve an argument about people's experience, or knowledge, or feelings. You wouldn't, for example, use the economic model of a 'pick your own' strawberry field as proof that strawberries are unhealthy and unpleasant.

A notable instance of this kind of reasoning was published in 2012: the appropriately-titled book, *Misunderstanding the Internet*, by James Curran,

Natalie Fenton, and Des Freedman. The book's blurb says that it 'aims to challenge both popular myths and existing academic orthodoxies surrounding the internet', but we will consider it at some length here because it is clearly playing to the conventional, cynical stands of media academics, whose leading lights are lined up in praise of the book on its back cover.

The book is potentially valuable for the way in which it reminds us of various truths: that powerful media organisations are not easily shoved aside, for instance, and that those with money are often able to have the loudest voice. Unfortunately these good points—which remain true anyway—are undermined by poorly used data, a persistent distaste for online media compared with traditional media, and a patronising approach to the large numbers of everyday people who find some value or meaning in the use of social media services.

There are numerous places where the 'evidence' cited does not speak to the matter under discussion. For instance, Curran et al. quote a survey where 38 per cent said they went online for 'fun' while 25 per cent—quite a significant number—were apparently there for news and politics (p. 14). This is used to show that the internet is not a powerful way of exchanging political ideas or information. But the claims don't really line up. For one thing, the 38 per cent statistic reveals an interestingly serious majority, 62 per cent, who do *not* think that the internet is primarily for 'fun'. And second, if 25 per cent of the millions of people online are attracted to the diverse material about politics and current affairs available there, this is a striking new development, and not something to be brushed aside simply because people *also* use the internet for entertainment, which is a true but irrelevant parallel fact. It is like saying that people have no interest in museums and galleries because evidence shows that they more frequently go to the cinema.

The authors are keen to reject the idea that online communications can contribute to social and political change. Where citizens appear to have organised against authoritarian regimes using online tools—such as in the most striking 'Arab Spring' cases—Curran et al. assert that 'even in these circumstances, the internet did not "cause" resistance but merely strengthened it' (p. 12). But this is a silly point: nobody believes that the internet would 'cause' political resistance—for one thing, the internet is a network of cables and electronics, with no known beliefs or values of its own. If the authors are conceding that networked connections have 'strengthened' real-life political activity and social change, then this would seem to be a surprising new capacity for technology to support social action—which would be the *opposite* of the 'nothing happening here' conclusion that they imply.

In another example of fuzzy logic, Fenton notes that many Twitter users have a smallish number of followers, around 100, whilst some big stars can have several million. This fact is taken to demonstrate that 'Participation … is still the preserve of a few' (p. 127). Again, this doesn't make sense. The millions of everyday people on Twitter who are having conversations, and sharing ideas, links, notes, and wry observations, are found to be not 'participating' because Britney Spears has got a few million followers. This doesn't line up, and indeed, the smaller and more close-knit networks are likely to have much greater connection and participation; it is Britney Spears who is denied meaningful 'participation,' because she is one of a minority of users who cannot engage meaningfully with her online community because it is impractically massive.

Similarly, Fenton and colleagues note that it is difficult for individuals to compete with established media providers in the battle for people's attention online. That's true. But curiously they take this to demonstrate that self-made media is, by implication at least, a waste of time (pp. 134–5). They offer statistics which show emphatically that established media brands, such as CNN and the BBC, are much more visited than home-made alternatives. Readers will be unsurprised by this information. More surprising is Fenton's conclusion that this means that people's personal creative work is 'framed by and subsumed under the influence of established powerful media actors' (p. 135). Again, this is quirky. If I offer you a delicious cake that I have made, would it make sense for you to observe that a popular supermarket produces cakes which are consumed much more frequently than mine, and therefore that my cake is 'framed by and subsumed under' the influence of established powerful cake bakers? No. My cake is unique, personal, and independent of this more corporate level of baked goods. The quantitative success of other bakers would have no impact on how we evaluate my own home-made cake.

People use social media services to communicate something for themselves, or about themselves, an urge which has been part of human creative practice for thousands of years. Today this offers a powerful corrective to the more standardised mass media products made by professionals, which—as left-wing critics have rightly argued for decades—do not reflect the diversity of the population. But here, this kind of 'mass self-communication' is dismissed by Fenton as an aspect of 'neoliberalism' (p. 135). However, if neoliberalism refers to the shift of things that used to be done at a social level to the responsibility of individuals, then the term does not fit. Perhaps the idea is that newspapers and traditional media used to helpfully 'represent' people, and now people are

required to represent themselves instead. But being able to speak for yourself is much more progressive than the idea of elites speaking 'on behalf of' people, which is not a notion with any record of working successfully.

The purpose of this extended focus on one book, *Misunderstanding the Internet*, has been to illustrate the status quo of media and communications research, happy to show off how 'critical' it can be without concern for precise argumentation, and disregarding the feelings of users of digital communications media, who are regarded as hapless dupes of the system. In terms of the core theme of this chapter, this is the overconfident establishment, which is disrupted by a typically younger and more technologically competent generation of academics. As noted above, this is not a matter of anti-capitalists versus pro-capitalists. On the contrary, many of the disruptive generation share concerns about the role of dominant businesses in the online sphere, but they make more persuasive critical remarks when informed by how technologies work (rather than the nonsensical comparisons and slippage-of-argument noted above), and are able to propose meaningful alternatives—such as the model of the digital public sphere (Stray, 2011) and the need for non-commercial public platforms (Gauntlett, 2011b, 2011c).

## Case #3: Everyday arts and humanities research

Until recently, the work of archiving, collecting, analysing and writing about art, literature, history, philosophy, media and culture was the more-or-less exclusive role of professional academics, museum curators and other experts. Of course, some of this was also done by hobbyists and enthusiasts, but was rarely recorded or shared in a significant way that made the work accessible to others. (Again, this was the distribution and sharing problem which the internet solved, offering for the first time a straightforward and inexpensive way to make material available to a potential broad audience). But today, the dominance of professional experts is being disrupted by the conspicuous appearance of online enthusiasts who are doing similar work, usually performed and shared for free, and often to a high standard, just because they want to.

The most obvious and well-known example is Wikipedia. In 2001 it seemed unremarkable and obvious to almost everyone that the job of compiling and editing an encyclopedia was a huge, difficult, and responsible task which would rightly be done by established experts who have the appropriate training, and skills, and know what they are talking about. But this assumption about encyclopedia creation was, famously, massively disrupted by the

Wikipedia platform, which encouraged anyone and everyone to join in. Wikipedia grew incredibly quickly, and by its 10th anniversary in 2011 was home to 19 million articles across 282 different language editions, widely regarded as *usually* reliable and generally of good quality. This is not what would have been predicted in 2001. Also unexpected were the emergence of dedicated communities around particular articles, and groups of articles, who debate and learn from each other in their ongoing project to make a high-quality set of articles (Lih, 2009; Dalby, 2009).

This model of collective learning and expertise-sharing is not limited to the (ubiquitous) Wikipedia example, however, although its unique level of success, as a non-profit venture, reminds us of the public appetite for a non-commercial 'commons' of knowledge. Nevertheless, there are a range of platforms being used for different purposes by amateur experts, who are eager to connect and collaborate in a way which often puts their more isolated and less communicative academic counterparts to shame.

On Pinterest, for instance, users curate collections displayed on 'pinboards'—a kind of online exhibition—of images or videos relating to themes of art, design, history, or anything else which can be represented visually. The service is home to collections of old postcards, historical images, space telescope images, artworks with interesting connections, and so on, the kinds of collections which previously would have been painstakingly assembled and annotated by professional curators and archivists. Now similar collections can be produced by non-professional enthusiasts, online, who can collaborate and assist each other with precise dating or labelling.

This kind of mutual support and collaborative informal learning is even stronger in the online DIY communities, where people who like to make and do things in the offline world share ideas and inspiration. A study by Stacey Kuznetsov and Eric Paulos (2010) surveyed 2,600 people who participated in a range of such sites, and found very high levels of motivation to share knowledge and support each other (the study is outlined in a little more detail in the next chapter).

Another example is Minecraft, the popular online game where users can collaboratively construct environments using Lego-like blocks. The tool is very 'open' and non-prescriptive, and so users have been able to use it for a range of purposes: for instance, they have recreated historical environments such as 1940s New York, a Roman city, Cunard ocean liners from the early 20th century, and numerous others, as well as creating environments from literature, such as Hogwarts School from the Harry Potter books, and the

entirety of Tolkien's Middle-Earth.[4] These projects represent a huge amount of 'work' by players who are spending their time in this way for fun, but the activity also happens to be the kind of thing previously done by professionals in museums and galleries, and in university departments of archaeology, history and literature. Minecraft has also been used by school teachers to engage students with the worlds of literature by means of collaboratively building them (Reilly & Cohen, 2012).

Greg Lastowka (2011) provides an insightful analysis of Minecraft as a system which cultivates user creativity and collaboration. He notes that the game itself offers little instruction to users, leading them to seek support in other online spaces:

> By making Minecraft players rely on each other, [game developer] Mojang effectively introduces the new players to other amateur creators and enthusiasts. By regularly updating and revising Minecraft (and giving fairly laconic details about the content of these updates) Mojang ensures that players return to their online communities to share information. By making community participation intrinsic to the game, Mojang builds social networks around the game. All this, plus its indie origins and its nature as a "sandbox" game, would seem to make Minecraft a paradigm for the marriage of amateur creativity and digital games. (Lastowka, 2011: 161)

The kind of activity outlined above may not look quite like a potential 'replacement' for professional academic research. Perhaps direct replacement is not what we are looking at. But as a set of highly active new agents in the ecosystem, these kinds of initiatives represent a significant challenge to the established order.

In some cases, this might drive up and filter for quality. For instance, there may remain a role for a small number of very talented film critics who can write beautifully, probably located in prestigious universities, but any of the academics producing mediocre film criticism have been effectively redundant for several years because there is already a huge amount of mediocre film criticism—alongside some very good film criticism—produced by enthusiasts and available free online. But other kinds of specialist expertise are less readily replicated; in history, philosophy, and social theory, for example, there is room for a number of authoritative and insightful thinkers whose contributions to knowledge are unlikely to be reproduced by random people in their spare

---

4    See for example: New York: http://youtu.be/_tAU8gYiLuY, Roman city: http://youtu.be/4HZphUEa-WU, Cunard liners: http://youtu.be/lxzMZOs7sxw, Hogwarts: http://youtu.be/_qmVC5qO014, Middle-earth: http://youtu.be/0HdKXlN_gB0

time. There is even space for professors of film who have something insightful to say about, say, broader cultural and industrial trends. But it's easy to be complacent. We can be sure that there will be interesting shifts as tasks which were previously part of the 'work' of arts and humanities professionals become taken over by people online doing things just because they are interested.

We might ask how professional academics can connect with this world of non-professional activity without spoiling it, or appearing to want to dominate or exploit it. I have suggested (Gauntlett, 2012c) that it must be about *participating* in these networks—rather than hoping they will go away; *making* things happen—online and offline events that bring people together and inspire action; coupled with a kind of leadership which works *with* all these other people participating in the online space.

## Conclusion

The three types of disruption discussed in this chapter show ways in which creative material and ideas, when shared, discussed and networked via the internet, can challenge the status quo—not necessarily by *replacing* the old with the new, but by introducing novel elements into the ecosystem, necessitating change and renewal throughout the environment. Christensen's model of disruptive innovation has not yet played out fully in each of these spheres—the established incumbents have not been toppled per se—but the ecosystems in each case have taken substantial knocks. This is all as we would expect: as John Naughton notes, the internet is a 'global machine for springing surprises', and disruption 'is a *feature* of the system, not a bug' (2012: 4–5). In the examples I have discussed here, particularly in the first and third cases, it is a newly empowered grassroots of everyday people with creative ideas and aspirations, who are shifting our expectations about where valuable ideas, entertainment and learning can come from. The message that people can make culture and education for themselves, rather than merely selecting from the material made by professional elites, is a powerful and healthy one for our society.

# · 9 ·

# THE INTERNET IS ANCIENT, SMALL STEPS ARE IMPORTANT, AND FOUR OTHER THESES ABOUT MAKING THINGS IN A DIGITAL WORLD

Human beings have been creative, and made things, for many thousands of years. Indeed, the evidence suggests that the first human tools were made almost two million years ago (Donald, 2001). Digital technologies and the internet have not initiated creativity, therefore, but they have certainly given creative practices a boost, by enabling several things to be achieved much more simply and quickly: connections between people, distribution of material, conversations about it, collaborations, and opportunities to build on the work of others.

Therefore I would say that the internet is certainly empowering for people who like to make things, share ideas, and learn together. The six theses which I will discuss in this chapter all concern different dimensions of that strength. Before we get going, though, I'd like to directly address how self-conscious one can feel in saying such a thing.

There is, unmistakably, a fundamental divide between those who say positive things about the value of the internet for culture and society, and those who are broadly critical or negative. If you read things published in this area, you can't really miss it. The pessimistic ones—which includes a majority of the academic writers—clearly take pride in their 'critical' position, as if they have been really clever to avoid being brainwashed by the pro-internet propaganda

(whatever that is), and like to give the impression that their position is risky and iconoclastic, even though it is the most common one in academic circles, and the most populist in terms of academic professional kudos. Whilst there is a valuable social role to be occupied by the critic who can observe that 'the emperor has no clothes',[1] I believe that there should still be an expectation that constructive alternatives can be offered. Some critics have made excellent points—Evgeny Morozov has shown that an online presence can make activists more liable to identification and persecution, for instance (Morozov, 2011), and has punctured the weirder parts of Silicon Valley 'solutionism' (Morozov, 2013). Jaron Lanier (2010) makes persuasive points against the Facebook-style 'template identity' and certain ideas of collective creativity (although Lanier perhaps does not belong in the 'pessimistic' camp anyway, as he is only raising cautionary notes about the development of a creative online life, which he potentially still believes in). Other critics have fewer ideas of their own, and are content to make fun of everyday people's genuine creative efforts (Miller, 2009; Curran, Fenton & Freedman, 2012). As we saw in the previous chapter, these writers suggest that the shift where citizens become media creators, rather than mere consumers, is a waste of time—which I find rather shocking.

The book which the present chapter originally appeared in—*Creativity in the Digital Age* (Zagalo and Branco, eds., 2015)—is clearly on the optimistic side of the fence. The blurb sent to me by the editors says things like: 'This [online] movement is providing a "voice" through which anyone can express to everyone whatever their imagination can create, democratizing innovation and creativity like never before'. The pessimists like to shoot down this kind of statement as recklessly giddy—and indeed the terms 'anyone' and 'everyone' here are ill-advised—but this optimistic stance is at least preferable to the grim elitism of those who seem to wish we could go back to a world where professional people made professional media which professional researchers knew how to deal with.

The 'critical' scholars implicitly sneer at those of us who try to be more constructive and optimistic. Their working assumption is that they are the ones blessed with the intelligence to see through the 'hype' about possible uses of the internet. (This ignores the fact that they are often engaged in a different kind of 'hype', which is—even less helpfully—in praise of themselves). As a father of young children I couldn't live with myself if I merely stood around

---

1    If you are a stranger to this cultural reference, see https://en.wikipedia.org/wiki/The_Emperor's_New_Clothes

moaning about things. It's certainly true that the dominant internet companies are not angelic and may have regrettable ways of working, but to dismiss the potential of what people can do online because particular providers are problematic is like saying that people shouldn't have footwear because some sneaker companies use sweatshops.

In spite of all this discord, I think that it is possible to make some strong positive statements about qualities of the internet which it is difficult to disagree with. I present six of them here. Several of them are pragmatic 'X is better than Y' statements which I would hope are pretty irrefutable. Let's see.

The statements to be discussed are:

1. The internet is ancient (*in other words*: the internet has affordances which connect with ancient, great aspects of humanity).
2. A world with lots of interesting, creative things is always better than a world which offers a small number of popular, smartly-finished things.
3. People doing things because they want to is always better than people watching things because they are there.
4. The distribution and funding possibilities of the internet are better than the traditional models.
5. Small steps into a changed world are better than no steps.
6. The digital internet is good, but hands-on physical things are good too.

## 1. The internet is ancient (*in other words*: the internet has affordances which connect with ancient, great aspects of humanity)

The internet, and the World Wide Web which was built on top of it, are powerful tools for humanity, and connect with ancient ways of doing things. The internet enables humanity to get back onto the track which had been the main story for centuries, where we at least *try* to develop bonds and communities and exchange things largely at a manageable, social level. The industrialism of the late 19th and the 20th centuries, and the broadcast mass media model of communications which peaked in the 20th century, destroyed this sense of collective engagement with a one-size-fits-all, have-what-you're-given, service-the-masses model. Having gone off down that path—a path associated with political passivity and environmental destruction—it was hard to see a way back. But the internet offers a way of exchanging communications,

and goods and services, which is much more like the previous model but on a bigger, broader, and international scale. A lot of it is about *conversation*, but the conversations can happen on a vastly bigger canvas than before. Nevertheless, the conversations can retain focus, because any one conversation is only there for those who want to participate, there are no limits to the number of conversations, and anyone not interested in a conversation can just ignore it—indeed, would not even be aware of it.

Of course, this view is simplistic and romantic in all directions—both overly romantic about the past and the present, and crudely dismissive of the 20th century bit in the middle. Nevertheless, I think it represents a sketch of something genuine—and part of the evidence in its favour is the enthusiasm with which people over the world, from all walks of life, have adopted online communications. The internet could have remained a forum for exchange of information amongst scientists, geeks, and government and military organisations, whilst the majority of people stuck with the mass-market (or even relatively niche) television and movie formats that had already established their popularity. This did not happen.

This argument may also seem to be compromised by the fact that, as has been observed, there are certain internet-based businesses that can be accused of profiting from everyone else's creativity. However, those companies are not necessary or inevitable for what the internet can do. We could also note that the human capacity for greed is also well documented in ancient texts.

In a 2012 essay about online social networks, Daniel Miller argues that networks such as Facebook offer the possibility of communities which offer 'something much closer to older traditions of anthropological study of social relations such as kinship studies' (Miller, 2012: 147). Facebook itself has many dubious qualities and is not the best expression of online-social-networking potential, but nevertheless, you can see his point:

> Instead of focusing on [social networking sites] as the vanguard of the new, and the rapidity of its global reach [or on the idea that they represent a trend towards individualism] it may well be that [social networking sites] are so quickly accepted in places such as Indonesia and Turkey because their main impact is to redress some of the isolating and individualizing impacts of other new technologies and allow people to return to certain kinds of intense and interwoven forms of social relationship that they otherwise feared were being lost. (Miller, 2012: 148)

The internet certainly offers the possibility of building social connections, with or without Facebook, and importantly enables people to share ideas

through these networks. There is a popular idea of the internet as a plat-form for an open, sharing culture, where ideas are made available for others to build upon. Over time, of course, some aspects of this open sharing have been closed down and/or replaced by more modern systems aligned with to-day's conventional ideas of intellectual property, copyright and ownership. Nevertheless—or perhaps *because* of this—there remains a strong interest in the idea of the commons, a shared space where things are made available for use by others, of which Wikipedia is a strong and popular example. The Cre-ative Commons licensing system offers creators the opportunity to make their work available with specific prescriptions, for example that the creator should be credited. The 'commons' model connects—indeed, is based upon—ancient notions of communal public space, although the self-serving regimes of the rich and powerful, as well as the casual selfishness of individuals, have histor-ically meant that a thriving commons is difficult to sustain (Hardin, 1968). A digital commons is different, of course, as digital resources can be copied and used without depleting and damaging the stock available to everyone else.

The commons is about having free access to resources, so that people can share and build together. This is a valuable dimension of culture. It does not necessarily follow, however, that everything online must be free. In everyday life, we are able to comprehend a library and a bookshop, side by side, with-out thinking that one cancels out the other; and it is unfair to assume that only the malign or greedy would seek to charge money for things online. For example, Jaron Lanier offers a sensible defence of the right of an artist to make a living by selling their work directly online (2010, 2013). The kind of trans-action that Lanier suggests is more like an ancient market, or bazaar, where the producers of diverse goods sell them directly to people—presenting and selling them across their own stall. This kind of trade is much more convivial, and good for the producer, than the 20th-century idea that we should be able to get everything via one 'supermarket'.

I also like to think that between the poles of the open (free) and the closed (paid for) there might be a compromise position which is known as: reasonably open (inexpensive). When the artist or producer has cut out the 'middle person' such as a publisher, they can make the same amount of mon-ey by charging far less for the product, as in the argument for 'Latte-priced ebooks' (Dunleavy, 2012; Gauntlett, 2012a) which suggests that books can both be cheap for readers and still provide a modest return for their authors.

The internet, then, forms the basis for a new set of technologies, which enable people to converse, exchange, share and trade in ways which are closer

to ancient and traditional ways of interacting than the monolithic technologies of the previous century, such as television and supermarkets. Even when conducted via proprietary platforms (such as Google services, Pinterest, or Etsy)—which they often are, but don't have to be—these exchanges are still much more healthy than the one-way, mass-market kinds of product and communication that had otherwise become the norm.

## 2. A world with lots of interesting, creative things is always better than a world which offers a small number of popular, smartly-finished things

The slightly longer formulation of this is: 'An ocean of interesting, creative things, regardless of their professionalism or audience size, is always better than a small box of popular, smartly-finished things'. Let me explain.

Way back in 2006, Chris Anderson published *The Long Tail*, which became a successful and much-cited analysis of one of the big differences that the internet makes. 'The long tail', you may recall, refers to the kind of graph where the vertical axis represents popularity (measured as number of readers, or viewers, or sales), and the horizontal axis represents a row of particular items (such as specific books, songs, videos, blog posts, or whatever). When these items are sorted by popularity, there is typically a peak of popular items on the left—that's the 'hits'—and then the graph quickly curves down and along to an apparently infinite number of little-loved, not-very-popular items bobbling along the bottom of the graph—which is the long tail.

Much of Anderson's book was concerned with highlighting the striking difference in what you can sell when you're not limited to shelf space in a physical shop. So whilst a physical bookshop might offer, say, 20,000 titles—all the current bestsellers, some classics, and a scattering of everything else—an online bookshop could have literally millions of titles on sale. Apple's iTunes did the same for music, Netflix for movies, and so on. Anderson highlighted the fact that although any single item in the long tail was apparently not-very-successful—in physical shop terms, it was *literally* a waste of space—when all these long tail items were taken together, they added up to a huge market. The demand for obscure and back-catalogue music, films or books is such that these non-hits (or at least, not *current* hits) represent 'a market as big as, if not bigger than, the hits themselves' (2006: 8).

Sold as a 'business' book, *The Long Tail* left readers with the memorable insight that in the new digital economy, businesses could cater to fans of all kinds of things and still make a profit. Whilst it would still be good to have big successes, the emphasis would shift from a focus solely on mass-market, 'lowest common denominator' hits, to a broader and rational support for making available *anything* that someone, somewhere, might want, because that business was as good as any other kind of business.

This was all interesting and, at the time, a revolutionary observation (although, as Anderson acknowledges, it was basically the insight that Jeff Bezos of Amazon had had a decade earlier). But perhaps the most important *cultural* point of *The Long Tail* was lost on most readers at the time—including me.

What *now* seems really striking is that you can forget about big media altogether. The point is not 'the long tail is also quite interesting'. The point is that the long tail is *everything* that is most interesting—it's genuinely rich and interesting and wonderful. The things with big audiences aren't the successful siblings of everything else—they're in a different category. But they're not in a *better* category.

One of the errors made by critics such as Natalie Fenton (2012) is to look at online media through a traditional media lens, where size of audience is a key measure of significance. Comparing the online presence of established media brands, such as CNN and the BBC, with home-made sites made by amateur enthusiasts in their spare time, Fenton unsurprisingly finds that the former have much bigger audiences (pp. 134–5). Rather more surprisingly, she concludes from this that self-made media is a waste of time, made by deluded narcissists (I paraphrase, but that *is* what she says—see Fenton, 2012: 135). Even if we ignore that extreme misanthropic view, the old-media lens nevertheless tells us that a typical article on the BBC website, read by a million people, is important, whereas a number of blogs that are only read by 500 people each are basically irrelevant.

But what, we might ask, if there are lots of these blogs—what if there are 10,000 of them? The old-media lens says, 10,000 times nothing is still nothing—they're still irrelevant, they're just too small. However, if we take a more contemporary view, where small pebbles can add up to something significant alongside the big boulders (to borrow a metaphor from Leadbeater, 2008), the 10,000 blogs read by only 500 people have an 'audience'—to use a now-clumsy term—that add up to 5 million people, five times our example BBC number. In terms of which *single* source has the most power, clearly the BBC wins. But in terms of a diverse and interesting hubbub, the BBC can't compete. And if

you look on the production side—who made the thing and the difference it made in *their* own lives—in the BBC case you are likely to have two or three employees who have contributed to the production of a webpage, because it is their job to do so—in terms of human engagement and excitement, that's pretty close to nothing. Compare that with the 10,000 people who are so engaged with a subject, so passionate about it, that they have bothered to create a diverse array of original content about it, and that's really powerful in itself before we have even started to think about the 'audience'.

So the really key thing about the 'long tail' is not exactly about the size of markets, but rather that it describes an ocean of independent amateur activity that's as *big* as (or bigger than) the produce of the mainstream and professional brands—and richer as well as wider, with a thousand independent ideas for every one professional message. This is why a world with lots of interesting creative things is always better than a world which offers a small number of popular smartly-finished things. The implication of critics such as Fenton (2012) is that the wealth of interesting creative things are, at best, a distraction from the important arena of professional products with larger audiences, where we should, presumably, focus our demands for better and more critical media content (or something). But the implication that you can't trust ordinary people to do good things themselves, or that it's pointless because nobody is listening, is unreasonably nihilistic. The ocean of independent amateur activity is where the interesting and powerful stuff is to be found.

## 3. People doing things because they want to is always better than people watching things because they are there

After *Making is Connecting* was published in spring 2011, I did a number of talks about it in different places, enlivened by a swooshy Prezi presentation with some pictures and a few words which sought to remind me of central points from the book that I wanted to highlight. I was about half way through this 'tour' when it suddenly struck me that I should add a bit in the middle which summarised the spirit of so much of what the book was saying: the words '*because we want to*'[2] (mentioned also in chapter 6). People creating

---

2    Unintentionally influenced, perhaps, by the 1999 Billie Piper #1 pop hit of the same name.

music videos for YouTube, or making puppets by hand, or writing a blog about environmental politics, or setting up a free library on a street corner—all of these are people doing stuff just *because they want to*.

This is obvious, but important, in part because it relates to the category error made by critics when they talk about the exploitation of digital labour. The exploitation of labour is a useful Marxist concept which—in simple terms—describes the situation where someone does work, which they wouldn't be doing if they weren't doing it for the money, but their employer sells the product of this work on for *more* money, and keeps the difference. This is exploitation in the straightforward technical sense—the employer 'exploits' the difference between cost x (the amount they have to pay a worker to get them to do the work) and cost y (the amount they can sell the fruits of that work for)—and it may well also feel like exploitation in the negative personal sense—where the worker feels frustrated and miserable at this shoddy situation.

Most amateur making is not at all like this, because it is done by people 'because we want to': because they have a message or meaning that they wish to share with others, and a desire to make their mark on the world in some way. Therefore their effort is not 'labour' at all in the Marxist sense, and so they cannot be 'exploited' in the manner of a supermarket employee. Nevertheless, of course, the vast amounts of online creative work produced in this way *are* exploited, en masse, to make a profit for the companies that host them—but this is an exploitation of aggregated content, rather than of individual workers, because they are not *working* in that sense.

The desire of people making things because they want to is much better understood as part of a human need to shape our environment to our own needs and preferences (Illich, 1973), as part of a resistance to being positioned as a consumer (Gauntlett, 2011a), and as a central plank of human happiness—as economist Richard Layard says, summarising piles of data on human activities and satisfactions: 'Prod any happy person and you will find a project' (Layard, 2006: 73).

This self-motivated activity is not *brought about* by the internet, but the ways in which the internet enables people to share creative things, and have conversations around them, works as a significant boost to amateur creativity (Gauntlett et al., 2012). This helps to foster an environment which is more about being a maker and a thinker, less about being 'audience' and a consumer, and this can only be a good thing.

## 4. The distribution and funding possibilities of the internet are better than the traditional models

As a word, 'distribution' doesn't sound like something to get excited about. But distribution is just a word for how we get stuff to people, and—as suggested above—the internet is an incredibly efficient way of getting stuff to people—anything you can transport digitally anyway: brilliant for songs, videos, or stories, although not so good for actual cats or bananas. The delightfulness of this efficiency is especially noticeable to anyone who has tried to distribute physical publications or products themselves (Gauntlett, 2000: 13).

For things that can be conveyed digitally, such as texts, videos, poems, pictures, and songs, we now have remarkably simple tools for getting them out and about. There is still the big problem of getting people to look at your stuff. That's not to be underestimated—but it's not the killer blow that some critics (Fenton, 2012, again, and others) seem to think it is. The online world offers many ways of drawing attention to your interesting stuff, and building networks around it, or having communities talk about it.

In terms of how creative work is funded, or can be financially supported and then exchanged: first of all, we should acknowledge that it's nice that much of this can just be done for free. You can make your own animation, video, song or blog post in your 'spare time', and it doesn't really cost anything. That's wonderful. (Admittedly there are some costs of equipment and internet access, but these are costs which have *already* been borne by a substantial proportion of the population in developed countries). Second, we should acknowledge that we might imagine a post-capitalist vision of our society, which may enable all kinds of collectively-supported creative activity with no cost to the individual (and no profit made by companies putting adverts on it), but we won't spend time on that here because frankly it's not going to materialise any time soon. So then third, it's interesting to look at the disruptive ways of funding larger-scale creative projects which are emerging within the present system—notably the crowdfunding platforms such as Kickstarter and Indiegogo.

IndieGoGo was launched in 2008; Kickstarter came along a year later, with a then-unique all-or-nothing model which seemed to make quality outputs more likely: if a project couldn't raise its desired total within a set period (normally 30 or 60 days), then it wouldn't be funded at all and no money would change hands. Kickstarter has gathered media attention for certain high-profile fundraises—such as the creators of cult TV series *Veronica Mars* hitting their

target of $2 million for a movie version in 10 hours, in March 2013 (and raising $5.7 million over their 30-day period)[3]—but the founders of the site are keen to emphasise that it is primarily a community for small-scale artists and projects. Interviewed in *Fast Company* magazine (Chafkin, 2013), Kickstarter co-founder Yancey Strickler suggests that, unlike Indiegogo which will more-or-less accept any project, Kickstarter is a more carefully curated enterprise:

> The thing is, if [blockbuster movie director] Michael Bay came along and wanted to do a Kickstarter we'd probably tell him, please don't. I would never want to scare the girl who wants to do a $500 lithography project, 'cause that's why we started this thing. We think we have a moral obligation to her.

The makers of *Indie Game: The Movie* (2012) offer an interesting account of their Kickstarter-funded production, and DIY approach to movie distribution, in a series of blog posts (as well as showing in some cinemas, the film was available DRM-free from their own website, and to download from platforms such as iTunes, and was the first to be distributed via the video game platform, Steam).[4] They discuss how they were inspired by Louis C.K., the stand-up comic who took a commercial risk by releasing his stand-up show *Live at the Beacon Theater* (2011) as an inexpensive, DRM-free download from his own website. As he explained in a blog post four days after its release (Szekely, 2011):

> The experiment was: if I put out a brand new standup special at a drastically low price ($5 [£3.25, €3.75]) and make it as easy as possible to buy, download and enjoy, free of any restrictions, will everyone just go and steal it? Will they pay for it? And how much money can be made by an individual in this manner?

The success of this DIY release (which took $1 million in 12 days[5]) seemed to establish an impressive precedent: however, a sensible amateur might think, 'well that worked for the already-established comedian, Louis C.K.—but I'm

---

3    The *Veronica Mars Movie Project* page on Kickstarter: http://www.kickstarter.com/projects/ 559914737/the-veronica-mars-movie-project. Actor and director Zach Braff was inspired by this and raised $3.1 million for his feature film *Wish I Was Here* a month later (http:// www.kickstarter.com/projects/1869987317/wish-i-was-here-1). Spike Lee also launched a fundraising effort in July 2013, raising $1.4 million for his next film project (http://www. kickstarter.com/projects/spikelee/the-newest-hottest-spike-lee-joint).

4    See all details at http://www.indiegamethemovie.com/news/2012/10/31/indie-game-the-movie-the-case-study.html

5    Details at https://buy.louisck.net/news/a-statement-from-louis-c-k and https://buy.louisck. net/news/another-statement-from-louis-c-k

not Louis C.K.'. In a blog post entitled 'We're not Louis C.K.—and you can be too!',[6] the makers of *Indie Game: The Movie* discuss this reservation, from the standpoint that they managed to have a successful DIY-released movie without already being well-known movie makers. As they point out: 'Even Louis C.K. wasn't "Louis C.K." until he was "Louis C.K."'. Nevertheless, they note that they, like him, did work very hard, establishing their skills and their contacts over a number of years, building up the position which would enable their eventual success. So, on the one hand, it is obviously the case that not everyone can spontaneously generate a big DIY hit. But it *is* the case that new online platforms enable crowdfunding and DIY distribution opportunities which help talented and dedicated people to break through without having to gain the support of others already embedded in mainstream media businesses.[7]

Of course, the potential of online crowdfunding goes beyond individual creators wishing to realise their publishing or film projects. A really notable tool that was made possible by Kickstarter is MaKey MaKey, 'An Invention Kit for Everyone', which enables children and adults to use everyday objects as input devices for a computer, and so use food, cutlery or pets as interfaces

---

6    See http://www.indiegamethemovie.com/news/2012/11/19/were-not-louis-ck.html

7    A simple way of thinking about the economics of this kind of thing was offered by Kevin Kelly in 2008, in a blog post entitled '1,000 True Fans'. Kelly suggests that a creator 'needs to acquire only 1,000 True Fans to make a living'. A 'True Fan' is defined as 'someone who will purchase anything and everything you produce'. Kelly explains:

> Assume conservatively that your True Fans will each spend one day's wages per year in support of what you do. That 'one-day-wage' is an average, because of course your truest fans will spend a lot more than that. Let's peg that per diem each True Fan spends at $100 per year. If you have 1,000 fans that sums up to $100,000 per year, which minus some modest expenses, is a living for most folks.

This sounds promising, although in subsequent posts ('The Reality of Depending on True Fans' and 'The Case Against 1,000 True Fans') Kelly had to admit that for artists bumping along at this level of success, with no security and a rather continuous need to generate products or ticket sales to avoid the drift into poverty, this is an uncomfortable existence. Conversely, as one commenter said:

> In the old environment most musicians weren't making any money anyway or had debts to the record companies. And they did not have control over rights [to their own work]. At least some things have changed for the better now. ('Max', 11 May 2010).

Certainly, a lot of comments on these posts referred to the pleasure of *control* over an artistic career, and 'making a living' from it, with a meaningful connection to some people who love the work, even if the artist is not having big hits.

for the internet. A popular example is the 'banana piano', a music keyboard made from a row of bananas.[8] Furthermore, as Matthew Hollow (2013: 70) notes, platforms such as Kickstarter can support community-focused social projects as well:

> For civil society activists and others concerned with local welfare issues, the emergence of these new [crowdfunding platforms] has been hugely significant: It has opened up a new source of funding when governments and businesses around the world are cutting back on their spending as a result of the on-going financial crisis. [As well as artists and film-makers, a] number of local civic initiatives also have received substantial backing from funders on online [crowdfunding platforms]. For instance, when ... Kickstarter launched in the UK in October 2012, the first project to successfully reach its funding goal was a student-led architecture project to design a new pavilion for a park owned by The National Trust conservation charity.

This section was entitled 'The distribution and funding possibilities of the internet are better than the traditional models'. In this kind of case, of course, the 'traditional models'—decent state funding for civic services and amenities—could well be preferable (although the crowdfunded solutions offer a working alternative where otherwise there is none). For individual people, though—or amateur groups, or an innovative duo, say—the Kickstarter model is a powerful new way of making things happen where otherwise they simply wouldn't happen.

## 5. Small steps into a changed world are better than no steps

In the second thesis we have already discussed the value of having a vibrant culture of 'interesting, creative things, regardless of their professionalism or audience size'—where the value was in terms of the array of cultural items available to people in the world. This fifth thesis emphasises the value of making things, no matter how small, for an audience, no matter how small, for the creators *themselves*. My research for *Making is Connecting* (Gauntlett, 2011a) and for other reports (Gauntlett et al., 2011; Gauntlett et al., 2012; Gauntlett

---

8    MaKey is described on its Kickstarter page as 'a simple Invention Kit for Beginners and Experts doing art, engineering, and everything in between', and in June 2012 the project exceeded its fundraising target by 2,272 per cent (with $568,106 pledged against a mere $25,000 goal). See http://www.kickstarter.com/projects/joylabs/makey-makey-an-invention-kit-for-everyone and http://www.makeymakey.com

& Thomsen, 2013) has clarified for me the significance of people taking a step, however small, into the world of making, and the sharing of that making.

Making things is not a rare or elite activity, of course. Everyone makes things: as children, when creative activity is common, and as adults, when preparing a meal, or setting up a new home, or fixing something in an inventive way. But the act of consciously making something as a maker, and deliberately offering it to be seen by others, may be slightly different. In a talk called 'Six Amazing Things About Making,' that I presented with Mitch Resnick of MIT at the Fourth World Maker Faire in New York, September 2013, I said:[9]

> When you are a maker yourself—when you make something and put it into the world—I think that this changes your relationship to the world, to your environment, the people around you, and the stuff in the world.
>
> So often we're expected to be participating in the world, but essentially using stuff made by other people, and consuming stuff, or being active fans of, things made by other people.
>
> When you make things yourself, you break that expectation. You step into the world more actively. I think it's about taking a step. It doesn't matter what you've made, whether it's as good or effective or neat as something made by someone else, or made by a company. Just the fact is, you've made a thing and put it into the world. So you're making your mark, and you've taken that active step. You're making a difference. It's fine if it's a tiny difference, or if it's only noticed by one person. It's the step you've made. It's a great step.

The psychotherapist Nossrat Peseschkian notes that the search for meaning in life is always 'a path of small steps'. This leads, he says, to a common paradox, 'that we must strive for something that we already carry within us' (1985: xi)—but it is only unlocked through a process of taking a small step, and developing confidence and stability, before taking the next.

The importance of small steps into a changed world is also a notion suggested by the phrase 'the personal is political', popular in feminist movements since the late 1960s, and sometimes attributed to Carol Hanisch or Shulamith Firestone.[10] 'The personal is political' highlights the obvious but often

---

9　This quotation is from the notes I made in advance, rather than what was actually said. The video of the talk can be seen at: http://fora.tv/2013/09/22/six_amazing_things_about_making

10　Discussion of the origins of the phrase can be found at http://womenshistory.about.com/od/feminism/a/consciousness_raising.htm

overlooked fact that real change begins in homes, and workplaces, in the terrain of everyday life; that slogans or manifestos are empty if not backed up by efforts, however modest, to change one's actual practices. The notion also reminds us that such personal changes are not trivial, but are crucial, and are the bedrock of everything else. Better to be the person who tries to make ethical changes in everyday life, even if those choices only affect one or two people, than to be the one who broadcasts political messages of fairness and equality to a large audience, but who is not fair and ethical in everyday life.

Therefore, 'small steps into a changed world are better than no steps': in terms of 'X is better than Y' arguments, this one is so easily defended that it might seem pointless. But small steps are easily derided by those who imagine that they are concerned with bigger things. The surly critics that I noted in the introduction to this chapter may dismiss the significance of little actions, preferring to call instead for vast changes to the social structure. But lots of little things can add up to something very big indeed. When lots of people take the step into being active makers and sharers, it alters the character of that group previously thought of as the 'masses'—or the 'audience'—and moves us from a world of 'reception' to one of creativity, exchange, inspiration and conversation.

## 6. The digital internet is good, but hands-on physical things are good too

The excitement about the internet's capacity to distribute material, build networks and make connections can at times lead to a sense that human creativity only really found its feet in the mid-1990s. Of course, that is obviously far from being the case, as was noted at the very start of this chapter. It is surely preferable to see continuity between today's creative practices and those of earlier times, and continuity between what people do in the digital realm and what they do in the physical world.

Services that make connections between the 'virtual' and 'real' worlds have turned out to be offering something that people want. As Dougald Hine (2009) has noted, the entirely virtual world of Second Life was somewhat popular in the mid-2000s, but never quite took off, because most people didn't really dream of swapping their physical existence for a cyberspace avatar.[11]

---

11   This bit about Dougald Hine and the School of Everything is a summary of some material that previously appeared in Gauntlett (2011a).

Meanwhile, much simpler technologies, such as Twitter, and Meetup.com, which enable people to build quite straightforward conversations and relationships with people whom they might actually have met, or can plan to meet, have been more successful. Hine was a co-founder of the School of Everything, which connects people who want to learn something with people who want to share their knowledge. Hine sees the School of Everything 'as part of a larger shift in the way people are using the web, away from spending more and more of our lives in front of screens, towards making things happen in the real world' (Hine, 2008).

The rise of craft and maker communities (Levine & Heimerl, 2008; Gauntlett, 2011a) offers a clear example—or rather, a vast and diverse *range* of examples—of people who like to do 'real world' things, but whose activity has been given a substantial boost by the opportunity to connect, organise, share ideas and inspire each other online. There is much evidence of this. A study of online DIY community participants by Stacey Kuznetsov and Eric Paulos (2010) obtained 2,600 responses to an online survey about their motivations and practices (which means it was a self-selected sample of enthusiasts, of course, but 2,600 is a remarkable number of people willing to share their experiences).[12] The responses indicated a strong ethos of 'open sharing, learning, and creativity' rather than desire for profit or self-promotion. Over 90 per cent of respondents said that they participated in DIY communities by posting questions, comments and answers. They did this frequently and diligently: almost half of the participants responded to others' questions, and posted comments or questions, on a daily or weekly basis. The online interactions did not remain purely 'virtual', with one third of the respondents attending in-person meetings, and over a quarter presenting their work in person at least several times a year. The other respondents used the internet to inspire and share their real-world making activities, even if they were not meeting up with other people in person.

The question of how to meaningfully connect digital and physical tools and experiences has been central to my work with the LEGO Group and the LEGO Foundation (Ackermann et al., 2009, 2010; Gauntlett et al., 2011, 2012; Gauntlett & Thomsen, 2013). This research concerns broad trends in learning, play and creativity, although it has an obvious starting-point in the fact the LEGO bricks themselves offer an engaging hands-on experience

---

12    This bit about the Kuznetsov & Paulos study draws on an account of the study that I first wrote in Gauntlett et al. (2012).

which is not easily mirrored in the digital world. (For sure, for well over a decade there have been several computer programs, games and online tools which simulate LEGO building, but the experience is not really the same as picking up a 'random' selection of LEGO pieces and putting them together).

In *Systematic Creativity in the Digital Realm* (Ackermann et al., 2010), we highlighted ways in which play forms a bridge between the virtual and physical worlds. Most striking of these was 'One reality'—the sense in which the notion of two worlds dissolves, and there is a seamless shift between things experienced as physical and those experienced as digital. These connections could be strengthened by stories and storytelling, as well as other meaningful people and shared interests (p. 77). In *The Future of Play* (Gauntlett et al., 2011) we prescribed an 'expanded playfield' in which there would be more room for free play, exploration and tinkering; an expansion of adult play, in both home and work contexts; and a blending of digital and physical tools (pp. 71–73). The role for an organisation such as LEGO would be in co-creating collaborative 'ecosystems', helping enthusiasts to connect with others, and build things together, without the company getting in the way (p. 69). The subsequent study, *The Future of Learning* (Gauntlett et al., 2012) developed these themes in the area of education, offering a vision where digital tools are used to weave together and magnify real-world learning experiences, and to add a valuable layer of social interaction and creative inspiration. Most recently, *Cultures of Creativity* (Gauntlett & Thomsen, 2013) suggested that creative tools should be available in everyday life which would support people to shift from the role of 'consumer' to that of 'designer'—facilitated by what Gerhard Fischer describes as 'a shift from consumer cultures, specialized in producing finished artifacts to be consumed passively, to cultures of participation, in which all people are provided with the means to participate and to contribute actively in personally meaningful problems' (2013: 76). These tools are likely to make use of the internet's affordances for social connection and inspiration.

Above all, this integration of online and physical practices of making, exploring and sharing can be seen as an archetype of 'open design', the movement persuasively advocated in the book *Open Design Now* (Van Abel et al., 2011). Open design, as the name suggests, describes a participatory sphere of sharing, exchange and collaboration across a broad range of design processes. To some extent, *Open Design Now* is reasonably keen to preserve a role for the professional designer albeit in a rich, collaborative relationship with 'everyone' (a term used on the back cover, which seems preferable) or with 'users'

(as in the chapter by Stappers et al., 2011, which seems to preserve some of the sense of 'us and them'). After the back cover has asserted that 'We have entered the era of design by everyone', it goes on to say: 'And the good news is: this is the best thing ever for professional designers'. This may be the case, but I would say that one of the most interesting dimensions of open design is the shift from a world where 'design' is something done by professionals, who are consulted by their clients, to a world where 'design' is the process where people work together—sharing ideas and inspiration, both online and offline—to create better things, processes or networks. Indeed you could say that one of the most significant impacts of the internet on culture and society was this broadening and opening-up of creative practices—not just that creative materials, tools and conversations are now more accessible, but rather that they become more central to everyday life, break down old hierarchies, and help to build a world where everyone is more creatively engaged.

## Conclusion

This chapter began by noting an academic resistance to the view that the internet may have changed anything for the better, and then set out six ways in which the internet *has* changed things for the better, in the sphere of people making and communicating. (Of course, the impact of the internet has actually reached many more areas than those mentioned here, with substantial shifts in the conduct of politics, protest, economics, news, entertainment, and war, to name but a few). When saying that 'the internet' can have changed something, it is always important to stress that the internet—a vast bundle of non-sentient cables and processors—couldn't have done this on its own. We are really talking about how people use technologies, for particular purposes of their own designs. Transformations take place within, and as part of, social relationships and everyday life. It can be easy to be negative, and take a cynical stance to changes associated with new technologies and new businesses, but this is insufficient and usually rather self-serving. As I hope the six theses here have shown, there are clear reasons to be positive about the role that online connections can make in people's lives—especially when integrated with everyday physical experience. And small steps can lead into a new world, which is less about consumption, and more about conviviality, conversation and creativity.

# · 10 ·

## CONCLUSION

I began this book with the observation that media studies had been thrown into a strange but reinvigorating place. As the media ecosystem changed around it, media studies clung onto the old certainties for a number of years, but is now—we can hope—adapting and remaking itself for the new environment. When many media consumers have become also media makers—exchanging, conversing and inspiring across diverse networks—we all have to be *making media studies* together.

In this Conclusion, I will pull together some of the most significant points from the book, and see where they point us.

### A significantly different era, and a changed ecosystem

At present—in modern Western societies, at least—we live with a mix of media and communications systems, and their diverse implications. We have traditional one-way media, which may now come to us via digital means, but are basically much like we had 30 years ago, produced by elites and distributed to the masses; and we have digital two-way media, where everyday people

can make and share material, and have conversations. These types—each of which includes a number of forms and technologies, and numerous brands and variants—are not completely distinct, and feed into and off each other. We also have a growing interest in things that connect the physical and digital realms, as well as thriving and developing cultures of people who like to make things by hand. And all this is cross-cut with inevitably mixed feelings about the super opportunities for creative exchange on the one hand, and the weird emergence of a surprisingly comprehensive system of citizen surveillance on the other.

I'm only restating the obvious components here, but when you take them all together, it's a strange mix. I think it's important to acknowledge the presence of the contradictory elements, but remember that they don't necessarily cancel each other out—which isn't necessarily easy. So on the one hand, the internet now stands revealed as a system hijacked by the state for mass surveillance—a depressing and far-reaching development within supposedly free societies. But at the same time, it is also, still, of course, a wonderful platform for connecting people, for conversations, and for the exchange of creative ideas and materials. I've noted the double-edged nature of this gift repeatedly—sorry—but it is *both*. And of course, the system that supports nice people to do brilliant things together also supports malicious people to do horrible things together. But the internet is a kind of mirror of human life, and this mix of delightful and worrying elements flows from that fact. So when I say positive things about the internet, as I will do below, we basically have to remember that there may also be negative things, but that doesn't show that the positive things aren't also true.

Another observation about this set of varied and sometimes contradictory components is that they are not just lined up alongside each other—they are an *ecosystem* (as outlined in chapter 8). This means that all of the parts are interrelated, and is why the rise of amateur creativity—or the rise of the *visibility* and *exchange* of amateur creativity—is so important: not just for its own sake, but for its knock-on impact on everything else. Making our own media, for instance, changes how we think about media made by other people; having conversations around creative practice changes what we might expect from other people's creativity—including the expectation that we might have conversations through or around it; and the ways that we give away or seek compensation for the things we make changes how we feel about taking or paying for things from other people.

## Media as triggers for experiences and making things happen – revisited

In chapter 1, I suggested we should look at media as triggers for experiences and for making things happen—as places of conversation, exchange, and transformation—and a fantastically messy set of networks filled with millions of sparks which can ignite new meanings, ideas, and passions. And in chapter 3 we saw the rise of a hugely expanded sense of what media are, and their transformed place as a tool of everyday life, all of which points towards a much more generative, creative view of what media can mean—and what 'media studies' can be.

In the rest of the book we have considered the implications of this for society and culture. We have seen, for instance, ideas about how this might change teaching and learning practices—and also how it aligns with how people are building their own learning, through social media, games, Minecraft, coding, and other means. We have seen evolving implications about how we might build bridges between digital and physical creative practices and experiences; and we have seen (in chapter 6) how media organisations struggle with the idea of really handing over creative responsibilities and opportunities to anyone other than themselves.

The 'maker movement' is a key carrier of the idea that media and other creative tools can be used by ordinary people to challenge, inspire, and change the world. The movement has become so mainstream that even Barack Obama had a Maker Faire at the White House and announced that citizens should be 'makers of things, not just consumers of things' (see chapter 5)—but this message, if taken seriously, is still quite subversive. And it's nice to have high-profile encouragement, but this is not a movement that responds to top-down instructions, as we note in the next point.

## People doing and making because it's what they want to do

A key strength of today's widespread creative practices is that their roots are in personal passions. People make things because they have something they want to explore, or something they want to say. This self-initiated, DIY approach has implications for the ways in which media and cultural organisations engage with people, because it's a shift from a 'push' model of media

content—where these organisations make things for us—to a model where we may 'pull' upon creative tools or resources that they may offer (or that we might find or make for ourselves), in support of us doing what we want to do. These tools should support people to share ideas or stories in whatever way they choose, without limitation, but should offer some form of recognition for the creators (as argued, amongst other things, in chapter 6).

So media studies now is not so much about media content and is more about media as platforms—media as things you can do something with, and the platforms and supports that can be arranged to stimulate that. It's about building creativity in society—and the things that can get in the way of that. This means we are still engaged with institutions and organisations, and more generally with issues of social change, culture, learning, and power in society—but in a different way, with a more active role for creative individuals to make a difference.

## Making and thinking, and 'critical making'

Making things has always been a way for humans to think about things, critically and reflectively. Richard Sennett's *The Craftsman* (2008) eloquently shows how making and thinking are inseparable aspects of the same process (and see Ingold, 2013). My own 'creative methods' work (Gauntlett, 2007) is based on the idea that you can reflect on ideas and experiences in a different way by *making* things about them—in particular by creating metaphorical representations of them, in three dimensions. And *Making is Connecting* (Gauntlett, 2011a) is all about how even small and everyday acts of making have a social and political dimension, as they represent a step into the world of creative engagement—becoming a *participant* in one's own environment. Matt Ratto has recently coined the term 'critical making' (Ratto, 2011, 2012, 2014), and it has caught on (see, for instance, its use by several contributors in Hertz, ed., 2012, and Ratto & Boler, eds., 2014). Ratto presents critical making as a way for researchers, designers and artists to explore concepts—especially concerned with the social study of technologies—through making things (Ratto, 2011: 252).

Of course, this growth of interest in making as a critical practice is very welcome; and Ratto has proposed and explored many intriguing instances of critical making. However, the idea that the 'critical' and thoughtful version of making is something done by politically-aware professionals,[1]

---

1    Ratto's exemplary cases of critical making at the start of his 2014 essay, for instance, are university researchers and students, and professional designers and artists (Ratto, 2014: 227),

positioned—perhaps unintentionally—in contrast to other acts of making done by others, is unfortunate. If we believe that all acts of thoughtful making have a critical, reflective dimension, then the separation of 'critical making' seems a bit odd. (By thoughtful making I mean any making that involves some creativity and imagination—therefore, *excluding* making activities which are just done very repetitively in a machine-like way, or by following strict instructions, but otherwise *including* any other acts of making, done by anyone, where some ingenuity or thoughtfulness is exercised).

Ratto's intention is to propose a deliberate kind of practice which can be adopted by those researchers and designers who previously were not discovering through making and tinkering—and obviously, that is a good recommendation for them. His outline of critical making also highlights some fruitful layers: 'materially productive, hands-on work intended to uncover and explore conceptual uncertainties, parse the world in ways that language cannot, and disseminate the results of these explorations through embodied, material forms' (2014: 227). But *all* making, I'd say, can be critical making; and critical making—or, as I would call it, making—is a 'tool for thinking' for everybody.

Perhaps the best way to think about this, suggested by Amy Twigger Holroyd (2013), is that although making *is* always a reflective process, it is possible to frame, facilitate and/or support particular creative exercises in a way that can *heighten* their critical or contemplative nature. So when Twigger Holroyd (2013) introduced 'unfamiliar challenges' to the group of knitters in her research, such as re-knitting or 'stitch hacking'—or, indeed, when I asked people to build metaphorical models of their identities in LEGO (Gauntlett, 2007)—we were setting novel tasks which knocked people from their normal mode of thoughtful making into a particularly self-aware mode of critical making. In this sense, critical making is not *different* to any other kind of making, but it is a particular way of framing creative tasks in order to prompt more explicit reflections on ideas, experiences or technologies. Which is, I guess, what Matt Ratto intended (and would be supported by some comments in Ratto, 2012). This would mean that 'critical making' is itself a kind of *platform* for creative practice.[2]

---

although the essay collection (Ratto & Boler, eds., 2014) does refer to a broader range of DIY activities.

2   As it turns out, Ratto agrees (personal conversation, September 2014)—and recognises a tendency in his own earlier work to overstate the separation between 'critical making' and 'everyday making'. In the introduction to his forthcoming monograph on the topic (Ratto, 2015), he reconstitutes critical making as incorporating a spectrum of activities in

# Millions of little things make a big difference

In an ever-more globalised world, and with an internet increasingly organised around big brands with far-reaching curatorial powers, we often focus on the powerful companies and institutions, and the most strikingly successful content and creators. And of course, those things deserve our attention. But alongside the big corporate operations are mountains of other small-scale activities that *add up to* something equally important:

- In chapter 8, in terms of content, we noted that the 'long tail' of non-professional material is so massive that it cannot be ignored; even where only small numbers of people are attending to each bit, overall this adds up to a vast sphere of activity.
- And in chapter 9, in terms of people, we saw that the 'small steps' taken into a world of creativity might seem unspectacular on an individual level, but that this shift in consciousness towards a more 'maker' orientation to the world—when it is a small step taken by millions of people—adds up to a major cultural shift.

These cheerful points about creative amateurs might seem like overoptimistic flannel that can easily be ignored—and, you might think, *should* be ignored—by critical scholars who believe that they have a more realistic appreciation of the power of big business and mainstream content. But these small, creative acts are the seeds of hope and change and diversity. Each case *individually* might appear to be more-or-less insignificant, but *together* these massive areas of activity have huge power and resonance.

# Make it happen

Finally—I can't tell you what the future will look like, but I do know that the future of people is made by people. To understand the transformations enabled by digital technologies, and the uses of any kind of media in everyday life, we need to make and think and build and create.

---

which makers reflect on their practice ('critical' in terms of interpreting their own work and its place in the world), as well as activities in which makers create objects intended to 'increase the liberatory forces in society' ('critical' in a more critical social theory sense). He notes that all such activities are not just the province of activists, academics, and professional designers, but are increasingly part of everyday making practices.

We need to explore new ways to express ourselves, and novel interventions to make sense of technology and culture. This isn't something that should be left to 'experts' or companies far away. This is work to be done here, by us, right now.

# REFERENCES

Ackermann, Edith, Gauntlett, David, & Weckstrom, Cecilia (2009), *Defining Systematic Creativity*, Billund: LEGO Learning Institute.

Ackermann, Edith, Gauntlett, David, Wolbers, Thomas, & Weckstrom, Cecilia (2010), *Systematic Creativity in the Digital Realm*, Billund: LEGO Learning Institute.

Anderson, Chris (2006), *The Long Tail: How Endless Choice Is Creating Unlimited Demand*, London: Random House Business Books.

Anderson, Chris (2010), 'Who's to Blame: Us', part of the feature 'The Web Is Dead. Long Live the Internet', *Wired*, August 2010, http://www.wired.com/2010/08/ff_webrip/all/1

Andrejevic, Mark (2009a), 'Exploiting YouTube: Contradictions of User-Generated Labor', in Snickars, Pelle, & Vonderau, Patrick, eds., *The YouTube Reader*, Stockholm: National Library of Sweden.

Andrejevic, Mark (2009b), *iSpy: Surveillance and Power in the Interactive Era*, Lawrence, Kansas: University Press of Kansas.

Antorini, Y.M., & Muñiz, A.M. (2013), 'The Benefits and Challenges of Collaborating with User Communities', *Research—Technology Management*, vol. 56, no. 3, pp. 21–8.

Antorini, Y.M., Muñiz, A.M., & Askildsen, T. (2012), 'Collaborating with Customer Communities: Lessons from the Lego Group', *MIT Sloan Management Review* (Spring).

Aristotle (335 bc), *Poetics*, available from various sources, such as The Internet Classics Archive, http://classics.mit.edu/Aristotle/poetics.html

Arts and Humanities Research Council (2009), *Leading the World: The economic impact of UK arts and humanities research*, available at http://www.ahrc.ac.uk/About/Policy/Documents/leadingtheworld.pdf

Baichtal, John, & Meno, Joe (2011), *The Cult of LEGO*, San Francisco: No Starch Press.

BBC (2013), *BBC Annual Report and Accounts 2012/13*, available at http://www.bbc.co.uk/annualreport/2013/home/

Brown, Tim (2009), *Change by Design: How Design Thinking Transforms Organizations and Inspires Innovation*, New York: HarperCollins.

Buckingham, David (2011), comments made in discussion at the Manifesto for Media Education Symposium, held at the Royal Institute of British Architects, London, 10 June 2011.

Burgess, Jean, & Green, Joshua (2009a), *YouTube: Online Video and Participatory Culture*, Cambridge: Polity.

Burgess, Jean, & Green, Joshua (2009b), 'The Entrepreneurial Vlogger: Participatory Culture Beyond the Professional–Amateur Divide', in Snickars, Pelle, & Vonderau, Patrick, eds., *The YouTube Reader*, Stockholm: National Library of Sweden.

Burgess, Jean & Green, Joshua (2013), *YouTube: Online Video and Participatory Culture—Revised and Updated Second Edition*, Cambridge: Polity.

Chafkin, Max (2013), 'True To Its Roots: Why Kickstarter Won't Sell', *Fast Company*, April 2013, http://www.fastcompany.com/3006694/where-are-they-now/true-to-its-roots-why-kickstarter-wont-sell

Chesbrough, Henry (2003), *Open Innovation: The New Imperative for Creating and Profiting from Technology*, Boston: Harvard Business School Press.

Chesbrough, Henry (2011), *Open Services Innovation: Rethinking Your Business to Grow and Compete in a New Era*, San Francisco: Jossey-Bass.

Chesbrough, Henry, Vanhaverbeke, Wim, & West, Joel (2008), *Open Innovation: Researching a New Paradigm*, Oxford: Oxford University Press.

Christensen, Clayton M. (1997), *The Innovator's Dilemma: When New Technologies Cause Great Firms to Fail*, Boston: Harvard Business School Press.

Christensen, Clayton M., & Eyring, Henry J. (2011), *The Innovative University: Changing the DNA of Higher Education from the Inside Out*, San Francisco: Jossey-Bass.

Christensen, Clayton M., Allworth, James, & Dillon, Karen (2012), *How Will You Measure Your Life?*, London: HarperBusiness.

Claxton, Guy (2008), *What's the Point of School?: Rediscovering the Heart of Education*, London: Oneworld.

Coughlan, Peter, Fulton Suri, Jane, & Canales, Katherine (2007), 'Prototypes as (Design) Tools for Behavioral and Organizational Change: A Design-Based Approach to Help Organizations Change Work Behaviors', *Journal of Applied Behavioral Science*, March 2007, vol. 43, no. 1, pp. 122–134. Available at: http://www.ideo.com/images/uploads/news/pdfs/Prototypes_as_Design_Tools_1.pdf

Couldry, Nick (2004), 'Theorising media as practice', *Social Semiotics*, vol. 14, no. 2, pp. 115–132.

Couldry, Nick (2012), *Media, Society, World: Social Theory and Digital Media Practice*, Cambridge: Polity.

Csikszentmihalyi, Mihaly (1997), *Creativity: Flow and the Psychology of Discovery and Invention*, New York: Harper Perennial.

Csikszentmihalyi, Mihaly (2002), *Flow: The Classic Work on How to Achieve Happiness (revised edition)*, London: Rider.

Curran, James, Fenton, Natalie, & Freedman, Des (2012), *Misunderstanding the Internet*, Abingdon: Routledge.

Dalby, Andrew (2009), *The World and Wikipedia: How We Are Editing Reality*. London: Siduri.

DeMillo, Richard A. (2011), *Abelard to Apple: The Fate of American Colleges and Universities*, Cambridge, MA: MIT Press.

Donald, Merlin (2001), *A Mind So Rare: The Evolution of Human Consciousness*, New York: W.W. Norton.

Doorley, Scott, & Witthoft, Scott (2012), *Make Space: How to Set the Stage for Creative Collaboration*, Hoboken, New Jersey: John Wiley & Sons.

Dunleavy, Patrick (2012), 'Ebooks Herald the Second Coming of Books in University Social Science', 6 May 2012, http://blogs.lse.ac.uk/lsereviewofbooks/2012/05/06/ebooks-herald-the-second-coming-of-books-in-university-social-science/

Dyer, Jeff, Gregersen, Hal, & Christensen, Clayton M. (2011), *The Innovator's DNA: Mastering the Five Skills of Disruptive Innovators*, Boston: Harvard Business School Press.

Eldridge, Richard (2003), *An Introduction to the Philosophy of Art*, Cambridge: Cambridge University Press.

Eno, Brian (1981), interview in *Keyboard* magazine, July 1981. Available at http://music.hyperreal.org/artists/brian_eno/interviews/keyb81.html

Eno, Brian (1996), *A Year with Swollen Addendices*, London: Faber and Faber.

Eno, Brian (2013), *Re-valuation (A Warm Feeling)*, interview with Irial Eno, *Mono.Kultur*, no. 34, summer 2013, Berlin: Mono.Kultur.

Etzkowitz, Henry (2008), *The Triple Helix: University-Industry-Government Innovation in Action*, New York: Routledge.

Everitt, Dave, & Mills, Simon (2009), 'Cultural Anxiety 2.0', *Media, Culture & Society*, vol. 31, no. 5, pp. 749–768.

Facer, Keri (2011), *Learning Futures: Education, Technology and Social Change*, Abingdon: Routledge.

Fenton, Natalie (2012), 'The Internet and Social Networking', in Curran, James, Fenton, Natalie, & Freedman, Des, *Misunderstanding the Internet*, Abingdon: Routledge.

Fischer, G. (2013), 'Social Creativity and Cultures of Participation: Bringing Cultures of Creativity Alive', Billund: The LEGO Foundation. Available from: http://www.legofoundation.com/en-us/research-and-learning/foundation-research/cultures-of-creativity/

Fitzpatrick, Kathleen (2011), *Planned Obsolescence: Publishing, Technology, and the Future of the Academy*, New York: New York University Press.

Frankel, Lois, & Racine, Martin (2010) 'The Complex Field of Research: For Design, through Design, and about Design', paper presented at Design & Complexity, International Conference of the Design Research Society, Montreal, 7–9 July 2010. Available at: http://www.designresearchsociety.org/docsprocs/DRS2010/PDF/043.pdf

Frayling, Christopher (1993) 'Research in Art and Design', Royal College of Art Research Papers, 1 (1), pp. 1–5. Available at: http://researchonline.rca.ac.uk/384/3/frayling_research_in_art_and_design_1993.pdf

Fuchs, Christian (2008), *Internet and Society: Social Theory in the Information Age*, New York: Routledge.

Fuchs, Christian (2011), *Foundations of Critical Media and Information Studies*, Abingdon: Routledge.

Fuchs, Christian (2014), *Social Media: A Critical Introduction*, London: Sage.

Gauntlett, David (1997), *Video Critical: Children, The Environment and Media Power*, London: John Libbey. Online version at http://www.artlab.org.uk/videocritical

Gauntlett, David, & Hill, Annette (1999), *TV Living: Television, Culture and Everyday Life*, London: Routledge.

Gauntlett, David, ed. (2000), *Web.Studies: Rewiring Media Studies for the Digital Age*, London: Arnold.

Gauntlett, David (2000), 'Web Studies: A User's Guide', in Gauntlett, David, ed., *Web.Studies: Rewiring Media Studies for the Digital Age*, London: Arnold. Also available at http://www.newmediastudies.com/intro2000.htm

Gauntlett, David (2004), 'Web Studies: What's New', in Gauntlett, David & Horsley, Ross, eds., *Web.Studies*, 2nd edition, London: Arnold. Also available at http://www.newmediastudies.com/intro2004.htm

Gauntlett, David (2007), *Creative Explorations: New Approaches to Identities and Audiences*, London: Routledge.

Gauntlett, David (2008), 'Creative Methods in Social Research', two day workshop, December 2008', http://www.artlab.org.uk/workshop-dec2008.htm

Gauntlett, David (2009a), 'Stuck on the Sidelines', *Times Higher Education*, 6 August 2009, http://www.timeshighereducation.co.uk/story.asp?storyCode=407678&sectioncode=26

Gauntlett, David (2009b), 'RSA Workshop Using Creative Methods', http://www.artlab.org.uk/rsa-workshop.htm

Gauntlett, David (2011a), *Making is Connecting: The Social Meaning of Creativity, from DIY and Knitting to YouTube and Web 2.0*, Cambridge: Polity.

Gauntlett, David (2011b), *Media Studies 2.0, and Other Battles around the Future of Media Research*, London: Kindle book published by David Gauntlett.

Gauntlett, David (2011c), 'Good and bad times for making and thinking', *Networks*, Issue 14 (Summer 2011), Art Design Media Subject Centre, http://www.adm.heacademy.ac.uk/networks/networks-summer-2011/features/good-and-bad-times-for-making-and-thinking/

Gauntlett, David (2012a), 'A Tale of Two Books: An Experiment in Cutting Out The Middlepeople with Kindle Self-Publishing', 28 May 2012, http://blogs.lse.ac.uk/impactofsocialsciences/2012/05/28/tale-two-books/

Gauntlett, David (2012b), 'Digital Transformations and Open Access', 14 May 2012, available at http://davidgauntlett.com/digital-media/digital-transformations-and-open-access/

Gauntlett, David (2012c), 'Art and Design—and Innovation', Presentation at Skills 21 Kunsten, organised by Cultuurnetwerk Nederland, Leeuwarden, 8 October 2012. See http://www.youtube.com/watch?v=crzuJ3wS9n8

Gauntlett, David (2014), 'Enabling and constraining creativity and collaboration: Some reflections after Adventure Rock', in Popple, Simon, & Thornham, Helen, eds., *Content Cultures: Transformations of User Generated Content in Public Service Broadcasting*, London: I.B. Tauris.

Gauntlett, David, & Thomsen, Bo Stjerne (2013), *Cultures of Creativity*, Billund: LEGO Foundation. Available from: http://www.legofoundation.com/en-us/research-and-learning/foundation-research/cultures-of-creativity/

Gauntlett, David, & Holzwarth, Peter (2006), 'Creative and Visual Methods for Exploring Identities' in *Visual Studies*, Vol. 21, No. 1, April 2006, pp. 82–91.

Gauntlett, David, Ackermann, Edith; Whitebread, David; Wolbers, Thomas, & Weckstrom, Cecilia (2011), *The Future of Play: Defining the Role and Value of Play in the 21ˢᵗ Century*, Billund: LEGO Learning Institute.

Gauntlett, David, Ackermann, Edith, Whitebread, David, Wolbers, Thomas, Weckstrom, Cecilia, & Thomsen, Bo Stjerne (2012), *The Future of Learning*, Billund: LEGO Learning Institute.

Google Trends (2014), comparison of blogging platforms, http://www.google.com/trends/explore#q=blogger%2C%20drupal%2C%20sharepoint%2C%20wordpress%2C%20tumblr

Gray, Ann (1992), *Video Playtime: The Gendering of a Leisure Technology*, London: Routledge.

Greenwald, Glenn (2014), *No Place to Hide: Edward Snowden, the NSA and the Surveillance State*, London: Hamish Hamilton.

Hardin, Garrett (1968), 'The Tragedy of the Commons', *Science*, vol. 162, no. 3859, pp. 1243–1248. Available from http://www.sciencemag.org/content/162/3859/1243.full

Harding, Luke (2014), *The Snowden Files: The Inside Story of the World's Most Wanted Man*, London: Guardian Faber.

Hatch, Mark (2013), *The Maker Movement Manifesto*, New York: McGraw-Hill Education.

Hertz, Garnet, ed. (2012), *Critical Making* series, Hollywood, California: Telharmonium Press. Available at http://conceptlab.com/criticalmaking/

Hine, Dougald (2008), 'The "Why Don't You?" Web', 1 December 2008, http://schoolofeverything.com/blog/why-dont-you-web

Hine, Dougald (2009), 'How Not to Predict the Future (or Why Second Life Is Like Video Calling)', 27 April 2009, http://otherexcuses.blogspot.com/2009/04/how-not-to-predict-future-or-why-second.html

Hobson, Dorothy (1980), 'Housewives and the Mass Media' in Hall, S., Hobson, D., Lowe, A., & Willis, P., (eds.) *Culture, Media, Language: Working Papers in Cultural Studies 1972–79* (pp. 105–116), London: Hutchinson.

Hobson, Dorothy (1982), *Crossroads: The Drama of a Soap Opera*, London: Methuen.

Hollow, Matthew (2013), 'Crowdfunding and Civic Society in Europe: A Profitable Partnership?', *Open Citizenship*, vol. 4, no. 1, pp. 68–73. http://www.opencitizenship.eu/ojs/index.php/opencitizenship/article/view/80/73

Holt, John (1964), *How Children Fail*, New York: Pitman.

Holt, John (1967), *How Children Learn*, New York: Pitman.

Hyde, Lewis (2007), *The Gift: How the Creative Spirit Transforms the World*, London: Canongate.

Illich, Ivan (1971), *Deschooling Society*, London: Calder & Boyars.

Illich, Ivan (1973), *Tools for Conviviality*, London: Calder & Boyars.

Illuminations, eds. (2002), *Art Now: Interviews with Modern Artists*, London: Continuum.

Ingold, Tim (2013), *Making: Anthropology, Archaeology, Art and Architecture*, Abingdon: Routledge.

Jackson, Lizzie, Gauntlett, David, & Steemers, Jeanette (2008a), *Virtual Worlds: An Overview, and Study of BBC Children's Adventure Rock*, available at http://www.bbc.co.uk/blogs/knowledgeexchange/westminstertwo.pdf

Jackson, Lizzie; Gauntlett, David, & Steemers, Jeanette (2008b), *Children in Virtual Worlds: Adventure Rock Users and Producers Study*, available at http://www.bbc.co.uk/blogs/knowledgeexchange/westminsterone.pdf

James, Alison (2012), 'Guest Post: On Being Digitally Transformed', post on Digital Transformations blog, 26 July 2012, available at http://www.digitaltransformations.org.uk/guest-post-on-being-digitally-transformed/

James, Alison, & Brookfield, Stephen D. (2014), *Engaging Imagination: Helping Students Become Creative and Reflective Thinkers*, San Francisco: Jossey-Bass.

Jeffries, Stuart (2014), 'How the Web Lost Its Way—and Its Founding Principles', *The Guardian*, 24 August 2014, http://www.theguardian.com/technology/2014/aug/24/internet-lost-its-way-tim-berners-lee-world-wide-web

Jenkins, Henry (2009), 'What Happened Before YouTube', in Jean Burgess & Joshua Green, *YouTube: Online Video and Participatory Culture*, Cambridge: Polity.

Jenkins, Henry, Ford, Sam, & Green, Joshua (2013), *Spreadable Media: Creating Value and Meaning in a Networked Culture*, New York: New York University Press.

Kaufman, James C., & Sternberg, Robert J. (2010), *The Cambridge Handbook of Creativity*, Cambridge: Cambridge University Press.

Kelly, Kevin (2008), '1,000 True Fans', *The Technium* [blog], 8 March 2008, http://kk.org/thetechnium/archives/2008/03/1000_true_fans.php

Krajina, Zlatan, Moores, Shaun, & Morley, David (2014), 'Non-Media-Centric Media Studies: A Cross-Generational Conversation', *European Journal of Cultural Studies*, vol. 17, no. 5.

Krause, Steven D., & Lowe, Charles, eds. (2014), *Invasion of the Moocs: The Promises and Perils of Massive Open Online Courses*, Anderson, South Carolina: Parlor Press. Also available at http://www.parlorpress.com/pdf/invasion_of_the_moocs.pdf

Kuznetsov, Stacey, & Paulos, Eric (2010), 'Rise of the Expert Amateur: DIY Projects, Communities, and Cultures', paper presented at the 6th Nordic Conference on Human-Computer Interaction, October 2010. Available at http://www.staceyk.org/hci/KuznetsovDIY.pdf

Lanier, Jaron (2010), *You Are Not a Gadget: A Manifesto*, London: Allen Lane.

Lanier, Jaron (2013), *Who Owns The Future?*, London: Allen Lane.

Lastowka, Greg (2011), 'Minecraft as Web 2.0: Amateur Creativity and Digital Games', in Hunter, Dan, Lobato, Ramon, Richardson, Megan, & Thomas, Julian, eds., *Amateur Media: Social, Cultural and Legal Perspectives*, Abingdon: Routledge, pp. 153–169. Available at http://ssrn.com/abstract=1939241 or http://dx.doi.org/10.2139/ssrn.1939241

Layard, Richard (2006), *Happiness: Lessons from a New Science*, London: Penguin.

Leadbeater, Charles (2008), *We Think: Mass Innovation Not Mass Production*, London: Profile Books.

LEGO Group (2013), *LEGO Annual Report 2013*, available at http://aboutus.lego.com/en-gb/lego-group/annual-report

Levine, Faythe, & Heimerl, Cortney, eds. (2008), *Handmade Nation: The Rise of DIY, Art, Craft and Design*, New York: Princeton Architectural Press.

Lih, Andrew (2009), *The Wikipedia Revolution: How a Bunch of Nobodies Created the World's Greatest Encyclopedia*. London: Aurum.

Marwick, Alice E. & boyd, danah (2011). 'I Tweet Honestly, I Tweet Passionately: Twitter Users, Context Collapse, and the Imagined Audience', *New Media and Society*, vol. 13, no. 1, pp. 114–133.

Merleau-Ponty, Maurice ([1964] 2004), 'Merleau-Ponty's Prospectus of his Work', in Baldwin, Thomas, ed., *Maurice Merleau-Ponty: Basic Writings*, London: Routledge.

Miller, Daniel (2012), 'Social Networking Sites', Horst, Heather A., & Miller, Daniel, eds., *Digital Anthropology*, London: Berg.

Miller, Toby (2009), 'Cybertarians of the World Unite: You Have Nothing to Lose but Your Tubes!', in Snickars, Pelle, & Vonderau, Patrick, eds., *The YouTube Reader*, Stockholm: National Library of Sweden.

Moore, Kerry (2014), 'Where would we be without Alain de Botton?' 30 January 2014, http://www.jomec.co.uk/blog/where-would-we-be-without-alain-de-botton/

Moores, Shaun (2005), *Media/Theory: Thinking about Media and Communications*, London: Routledge.

Moores, Shaun (2012), *Media, Place and Mobility*, Basingstoke: Palgrave Macmillan.

Moores, Shaun (2013), 'We Find Our Way about: Everyday Media Use and "Inhabitant Knowledge"', *Mobilities*, published online 27 Aug 2013 (DOI: 10.1080/17450101.2013.819624).

Morley, David (1986), *Family Television: Cultural Power and Domestic Leisure*, London: Comedia.

Morley, David (2009), 'For a Materialist, Non-Media-Centric Media Studies', *Television & New Media*, vol. 10, no. 1, pp. 114–116.

Morley, David (2011), 'Communications and Transport: The Mobility of Information, People and Commodities', *Media, Culture & Society*, vol. 33, no. 5, pp. 743–759.

Morozov, Evgeny (2011), *The Net Delusion: How Not to Liberate the World*, London: Allen Lane.

Morozov, Evgeny (2013), *To Save Everything, Click Here: Technology, Solutionism, and the Urge to Fix Problems That Don't Exist*, London: Allen Lane.

Naughton, John (2006), 'Blogging and the Emerging Media Ecosystem', Background paper for an invited seminar to Reuters Institute, University of Oxford, 8 November 2006. http://reutersinstitute.politics.ox.ac.uk/fileadmin/documents/discussion/blogging.pdf

Naughton, John (2012), *From Gutenberg to Zuckerberg: What You Really Need to Know about the Internet*, London: Quercus.

Nielsen (2012), 'State of the Media: The Cross-Platform Report: Quarter 1, 2012, US', New York: Nielsen. Available at http://www.nielsen.com/us/en/insights/reports-downloads/2012/state-of-the-media--cross-platform-report-q1-2012.html

Nielsen (2014), 'Shifts in Viewing: The Cross-Platform Report Q2 2014', New York: Nielsen. Available at http://www.nielsen.com/us/en/insights/reports/2014/shifts-in-viewing-the-cross-platform-report-q2-2014.html

O'Reilly, Tim (2006a), 'Levels of the Game: The Hierarchy of Web 2.0 Applications', 17 July 2006, http://radar.oreilly.com/2006/07/levels-of-the-game-the-hierarc.html

O'Reilly, Tim (2006b), 'Web 2.0 Compact Definition: Trying Again', 10 December 2006, http://radar.oreilly.com/archives/2006/12/web-20-compact.html

Ofcom (2012), 'Communications Market Report 2012', published 18 July 2012, London: Ofcom. Available at http://stakeholders.ofcom.org.uk/market-data-research/market-data/communications-market-reports/cmr12/

Ofcom (2014), 'Communications Market Report 2014', London: Ofcom. Available at http://stakeholders.ofcom.org.uk/market-data-research/market-data/communications-market-reports/cmr14/

Office for National Statistics (2012), '2011 Census: Key Statistics for Wales, March 2011', http://www.ons.gov.uk/ons/dcp171778_290982.pdf

Oreskovic, Alexei (2012), 'Exclusive: YouTube Hits 4 Billion Daily Video Views', Reuters, 23 January 2012, http://www.reuters.com/article/2012/01/23/us-google-youtube-idUSTRE80M0TS20120123

Orton-Johnson, Kate (2014), 'DIY Citizenship, Critical Making and Community', in Ratto, Matt & Boler, Megan, eds., *DIY Citizenship: Critical Making and Social Media*, Cambridge, Massachusetts: MIT Press.

Pajares, Frank, & Urdan, Tim, eds. (2006), *Self-Efficacy Beliefs of Adolescents*, Greenwich, CT: Information Age Publishing.

Peseschkian, Nossrat (1985), *In Search of Meaning: A Psychotherapy of Small Steps*, Heidelberg: Springer-Verlag.

Popple, Simon, & Thornham, Helen, eds., (2014), *Content Cultures: Transformations of User Generated Content in Public Service Broadcasting*, London: I.B. Tauris.

Postman, Neil (1982), *The Disappearance of Childhood*, New York: Vintage.

Postman, Neil (1985), *Amusing Ourselves to Death: Public Discourse in the Age of Show Business*, New York: Viking Penguin.

Ratto, Matt, & Boler, Megan, eds. (2014), *DIY Citizenship: Critical Making and Social Media*, Cambridge, Massachusetts: MIT Press.

Ratto, Matt (2011), 'Critical Making: Conceptual and Material Studies in Technology and Social Life', *The Information Society*, vol. 27, no. 4, pp. 252–260.

Ratto, Matt (2012), 'Matt Ratto—Interview by Garnet Hertz', in Hertz, Garnet, ed. (2012), *Critical Making* series, Hollywood, California: Telharmonium Press. Available at http://conceptlab.com/criticalmaking/

Ratto, Matt, (2014), 'Textual Doppelgangers: Critical Issues in the Study of Technology', in Ratto, Matt & Boler, Megan, eds., *DIY Citizenship: Critical Making and Social Media* (pp. 227–236), Cambridge, Massachusetts: MIT Press.

Ratto, Matt (2015), *Critical Making*, Cambridge, Massachusetts: MIT Press.

Reilly, Mary Ann, & Cohen, Rob (2012), 'Knowmads, Rhizomes, and Minecraft: Exploring the Edges of Learning in a Middle School Classroom', http://prezi.com/i8v_fyo0d3qe/knowmads-rhizomes-and-minecraft-exploring-the-edges-of-learning-in-a-middle-school-classroom/

Resnick, Mitchel, & Silverman, Brian (2005), 'Some Reflections on Designing Construction Kits for kids', *IDC '05: Proceedings of the 2005 conference on Interaction Design and Children*, New York: Association for Computing Machinery.

Ricoeur, Paul (1984), *Time and Narrative: Volume 1*, translated by Kathleen McLaughlin & David Pellauer, Chicago: University of Chicago Press.

Ricoeur, Paul (1985), *Time and Narrative: Volume 2*, translated by Kathleen McLaughlin & David Pellauer, Chicago: University of Chicago Press.

Ricoeur, Paul (1988), *Time and Narrative: Volume 3*, translated by Kathleen McLaughlin & David Pellauer, Chicago: University of Chicago Press.

Ricoeur, Paul (1992), *Oneself as Another*, translated by Kathleen Blamey, Chicago: University of Chicago Press.

Robertson, David, & Breen, Bill (2013), *Brick by Brick: How LEGO Rewrote the Rules of Innovation and Conquered the Global Toy Industry*. London: Random House. Kindle Edition.

Ross, Andrew (2006), 'Nice Work If You Can Get It: The Mercurial Career of Creative Industries Policy', *Work Organisation, Labour and Globalisation*, vol. 1, no. 1, pp. 13–30.

S4C (2014), *S4C: Annual Report & Statement of Accounts for the 15 Month Period to 31 March 2014*, available at http://www.s4c.co.uk/abouts4c/annualreport/acrobats/s4c-annual-report-2013-2014.pdf

Sawyer, R. Keith (2012), *Explaining Creativity: The Science of Human Innovation*, New York: Oxford University Press.

Schunk, D.H., & Pajares, F. (2011), 'Self-Efficacy Beliefs', in Järvelä, Sanna, ed., *Social and Emotional Aspects of Learning*, Oxford: Elsevier.

Selwyn, Neil (2011), *Education and Technology: Key Issues and Debates*, London: Continuum.

Sennett, Richard (2008), *The Craftsman*, London: Allen Lane.

Sevaldson, Birger (2010), 'Discussions & Movements in Design Research: A Systems Approach to Practice Research in Design', *FORMakademisk*, vol. 3, no. 1, pp. 8–35.

Shirky, Clay (2011), 'The Design of Conversational Spaces', document for module at New York University, January 2011, available at http://journalism.nyu.edu/assets/Syllabi/2011/Fall/Conversation-Syllabus.doc

Sørensen, Anne Scott, Ystad, Ole Martin; Bjurstrom, Erling, & Vike, Halvard (2010), *Nye Kulturstudier*, Copenhagen: Tiderne Skifter.

Stappers, Pieter Jan, Visser, Froukje Sleeswijk, & Kistemaker, Sandra (2011), 'Creation & Co: User Participation in Design', in Van Abel, Bas, Evers, Lucas, Klaassen, Roel, & Troxler, Peter, eds., *Open Design Now: Why Design Cannot Remain Exclusive* (pp. 140–151), Amsterdam: BIS Publishers.

Steen, John (2011), 'Do Universities Matter for Innovation?' 12 June 2011, http://www.innovationexcellence.com/blog/2011/06/12/do-universities-matter-for-innovation/

Storr, Anthony (1989), *Solitude*, London: Flamingo.

Strangelove, Michael (2010), *Watching YouTube: Extraordinary Videos by Ordinary People*, Toronto: University of Toronto Press.

Stray, Jonathan (2011), 'What Should the Digital Public Sphere Do?', blog post, 29 November 2011, http://jonathanstray.com/what-should-the-digital-public-sphere-do

Suber, Peter (2012), *Open Access*, Cambridge, Massachusetts: MIT Press.

Szekely, Louis (2011), 'A Statement from Louis C.K.', 13 December 2011, https://buy.louisck.net/news/a-statement-from-louis-c-k

Taillard, M., & Antorini, Y.M. (2013), *Creativity in the LEGO Ecosystem*, Billund: The LEGO Foundation. Available from: http://www.legofoundation.com/en-us/research-and-learning/foundation-research/cultures-of-creativity/

Thornham, Helen (2014), 'UGC, Journalism and the Future: An Interview with Claire Wardle', in Popple, Simon, & Thornham, Helen, eds., *Content Cultures: Transformations of User Generated Content in Public Service Broadcasting*, London: I.B. Tauris.

Thorp, Holden, & Goldstein, Buck (2010), *Engines of Innovation: The Entrepreneurial University in the Twenty-First Century*, Chapel Hill: University of North Carolina Press.

Twigger Holroyd, Amy (2012), 'The Knitting Circle', post on *Keep and Share* blog, 31 July 2012, available at http://www.keepandshare.co.uk/blog/2012-07-31-000000/knitting-circle

Twigger Holroyd, Amy (2013), *Folk Fashion: Re-Knitting as a Strategy for Sustainability* (doctoral thesis), Birmingham: Birmingham City University.

Van Abel, Bas, Evers, Lucas, Klaassen, Roel, & Troxler, Peter, eds. (2011), *Open Design Now: Why Design Cannot Remain Exclusive*, Amsterdam: BIS Publishers.

Wardle, Claire, & Williams, Andrew (2008), *ugc@thebbc: Understanding Its Impact upon Contributors, Non-contributors, and BBC News*, Cardiff: Cardiff School of Journalism, available at http://www.bbc.co.uk/blogs/knowledgeexchange/cardiffone.pdf

Wehr, Kevin (2012), *DIY: The Search for Control and Self-Reliance in the 21st Century*, New York: Routledge.

White House Blog (2014), 'President Obama at the White House Maker Faire: "Today's D.I.Y. Is Tomorrow's 'Made in America'"', 18 June 2014, http://www.whitehouse.gov/blog/2014/06/18/president-obama-white-house-maker-faire-today-s-diy-tomorrow-s-made-america

Yusuf, Shahid, & Nabeshima, Kaoru, eds. (2007), *How Universities Promote Economic Growth*, Washington, DC: The World Bank.

# ABOUT THE AUTHOR

David Gauntlett is a Professor in the Faculty of Media, Arts and Design, and Co-Director of the Communications and Media Research Institute, at the University of Westminster, UK. He is the author of several previous books, including *Creative Explorations* (2007) and *Making is Connecting: The social meaning of creativity, from DIY and knitting to YouTube and Web 2.0* (2011). He has made popular websites and YouTube videos, and has worked with a number of the world's leading creative organisations, including the BBC, the British Library, and Tate. For a decade he has worked with LEGO on innovation in creativity, play and learning.

See davidgauntlett.com for further information, blog, and videos.

# INDEX

*General Editor:* **Steve Jones**

**Digital Formations** is the best source for critical, well-written books about digital technologies and modern life. Books in the series break new ground by emphasizing multiple methodological and theoretical approaches to deeply probe the formation and reformation of lived experience as it is refracted through digital interaction. Each volume in **Digital Formations** pushes forward our understanding of the intersections, and corresponding implications, between digital technologies and everyday life. The series examines broad issues in realms such as digital culture, electronic commerce, law, politics and governance, gender, the Internet, race, art, health and medicine, and education. The series emphasizes critical studies in the context of emergent and existing digital technologies.

Other recent titles include:

Felicia Wu Song
  *Virtual Communities: Bowling Alone, Online Together*

Edited by Sharon Kleinman
  *The Culture of Efficiency: Technology in Everyday Life*

Edward Lee Lamoureux, Steven L. Baron, & Claire Stewart
  *Intellectual Property Law and Interactive Media: Free for a Fee*

Edited by Adrienne Russell & Nabil Echchaibi
  *International Blogging: Identity, Politics and Networked Publics*

Edited by Don Heider
  *Living Virtually: Researching New Worlds*

Edited by Judith Burnett, Peter Senker & Kathy Walker
  *The Myths of Technology: Innovation and Inequality*

Edited by Knut Lundby
  *Digital Storytelling, Mediatized Stories: Self-representations in New Media*

Theresa M. Senft
  *Camgirls: Celebrity and Community in the Age of Social Networks*

Edited by Chris Paterson & David Domingo
  *Making Online News: The Ethnography of New Media Production*

To order other books in this series please contact our Customer Service Department:
(800) 770-LANG (within the US)
(212) 647-7706 (outside the US)
(212) 647-7707 FAX

To find out more about the series or browse a full list of titles, please visit our website:
WWW.PETERLANG.COM